Leonard Bernstein

100

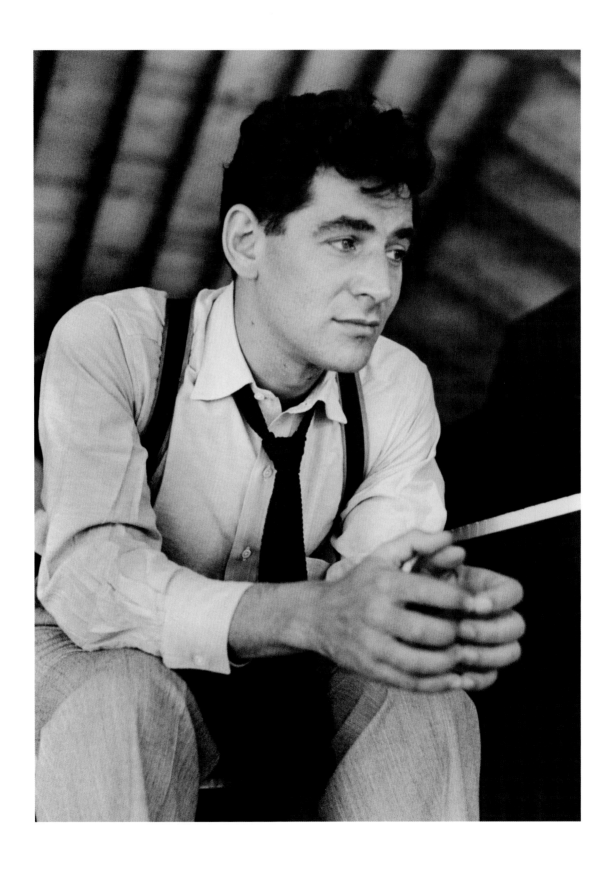

LEONARD BERNSTEIN
100

ONE HUNDRED
PHOTOGRAPHS OF
LEONARD BERNSTEIN

TAKEN BY SOME OF
THE GREATEST
PHOTOGRAPHIC MASTERS
OF THE 20TH CENTURY

PLUS ORIGINAL SCORES,
MANUSCRIPTS & LETTERS

COMPILED AND CURATED BY
STEVE J. SHERMAN
CONCEIVED BY STEVE J. SHERMAN,
JAMIE BERNSTEIN AND CRAIG URQUHART
FOREWORD BY ALEXANDER BERNSTEIN,
JAMIE BERNSTEIN, AND NINA BERNSTEIN SIMMONS

pH **powerHouse Books** Brooklyn, NY

Leonard Bernstein 100: The Masters Photograph the Maestro

Copyright © 2018 by Steve J. Sherman and Jamie Bernstein

Published in the United States by powerHouse Books,
a division of powerHouse Cultural Entertainment, Inc.
32 Adams Street, Brooklyn, NY 11201-1021
e-mail: info@powerHouseBooks.com
website: www.powerHouseBooks.com

First edition, 2018
Library of Congress Control Number: 2018954628
ISBN 978-1-57687-893-4
Printing and binding by Pimlico Book International

Book Design by Krzysztof Poluchowicz
Photo Research by Toby Greenberg

10 9 8 7 6 5 4 3 2 1
Printed and bound in China

To our ancestors,
to our parents,
to our children,
and to our future.

LEONARD
BERNSTEIN
100

—

TABLE OF CONTENTS

—

THE PHOTOGRAPHS

THE MAN, HIS MUSIC, AND HIS MIND

PREFACE,
ACKNOWLEDGMENTS,
FOREWORD

PREFACE
LENNY
AND
THE
CAMERA:
SWIMMING
WITH MY
HEROES

According to his children, Leonard Bernstein never showed any interest in taking pictures. Yet he had a constant and ongoing relationship with cameras. Bernstein spent his entire life being photographed and filmed, wooed by or hounded by, but always surrounded by cameras.

In 1956, Alfred Eisenstaedt was assigned to photograph Leonard Bernstein at Carnegie Hall for *Life* magazine, and during the session, for reasons unknown, Bernstein apparently picked up one of Eisenstaedt's Leica M3 rangefinder cameras and started to simultaneously photograph his photographer. This unique and marvelous exchange embodies the complex symbiosis between Maestro and Master that is the essence of this book.

In what would have been Leonard Bernstein's 100th birthday year, this book commemorates the excellent photography that documented his life. I have curated a centennial collection of 100 photographs of Bernstein, many taken by some of the greatest photographic masters of the 20th century, others taken by some of the multitude of great photographers out there who, while highly successful, never rose to the rarefied level of "master," and then some taken by unknown (at least to us) photographers—there are even a few snapshots by family and friends.

For every photograph in this anthology, there are hundreds of wonderful images, many by master photographers and by colleagues and friends, that did not make the final cut. The 100 that made it did so primarily for two reasons: their photographic and artistic merit as an individual image, and the piece of the story they tell when integrated into an essentially chronological photo essay that presents the story of Bernstein's multifaceted and deeply complex life. Each photo represents a specific aspect of or theme in Bernstein's life, portrays a particular person or event of major import, and offers one more piece of the vast enigmatic puzzle that was Lenny.

As such, this photo collection celebrates the remarkable synergy between Lenny and the camera.

Inevitably, with this double mission and limit of 100 frames, some of Bernstein's closest friends and colleagues are not included here—Lukas Foss, Michael "Mendy" Wager, Helen Coates, and Michael Tilson Thomas, to name just a few. Some, like brother Burton and mentor Serge Koussevitzky, appear only once—which hardly does justice to their abiding influence on Lenny.

• • •

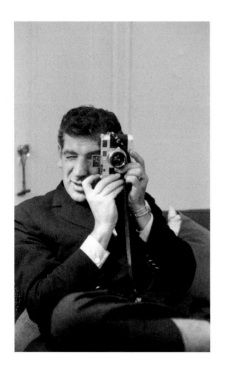

Leonard Bernstein by Alfred Eisenstaedt

PREFACE
LENNY
AND
THE
CAMERA:
SWIMMING
WITH MY
HEROES

Personally, creating this book has been a magnificent and humbling experience. And it has given me a wonderful and unexpected gift: the opportunity to swim together with so many of my heroes...

It's important to have heroes in life. I'm not talking about our natural heroes (parents, family, friends, etc.) although they too are essential. I'm talking about those we discover, acquire, and adopt along life's journey. Those people who impact us, challenge us, inspire us to greater heights, and whom we come to admire, emulate, and learn from, and with any luck, whose energy and knowledge we pass down to the next generation.

Leonard Bernstein was one such hero who came into my life relatively early, before I even realized I needed heroes. I first saw him at a Young People's Concert at Philharmonic Hall in the late 1960s, and even at the tender age of 8 or 9, I recognized that this man was different. As he spoke to the audience, I felt as if he were speaking directly to me. He clearly loved the music, but for some reason, it really mattered to him that I love it too.

Approximately 15 years later, having embarked upon a career in photography, I was able to merge my two "loves," and began working as a music photographer. I was lucky enough to become one of the small but select cadre of shooters who made the New York City performing arts scene our home and the focus of our lenses. At the time, it never occurred to me that I'd end up working with Leonard Bernstein, and that getting to know him would forever inspire me.

Sometimes meeting your heroes is not a good idea—one can be unprepared or disillusioned to see who they really are—and Lenny surely had his flaws, but somehow he never disappointed. He never masqueraded or pretended—Lenny was Lenny, for better or worse, always himself, always a true force of nature.

He was complicated: a brilliant and tormented genius, a Renaissance man whose extreme passion, potent conviction, total immersion, and perpetual curiosity transcended every norm and upended every convention. He was an unabashed gusher, schmoozer, and show-off with a huge ego, and he was a man tormented by demons his entire life, from substance abuse and overindulgence to chronic insomnia and depression.

Lenny was born just when photography was becoming the front line for journalism, as well as a powerful medium for art and entertainment. Advances in film and halftone printing technologies

Alfred Eisenstaedt by Leonard Bernstein

PREFACE
LENNY
AND
THE
CAMERA:
SWIMMING
WITH MY
HEROES

early in the 20th century, and the advent of the 35mm single-lens reflex camera in the early 1930s, allowed high-quality images to be taken and moved quickly, and be accurately reproduced. With the launches of *Life* magazine (1936–2000) and *Look* magazine (1937–1971), the photo essay was introduced to America, and the photographic revolution was on. Fascination with events also brought fascination with celebrity, and Lenny, with his instant story-book success at age 25, Hollywood good looks, charisma, and geniality, became a magnetic subject. The media swarmed; *Life* and *Look* sent their best young photographers, as did the newspapers and agencies... and Lenny was happy to entertain them all.

Not long thereafter, when television began to have a real impact on the world of media and information, Bernstein was there at the forefront, leading the way as if anointed, and blazing trails that remain heavily traveled to this day.

My first coffee-table photo book *Leonard Bernstein At Work: His Final Years 1984-1990,* was published by Amadeus Press in October 2010, marking the 20th anniversary of Bernstein's death. This book featured all my own photography, yet while researching Bernstein's letters and papers in the Library of Congress, seeking quotes for the book, I began to see numerous photographs of Lenny by all these amazing photographers—including those whose work had inspired me and dared me to become a photographer. It had never occurred to me that they had worked with Lenny, and the idea for this book was born—for here were so many of my heroes swimming together in the same pool, and all I needed to do was dive in...

I must mention a few by name, those who had a particularly powerful impact on me. I begin with Ken Heyman, whose work I first encountered while in the fourth grade when I began studying art with Myril Adler, my greatest teacher and very dear lifelong friend. Adorning her studio walls were a series of photographs by her close friend Ken Heyman that turned my life around—for I saw intense beauty, deep humanity, and poetry in his images of ordinary people doing ordinary things. Milly introduced this 10-year-old kid to Ken, and I remember that he was a big man with huge hands and an easy, gentle smile... I had a second hero.

I began to look at photography in a new light, poring over every issue of *Life* and *Look* that came through our home; I was swept up by the humanity of W. Eugene Smith's photography, illuminating the human condition and finding compassion amidst the horror of war.

PREFACE
LENNY
AND
THE
CAMERA:
SWIMMING
WITH MY
HEROES

I was fascinated by the technical brilliance of Alfred Eisenstaedt and Gjon Mili. Gordon Parks imbued politics and protest with gravitas, Irving Penn made his studio into a painter's canvas, and for years I tried (unsuccessfully) to copy Yousuf Karsh's magical lighting technique. Image-makers like Henri Cartier-Bresson, Carl Mydans, and Bruce Davidson all distilled life to its essential human elements. Ruth Orkin's photo of Leonard Bernstein conducting (page 47) brought art and music together in a way that deeply inspired me.

Very early in my career, I was fortunate to be introduced to the master portraitist Arnold Newman, who gave me an intense and harsh hour-long critique of my printing quality that was hard to listen to at the time but was an important lesson that I carry with me to this day. Soon after came the exciting opportunity to assist and work with the extraordinary Henry Grossman, who taught me (amongst many things) the psychology of photography. I also befriended the legendary Magnum photographer and gentleman Erich Hartmann, who urged me to view my photography as an art medium, whatever the subject.

Once my career was well-established, Richard Avedon (an avid concert-goer) often came over during concert intermissions to say hello and "talk shop." I was privileged to work alongside Heinz Weissenstein, Don Hunstein, Ken Reagan, Richard Corkery, and Walter Scott, among so many other photographers whom I wish could have been included in this book.

And to my delight I continue to see Ken Heyman from time to time, who at age 88 is still going strong, whose images are still my gold standard, and whose hands are still big and whose smile is still gentle and easy.

So imagine the feeling, given this opportunity to swim with so many of my heroes all at once, and able to say thank you.

I am deeply indebted to all these brilliant image-makers for allowing us to remember and celebrate Leonard Bernstein through their unique way of seeing and creating. And here's to Lenny who gave them the most incredible and beautiful and intriguing and irascible and difficult subject of their lives. And here's to the music and art that resulted... and will continue long after we all are gone.

So if you don't mind, I'm going swimming again, and this time invite you to join me. The water's fine, and the company simply can't be beat...

Steve J. Sherman

ACKNOWLEDGMENTS

On behalf of my coauthor Jamie and myself, I would like to acknowledge some of those without whose extraordinary help and support this work could never have been completed. This list barely scratches the surface, but our sincere and humble thanks are offered with profound gratitude...

To Lenny. For being Lenny.

To the photographers, who while "just doing their jobs" gave us all an extraordinary visual language with which to better see and understand our world, and in this case, the world of Leonard Bernstein.

To Alexander, Jamie, and Nina Bernstein for their unwavering support of this project, and for honoring the legacy of a great and good man. And a special hug to Jamie for being such an amazing, wise, and steadfast partner in this book project from beginning to end, and then some.

To Craig Urquhart, who helped conceive of this book and was a driving force in our getting it off the ground, and then had the trust and grace to let Jamie and me do it as we envisioned...

To Toby Greenberg, whose photo researching skills and sleuthing prowess allowed us to obtain permissions normally impossible to get, and whose insights, creative instincts, and eagle eye proved to be invaluable in completing this collection.

To Daniel Power, Craig Cohen, Lizzi Sandell, Krzysztof Poluchowicz, Wes Del Val, and the whole powerHouse team for believing in this project, and making it such a beautiful reality.

To Christopher Sweet for his invaluable support in finding our publisher and finalizing the deal.

To Michael Carlisle and Inkwell Management for guiding us through the contract process.

To Mark Eden Horowitz of the Library of Congress's Music Division, who perhaps more than any other single person was so crucially helpful on so many different fronts, and always with a smile and an immediate reply.

To Humphrey Burton, whose biography *Leonard Bernstein* (Doubleday Books, 1994/Faber & Faber, 2017) remains the go-to Bible for anything Lenny and informed me at every juncture of this journey. His support, along with that of his wife Christina, was so important.

To Jacob Slattery, Hannah Webster, and Marie Carter of the Leonard Bernstein Office for their wonderful support and help.

To Frankie Jay Thomas for her stellar work in transcribing the Trialogue for us.

Our sincere and grateful thanks to the many people who were so helpful in our efforts to find, secure, and license these photos, including: Jonathan Cameron—SK Archives; Aaron Copland Fund for Music, Inc.; Bridget Carr—the Boston Symphony Orchestra Archives; Ted Ciuzio—Associated Press; Sean Corcoran and Lauren Robinson—Museum of the City of New York; Mary Engel—Ruth Orkin Photo Archive; Joshua Greene; David Grossman; Erin Harris—Richard Avedon Foundation; Ruth Hartmann; Barbara Haws and Gabryel Smith—the NY Philharmonic Leon Levy Digital Archives; DeeAnne Hunstein; Amita Kiley—Lawrence History Center; Matthew Krejcarek—The Irving Penn Foundation; Thomas Lisanti—the New York Public Library; Wayne Mones; Chamisa Redmond, Paul Hogroian, Courtney Matthews, and Alexis Valentine—the Library of Congress; Lori Reese—Redux; Carolun Soltau—Vancouver Sun; Hilary Scott; Nada Severdija; Michael Shulman—Magnum Photos; Leslie Squyres—Center for Creative Photography, U of Arizona; Gesine Stross, Jenna Veren, Alessandra Bianco, and Leslie Stauffer—Getty Images; Jonas Studenzia; Thomas Tierney and Toby Silver, Sony Music; Peter Weissenstein; Matthew White—Boosey & Hawkes

And personally, I want to thank, with all my heart:

Véronique Firkusny whose brilliant support, wisdom, and enduring friendship was so generously given, and treasured, irreplaceable, and invaluable beyond words...

My parents Ruth and Robert for always being troopers, through and through—and always such wonderful, supporting, and loving parents... stay healthy!

And finally, to my truly incredible children Jesse and Fiona for putting up with my insane work schedule to get this book done, and for their understanding, and their unconditional love and support... I love you beyond any words...you are my true heroes.

Steve J. Sherman

FOREWORD
TRIALOGUE

Alexander, Jamie, and Nina Bernstein sat down one recent afternoon with Steve Sherman to talk about their father Lenny...

Lobsters

Jamie: Okay. So. It was summer in Fairfield, Connecticut.

Nina: August. Hot.

Alexander: And steamy.

J: And the plan was to have our dad's favorite summer meal: lobster. And corn on the cob. He liked to eat things with his hands. The messier, the better.

A: And the more butter involved, the better.

J: I don't remember how this happened, but somehow, Daddy got it into his head that the lobsters were not still alive when they were dropped into the pot. And his belief was that if the lobster was dead when you cooked it, then you would be poisoned.

N: He just decided that the lobsters were dead. So after dinner, he got all sweaty and upset. And he went and lay down.

Steve: And did everybody eat lobster?

A: Yeah. Everybody was fine.

N: He was taken to Bridgeport Hospital for testing.

J: He was there for three days for a complete workup.

S: How old was he at this point?

A: In his early 60s, I think.

S: So you guys were still young enough that this was traumatic.

A: It was a little scary. But he just seemed so fine, when we went to visit him. He was being all silly in the hospital—he had all his pals in the nursing staff, and the doctors were fawning all over him.

J: And everybody made a big fuss over him. Maybe what he really just needed was to have a big fuss made over him.

N: We were pretty sure he was okay.

J: Anyway, after three days, he was pronounced okay. And when he arrived back at our house in Fairfield, he got out of the car dressed in doctor's whites, with a stethoscope around his neck. He looked terrific! He went straight over to the swimming pool and jumped in—doctor's whites and all.

J: It is true that he needed a lot of attention. I think we could say that. Right?

N: Yeah.

A: Yeah.

N: That was why the composing periods were so difficult. Because there's nobody around while you compose music. But he loved it, too.

A: It's a very solitary task.

J: We think one of the reasons he enjoyed theater so much—ballet, theater, shows, opera—was that he had collaborators and it wasn't so lonely. But when he wrote a symphony, he was just stuck in that studio, all by himself, you know, night after night, and it was torture. He hated it.

A: But he needed it.

N: But he had to do it.

Insomnia, Anxiety, Success:

S: When you were younger, were you told not to disturb your dad while he was composing?

N: No. We were welcome to disturb him most of the time.

A: He didn't mind us coming in. He had lots of trinkets and things in his studio. We'd go in there and just play with stuff and bother him.

J: The only time we were not to disturb him was when he was sleeping, because sleep was so precious. He was an insomniac. So I remember once we were out in the hallway making a racket, and I don't know what time of day it was, but he was trying to sleep, and he opened the bedroom door and yelled, "Quiet, damn you!" and slammed the door. And we were so shocked that we burst into tears.

A: I don't remember that at all.

N: That's just not him at all.

J: That was a rare occurrence.

S: Was he an insomniac because his brain didn't turn off?

N: Yeah. I think it's the motor that wouldn't turn off.

J: Even if he was exhausted, which he was most of the time.

A: You know, as sure of himself as he came across—and his ego was enormous—he was equally insecure, thus needed the attention all the time. And so, I think a lot of the insomnia was a kind of panicked insecurity. A lot of it was serious anxiety.

N: Do you think he was replaying the day?

A: Replaying the day, or, worrying about the next day, or: Who am I? What am I doing? Am I gonna be discovered as the fraud that I am? The usual artists' problems. And he had them in spades, because he made the stakes really, really high, and so it was that much further to fall.

S: How much of it was the fact that he was catapulted into this high level of fame, suddenly and early, at 25 years old—suddenly, bang! One day not, and the next day yes?

A: I think he was prepared for it. I mean, you talk to anybody who knew him before 1943, and they say they had met a genius, this guy was gonna take over the world, he was so handsome, charismatic, brilliant, talented…it was all there. He was kind of expecting it, I think. Obviously he didn't know *how* it was gonna happen. He was this Jewish guy, American, you know, nobody like that had ever become a conductor before.

S: Everybody is "of their time" and his time happened to coincide exactly with the rise of the photo essay: *Life* magazine, *Look* magazine, even tabloid media. It was no longer just news events around the world. Now

Alexander, Jamie,
and Nina Bernstein,
photographed in 2016
by Steve J Sherman.

it was the people who made the news. So a lot of the photographs were assignments. "Hey, there's this guy Lenny Bernstein. Go take pictures. And then tomorrow there's this lady, whatever, go take pictures."

N: Like Kubrick did.

J: For *Look*.

S: Yes, Kubrick was shooting for *Look* and took all those shots. Who knew he was gonna become Kubrick? Who knew Bernstein was gonna become Bernstein? Didn't matter. It was an assignment. "The editor needs the shot."

A: Yeah. But you know, they had done all that with Toscanini, with Stokowski. I mean, just think of Stokowski, who in 1940 was Mr. *Fantasia*, and showed the world the power of the conductor...and Toscanini was on television even in the 40s, when it was first coming out. And so there were already these really well-known conductors—

N: But they weren't handsome the way Daddy was.

A: They weren't handsome, plus they weren't *also* composers—or American.

J: Right. That was the real difference.

A: The combination of all those things.

N: Yeah. The package was unbeatable.

J: And that's why when, let's say, Gustavo Dudamel is compared to Bernstein as a conductor—he's only Bernstein-like as a conductor. And not in all the other ways. The composer, the pianist...

A: It's as if Lin-Manuel Miranda were also a world-class conductor.

N: Which may well still happen! But, you know, it's that unbeatable kind of package.

A: And not only was he composing, but what he was composing was so diverse, it might as well have been 12 different careers right there, just in the composition.

What Kind of Composer?

S: I have a photo from very the early 40s, in which he's sitting sprawled at a piano with music all around him, and he wanted to be a classical music composer, but who knows what he's composing in this photo? He dove into all kinds of music, right from the start.

A: Yeah. I mean, he saw what Gershwin could do, and wanted to take that steps further. You know, there were others who were doing it with concert music, like Dvořák bringing in the folk idiom, and Ravel bringing in jazz. So it was something that was already possible.

N: But nobody before "LB" was bringing Prokofiev into a musical theater score. And not everybody loved that he was, either.

J: Who was it that referred to it, who said...?

N: "All that Prokofiev stuff!"

A: George Abbott, producer of *On the Town*.

J: Yeah, George Abbott—he called the ballet music in the show "that Prokofiev stuff."

A: You could make the other argument that Gershwin, who had a classical training, would borrow tunes from classical compositions.

J: But Gershwin didn't actually get the classical training from the beginning. He added it on as an adult. So in that sense, maybe LB was the first thoroughly classically trained composer who devoted himself to musical theater and brought that whole tool kit with him into the Broadway pit.

S: Could he have composed something that satisfied him and—I'm talking about the big picture—then say, "Ha, now I've done it"?

N: Yeah. The Great American Opera. That was his goal. And he said it. Out loud. And he thought he was the man for it.

A: He was still trying to write it at the end of his life. It was gonna be about the Holocaust. And it was called

Babel. But he just didn't get there.

J: But, you know, retrospectively, many people think that *West Side Story* is the Great American Opera.

S: Not everybody crosses over—not like he did.

A: No. This is why it was such a fortuitous, amazing collaboration with Jerome Robbins.

N: He had that same thing—

A: Because they were both—

J: Classically trained.

A: Absolutely: European, classically trained, but you know, American, brash—

N: Of the people!

A: ...Interested in new forms and Broadway and jazz.

N: They were no-brow.

J: All-brow.

A: Unibrow!

N: Omnibrow!

A: I was just asked a question today about Betty [Comden] and Adolph [Green]: Was it because of our dad's relationship with them and the Revuers, was that the reason that he got into Broadway theater? I said that could be true, but it was probably Jerry Robbins coming into the mix that brought the confidence, the stamp of approval that this could be done, because the dance guy was a ballet guy who had all this European training but thought the way LB himself did about American theater.

J: That's an interesting theory. But Betty and Adolph were very intellectual too. You know, they knew literature. They knew history.

A: Oh, absolutely.

N: To say nothing of symphonic works.

J: To say nothing of symphonic works. So they were already operating at a pretty high level.

N: Right. Yeah. Otherwise they would not have been pros.

J: Even though they were writing musical comedy, there were always those more serious intellectual underpinnings.

N: But I take your point about Jerry.

A: I mean, we'll never know. But...

Smoking

A: What would you say is the percentage of photos with a cigarette?

S: I found a couple of photos without.

[laughter]

A: So you'd say like, 90%?

N: When not on the podium.

S: And, I noticed, even on the podium during rehearsals—and everybody he's talking to just had to put up with it, because it's right there.

J: That sounds like an accurate reflection of the percentage of time he was smoking in life. 90% of the time.

J: Which is to say that he slept...

N: About 10% of his life. Maybe less.

J: If he was awake, he was smoking. Between courses at dinner, and...

A: And then there's the scotch! He used to give *me* scotch, as a little kid.

J: I came home from the hospital, with Evan just born. He was one day old. And my dad came over with three others—they'd brought a bottle of scotch in a brown paper bag, to celebrate. So I gave my dad a scotch on the rocks. And I put Evan in his lap to hold. He dips his pinkie right in the scotch and plops it into Evan's mouth.

N: Yup. That's him.

A Man in Motion

A: There's the interesting story of Avedon, who tried a billion times to take LB's picture and found it impossible.

S: Why?

A: I think the way I recall is that he said that he was just such a man in motion, and he couldn't capture it.

S: I found that to be true. He screwed up every one of my sessions that I posed. If it was unposed, he ignored me, and it was great. If it was posed, every one, he just had no tolerance for that, no patience for that.

Enjoying Fame

S: Because your dad was what I call a "reluctant celebrity," and didn't really…

N: Ehhhh, I wouldn't say that.

S: No?

N: He enjoyed his fame.

A: Absolutely! He loved going out on the town…

N: And being recognized.

J: If he walked through the park and nobody stopped him, he would say, only half-jokingly, "What? Nobody loves me!"

A: No, he absolutely enjoyed it—until later, when he felt he was becoming an industry. But he just loved, you know, the fact that people would recognize him. And he made a new friend every time. He was connecting with a new person, and that just added to the total of the billions of people that he was connecting with.

J: Right. And when you talk to people who had some kind of exchange or communication with him, they all feel like it was really special and intense—sort of laser-beam-y. Even if it was just a 90-second conversation.

N: It was an unforgettable 90 seconds. So much so that they're telling *us* about it now.

S: I took a picture of a young conductor who got 60 seconds with LB before people were yanking him away so somebody else could get a turn. And that's exactly what he said: "Those 60 seconds packed more for me in my career than anything else in the world. He looked me right in the eye. We really connected."

J: Right. We hear this again and again and again.

S: He was so fascinated with people, with people's stories.

N: I mean, I like people fine. But really—I mean, *all* of them?

A: Every single one??

N: I don't have that kind of patience. He was genuinely interested in what everybody had to say.

A: And going on tour with him…! I remember being in Japan, and after every concert, I don't know why it was particularly so in Japan, but people would line up around the block after the concert, and they'd all have these blank white square cardboard things for him to sign, or pictures. And so he would sit there for probably two hours after the concert, signing everybody's thing and talking to every single person. And he did it. He never complained about it. Never said, "Oh, I have to get to the reception," or "I'm tired, I want to go back to the hotel." He went until it was over. And, you know, he never really talked about this. He never said, "I'm going to always respond to everybody!" No. He responded to every letter he ever got, personally. He wrote a response. But he never made a big deal about it. It was just something that he assumed was his responsibility. I don't even think it was, you know, like Koussevitzky said, "You must always do it!"

N: "Honor your public!"

A: "Honor your public!" I think he just knew it was something he wanted to do.

S: Did you guys feel the same attention from him? Was it the same kind of intensity of communication?

J: Yeah. When he was hanging out with us, his attention was fully upon us, and we always felt welcome in his

company, that he was really glad to have us around—and to teach us things, of course. He was always in teacher mode. So that was part of the laser-beam thing.

N: But at the same time, he did value his privacy when he had it. A weekend in Fairfield, for example. Or a composing holiday in the Canary Islands with friends. Just, off duty.

J: Remember the story he told, was it in Caneel Bay?

A: Apparently the hotel had alerted the guests—they'd said, "Well, Leonard Bernstein's staying here, but he's here to have some quiet time by himself, so please don't disturb the Maestro."

J: And then he goes down to the beach, and these ladies yell at him across the beach, "Yoo-hoo! We're not bothering you!"

S: When you look at all the family pictures, you get the impression that this was a really happy group of people.

N: We were! Until we weren't.

J: There are no photos in our family, like the one that's just burned into my brain, of Donald Trump going up the steps to Air Force One holding an umbrella, while his son Barron is in the rain behind him.

A: There are lots of pictures of Melania in the rain, too.

N: Yep.

J: Yeah.

A: Our dad loved his family and had fun with his family, so, the end.

The Recurring Dream

S: Did you feel that your privacy was invaded upon, or taken away, because of all the people in your life?

N: Well, I don't know…do we want to talk about the recurring dreams?

J: Oh! I think we should.

A: Oh, that's interesting.

N: We, the three of us, each have the same recurring dream: that we're in Fairfield, and that suddenly The People start arriving. And we don't know who they are.

A: We all dream different ways that this happens.

J: But suddenly, the house and the grounds are overrun with strangers. And we have all independently had this recurring dream.

S: I'm guessing that when the house was filled with people, most of the time you knew them.

A: Oh yeah. Most of the time.

N: Most of the time.

A: Especially in Fairfield.

S: So it was more a matter of just…

N: The invasion of one's private space.

S: How did the camera play into that?

A: I never had a problem with the camera.

N: No, I didn't either.

J: Until Ansedonia.

A: Ansedonia. Exactly.

J: That was the one time that we rented this house in Italy and spent the whole summer there. And John Gruen was writing his book, *The Private World Of LB*. And Ken Hyman was the photographer. And they were around a lot. Like, a *lot*. So that summer we felt impinged upon in a way we never had before and never would again in quite that way.

A: I never had a problem with being photographed by Ken Hyman.

S: I just saw Ken three weeks ago, and I asked him about that summer. He remembers it well, as this assignment: Bernstein, the family. His big recollection was the Charlie Chaplin evening. That was, for him, a highlight.

A: "I knew someone elegant was coming!"

J: That was what four-year-old Nina said when Charlie

Chaplin came to the door of the house.

N: I opened the door, and there was Charlie Chaplin, and his family, and I said, "I knew someone elegant was coming!" Hahaha, I'm so cute.

[laughter]

J: You were! Awfully cute.

A Fluky Photographer

S: So I'm including that photo of your dad taking a picture, but only found one other of him with a camera. Was this just a fluke, one-time thing?

J: I think it was pretty fluky.

N: I never saw him take a picture in my life.

S: So he wasn't into photography?

A: No. He never said, "Oh, I need a picture of this!" No.

J: He would write about things later in letters.

A: His memory capacity was…

N: Infinite.

A: Insane.

J: Phenomenal. You know, he would show up in some city that he hadn't been to in 15 years, and some lady would come backstage, and he would say, "Oh, Mildred Plotnik, 284 Maplewood Drive! How are the twins?" It was like that.

Rock Star

S: I wanted to put in a shot from Japan where people are reaching up to the stage to try to touch him, and screaming—it's like The Beatles. And I wanted to juxtapose that with the photo of you guys watching The Beatles at the Ed Sullivan rehearsal.

A: You'll notice I'm the one without my fingers in my ears.

S: I think you were looking a little bored.

A: Well, what was boring was that you couldn't hear them play.

S: Because everybody was screaming?

A: Everybody was screaming. Same thing at Shea Stadium. It was like: why am I here?

J: Shea Stadium was useless.

N: And that's how they felt. That's why The Beatles stopped touring.

J: It wasn't about music anymore.

Security in Family

A: He found security in his siblings.

N: And not just security, but refuge.

S: But from friends too, I imagine.

J: Yup.

A: And my mother would make sure that there was always that cushion of those people around.

Shirley fills the empty space

S: There's a photo at the Kennedy Center, all of you together, but instead of your mom, there's Shirley.

N: Well, that tells the part of the story where that relationship became so crucial.

J: After our mother died.

N: And at the end of his life.

J: Shirley took up a lot of that emotional real estate.

The YPC/TV Influence

S: The first time I went to a Young People's Concert, I was blown away by "that guy" on the stage. He loved the music so much, and he made me want to love it. I came home from that concert a different kid.

J: So many people tell us this, everywhere we go. It's amazing the impact those Young People's Concerts had. Both on the audience and on the musicians who are in orchestras today.

N: Yeah, Marin Alsop just told that story where she went to the concert and saw this man flailing around, and she said, "Nobody told him to stop! Nobody told him to knock it off!"

J: So she decided, she said, "possibly just on an aerobic basis," that she wanted to be a conductor.

S: And then, not just for the 2,000 people in Carnegie Hall, but he put those concerts on TV.

A: For the millions.

J: Millions.

N: Millions!

S: And what that did for music is stunning.

J: And is still doing, because a lot of the butts in seats of concert halls today are the ones who were originally exposed to classical music through the Young People's Concerts.

A: But those people are starting to die off.

J: And those giant concert halls that they built in the 60s and 70s? Now they can't fill them. It's a problem.

N: There's a lot of great musicians, but not enough people wanting to attend their concerts.

J: My money's on all those youth orchestras for social change inspired by El Sistema in Venezuela. Symphonic music is coming into these completely different communities, where new audiences will eventually develop, because those kids in the orchestras are bringing along their families, their friends, and their communities. They all get exposed to the music that way for 15, 20 years, and they really get invested in the repertoire. This is what I saw for myself in Venezuela. But it took a long time. They've had that program down there for 40 years. So, we'll see how that goes up here.

Activism and Education (and Israel, and Wagner)

S: We talk about activism being a "movement," because everybody can only participate during their time on earth, and then the next generation takes over, and the next and the next... Your dad moved the bar substantially in his role as an activist. Do you feel like a part of that effort yourselves?

J: His humanitarian efforts had a really big effect on the three of us. We grew up in this environment where it was taken for granted that you were going to speak up if something wasn't right, if there was an injustice or an oppression that you saw in the world. Civil rights, Vietnam War...you'd speak up. And our mother was very much that way herself. So that's something that we take along with us and pass along to our kids.

A: I currently work on my father's living educational legacy, called Artful Learning. He started thinking about this toward the end of his life, not just making the arts part of education, but the artistic process. Putting that at the center of all teaching and learning, making it possible to connect one discipline with another. He always said, "The best way to know a thing is in the context of a different discipline." Artful Learning is growing and working in schools all over the country. It's magnificent just to see the kids so engaged, the teachers so engaged, and the parents and community.

S: What about Israel? His connection to Israel was clear. His connection to his Judaism was powerful. But politically, towards the end of his life, when it became clear what Israel was doing, how did he reconcile that? Or did he?

A: He had a very, very, very hard time.

J: He was super depressed about Israel. He was there for its creation, so he had such a passionate connection to what it represented and what it was supposed to be, and then when he saw what it was becoming, he was in despair.

N: But he went every year.

J: Yes, to do music. Over and over again in his life, I think he tried to put music on a higher plane than political discourse. He did that in Israel, and he did it in Vienna, and in Munich, and with Jerry Robbins and with Elia Kazan.

A: He was convinced—I mean, more than convinced, it was his very *being*—that music had all the power. Not just some power—had *all* the power, of love and connection and hope and humanity.

S: Did he conduct Wagner?

A: Sure.

N: All the time.

J: But he struggled with it.

A: He did, but he made an unbelievable recording of *Tristan*.

N: And he thought the music was glorious.

A: He struggled with it, but he loved it.

N: And he refers to it a lot in the Norton lectures, too.

J: He made a documentary with Humphrey Burton filming him in Freud's office, and he pretends to address Dr. Freud. "What am I gonna do about Wagner?" And then he says to Wagner himself, "I hate you, Wagner, but I hate you on my knees!" He struggled with it. As do we all. Because Wagner was the most disgusting human being you could possibly imagine.

A: And his operas are too long.

N: Way.

Dealing with LB Posthumously

J: You know, now that so much time has elapsed since we lost him, 28 years, it is a bit easier to talk about him and celebrate him and think back upon him, and comprehend what his legacy was. That was not so easy to do when we were all just living through it with him. Because his light was very blinding. It's easier to process it in retrospect, everything that he was to the world as well as to us.

A: I think that's pretty much true. I mean, if we had been interviewed in, say, 1988...

N: About "the importance of Leonard Bernstein."

A: I have no idea what I would have said.

J: Yeah.

N: I would have said, "Leave me alone."

A: Yeah. Exactly.

A: We had no sense of what the legacy would entail. The education part. The humanitarian part. We didn't know, right after he died, whether his compositions outside of *West Side Story* would have any legs.

J: We had no way of knowing that by now, contemporary composers all feel completely free to compose in any genre, or...

A: Combinations of genres.

J: Yeah, which is what our dad did. But he did it very much against the expectations of the time. In the mid-20th century, you had to write 12-tone music if you were going to be considered a so-called serious composer. And he did sometimes, but he wouldn't do it exclusively, thereby consciously disqualifying himself from being in the pantheon of "serious American composers." But he just wrote the way he was gonna write.

S: He composed true to his heart.

N: And his pieces are best when they are closest to his heart.

J: But we didn't know at the time that his approach was going to become the MO later on. By now he looks prescient, because he mixed up all the genres, and today's composers look to Bernstein as the template, the role model, for the way they compose now.

A: Which makes his Norton lectures look particularly prescient—

N: —since they theorize that tonality is in fact an organic component of human communication.

A: That final line of the last lecture: "The answer is yes!"

N: Oh, yeah.

Nina, Alexander, and Jamie
Bernstein, photographed in 2016
by Steve J Sherman.

LEONARD
BERNSTEIN

THE
PHOTOGRAPHS

1918 – 1943

THE
EARLY
YEARS

*"How could I know that my son
would grow up to be Leonard Bernstein?"*
–Samuel Bernstein

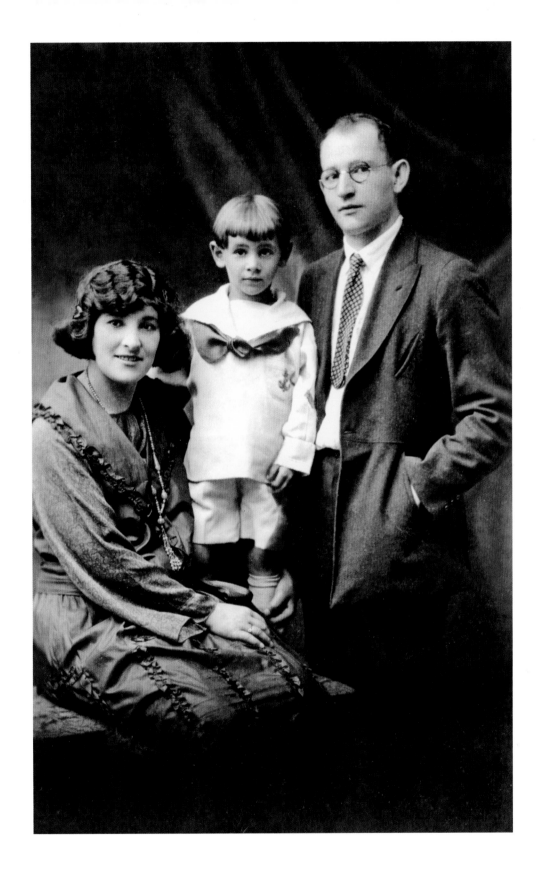

Photographer Unknown
c. 1922.
Leonard Bernstein, age 4, with parents Jennie and Samuel Bernstein.

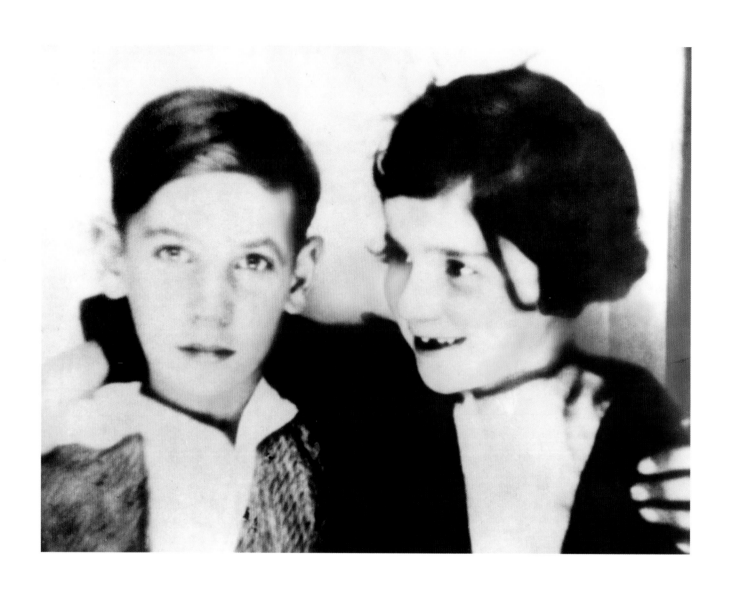

Photographer Unknown
c. late 1920s.
Leonard Bernstein with younger sister Shirley.

Photographer Unknown
1933.
Leonard Bernstein, age 15.

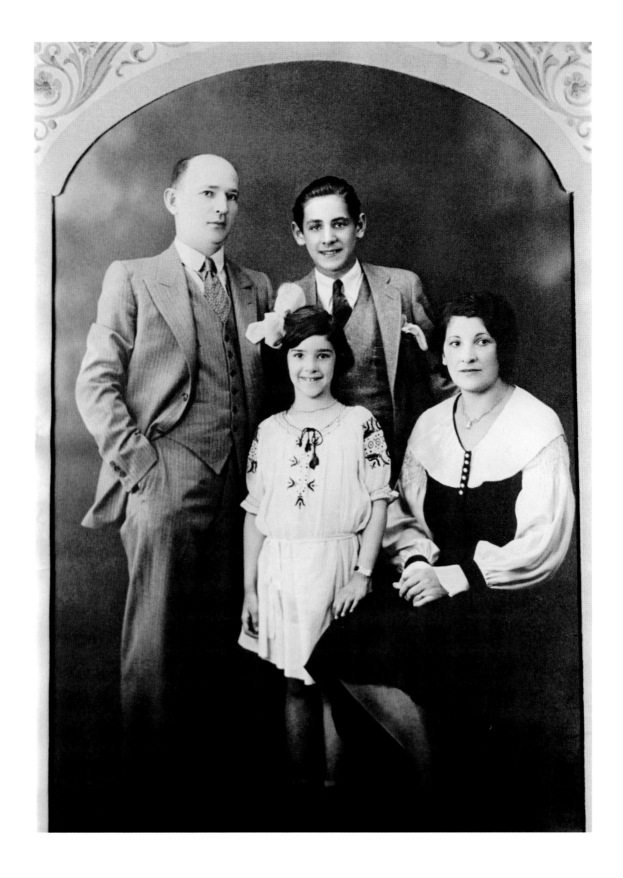

Photographer Unknown
1935.
Leonard Bernstein with his parents, Samuel and Jennie, and sister Shirley,
the year he graduated Boston Latin (high) School, and entered Harvard University.

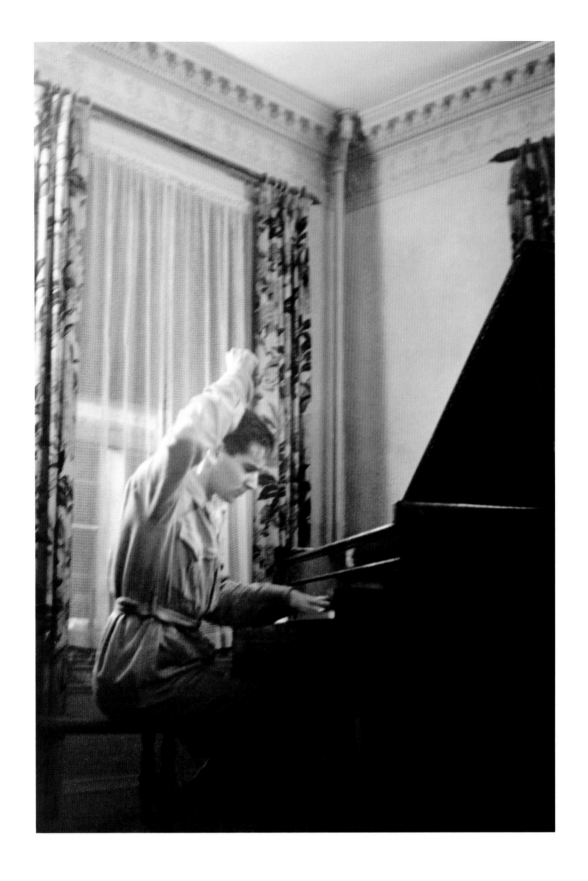

Photographer Unknown
1936.
Leonard Bernstein practicing on the piano gifted to him by his father.

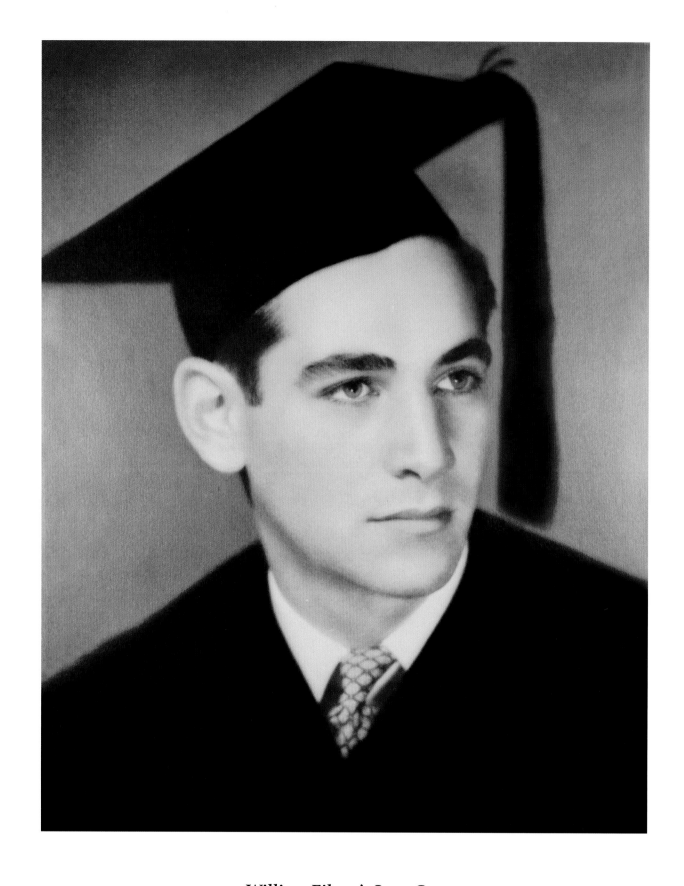

William Filene's Sons Co.
23 June 1939. Harvard University, Cambridge, MA.
Leonard Bernstein graduates with a BA degree in music—*cum laude.*

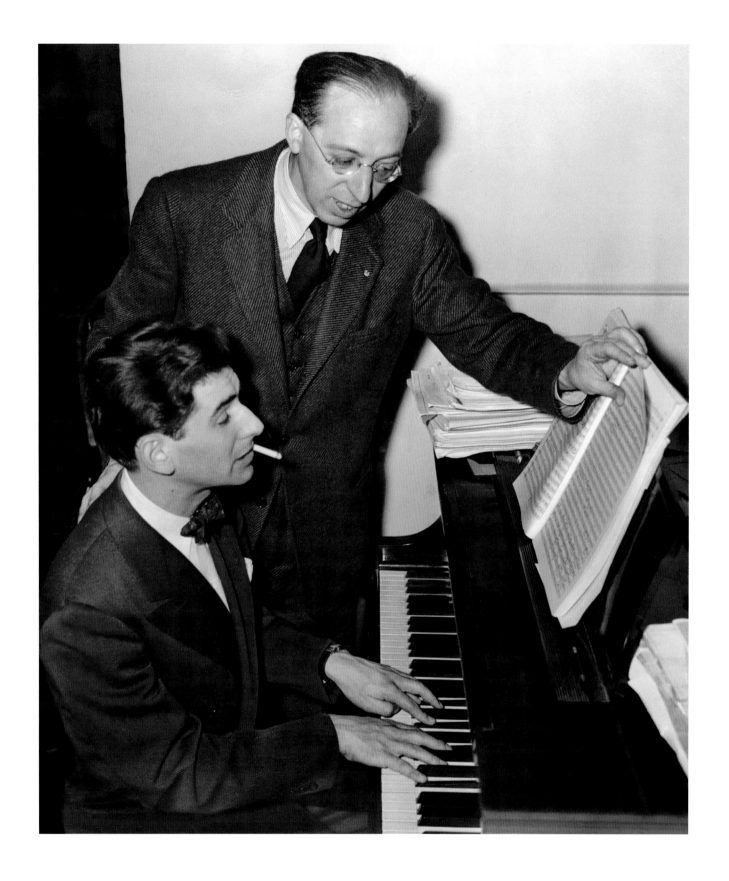

Victor Kraft
c. 1940. New York City.
Leonard Bernstein with Aaron Copland,
who would become one of his close lifelong friends.

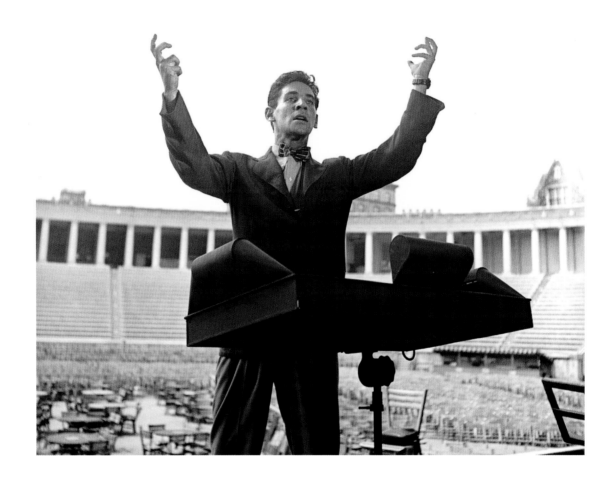

George Karger
1941. Lewisohn Stadium, New York City.
Leonard Bernstein conducting a rehearsal of the Lewisohn Stadium Symphony Orchestra
(aka the New York Philharmonic).

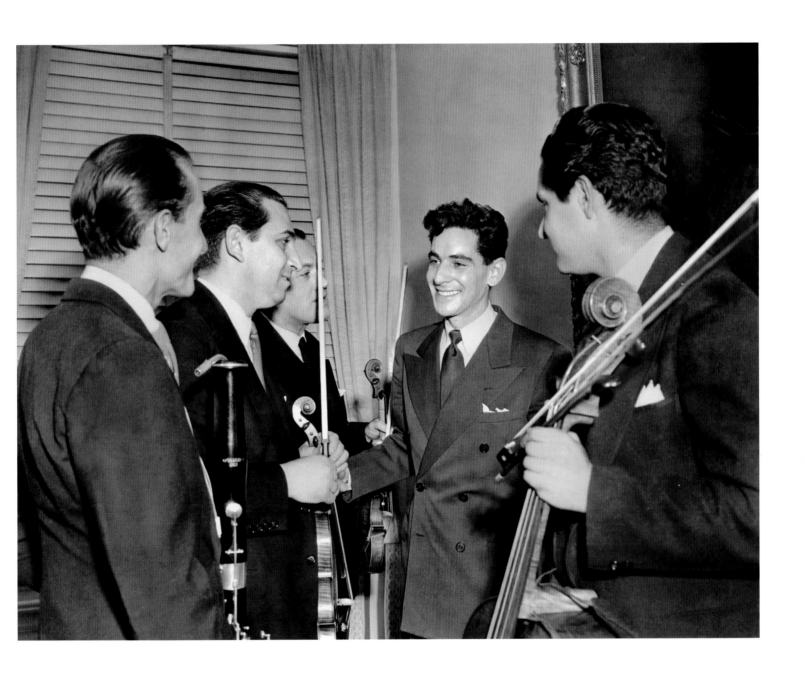

Photographer Unknown (*The New York Times*)
14 November 1943. Carnegie Hall, New York City.
Leonard Bernstein backstage with members of the New York Philharmonic
after his historic debut concert as a last-minute substitute for an ailing Bruno Walter.
Concertmaster John Corigliano Sr. is second from left.

1944 – 1956

THE RISE TO PROMINENCE

*"Some day, preferably soon, I simply must
decide what I'm going to be when I grow up."*
–Leonard Bernstein, 1955

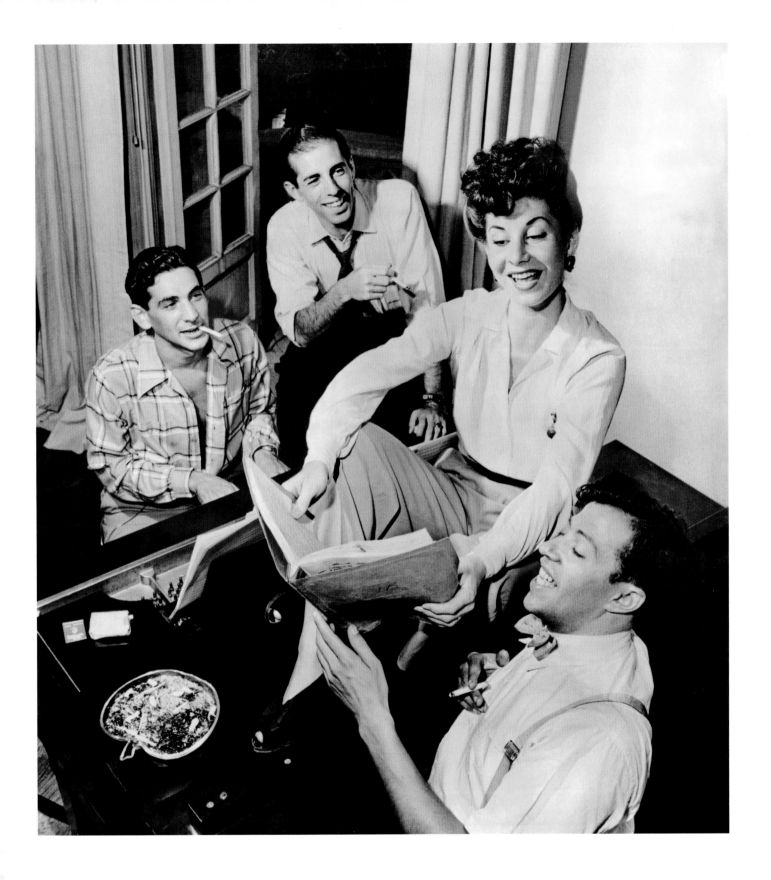

Photographer unknown
1944. New York City.
Leonard Bernstein with close lifelong friends Jerome Robbins, Betty Comden,
and Adolph Green, as they work on *On The Town*.

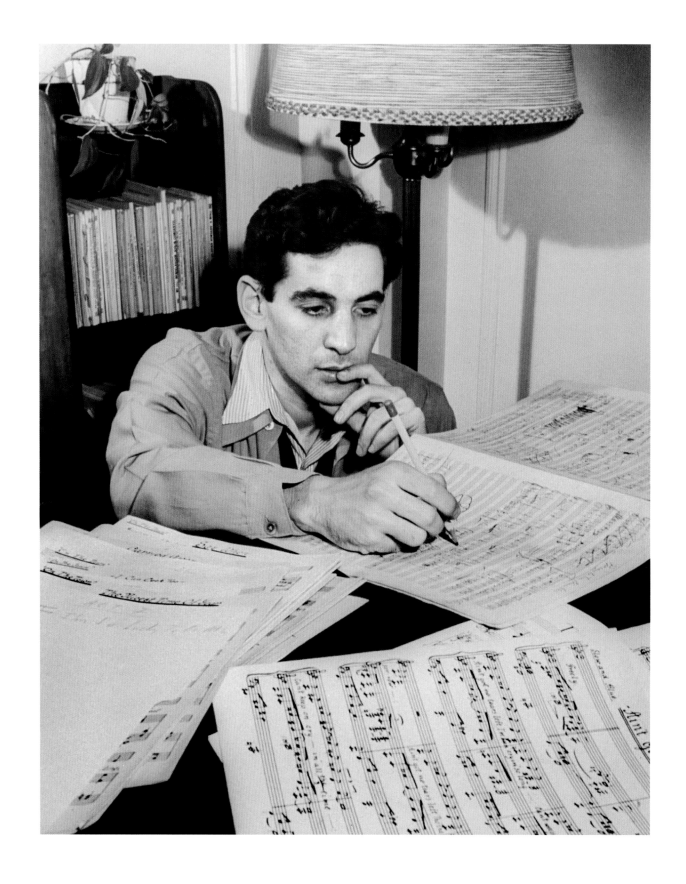

Eileen Darby
1945. New York City.
Leonard Bernstein composing at the piano at home.

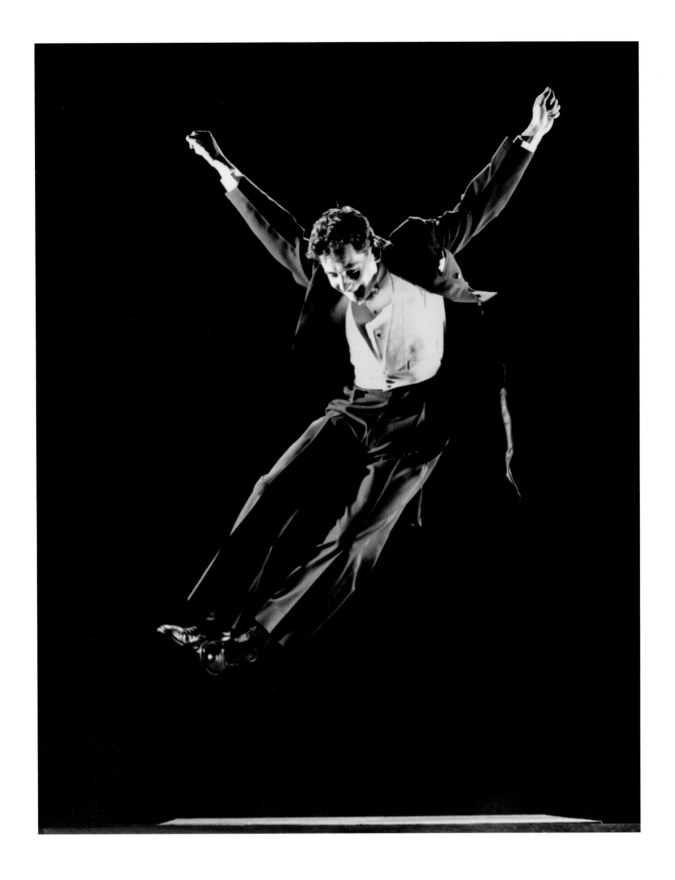

Gjon Mili
1945. New York City.
Leonard Bernstein in mid-air—one of Mili's
stroboscopic "stop-action" movement photographs.

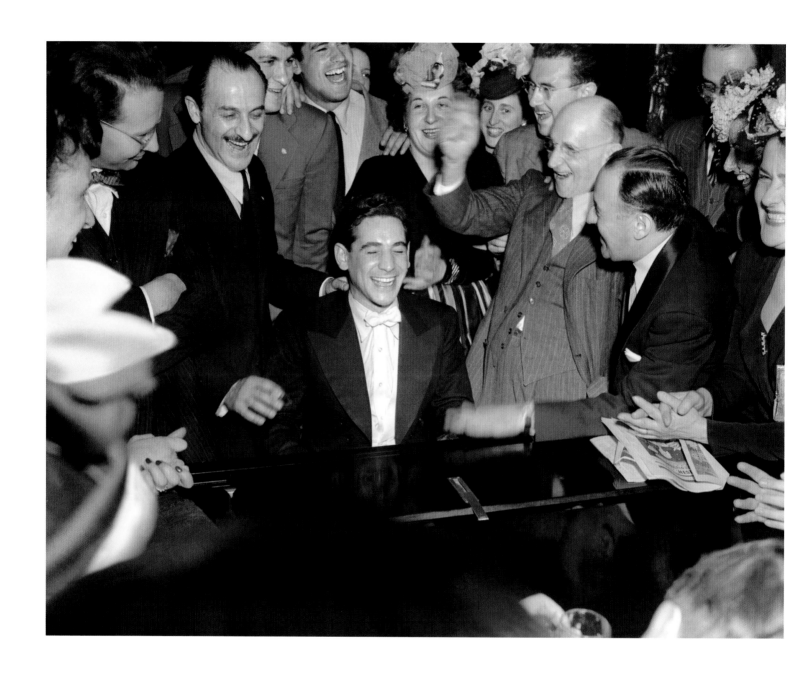

Heinz H. Weissenstein
16 March 1946. Hotel Dorset, New York City.
Leonard Bernstein at the piano entertaining friends and family following a Gershwin Memorial Concert.
Behind him, L to R: Marc Blitzstein, David Oppenheim, Naomi Berman,
Sam Bernstein (father—hand in air), and Cantor David Putterman.

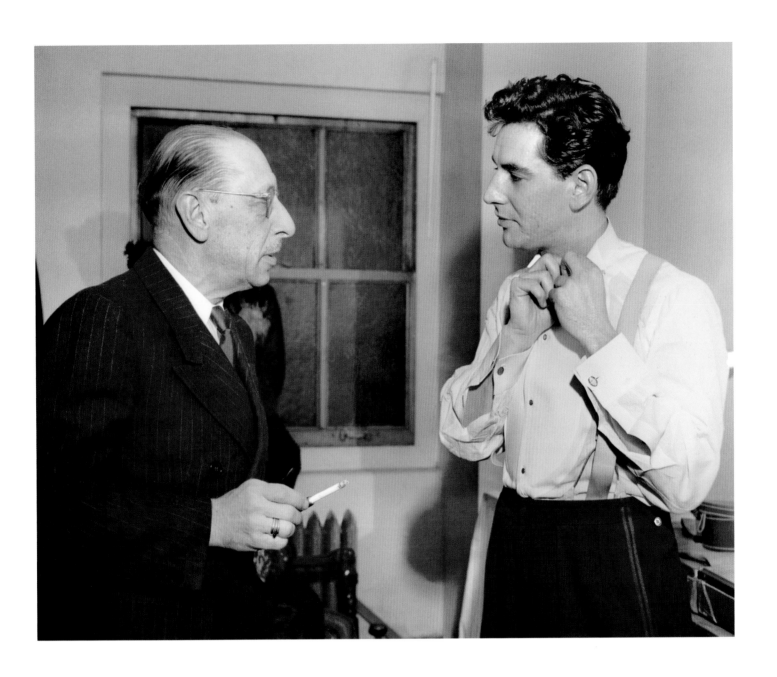

Ben Greenhaus
1946. Carnegie Hall, New York City.
Leonard Bernstein with Igor Stravinsky, backstage.

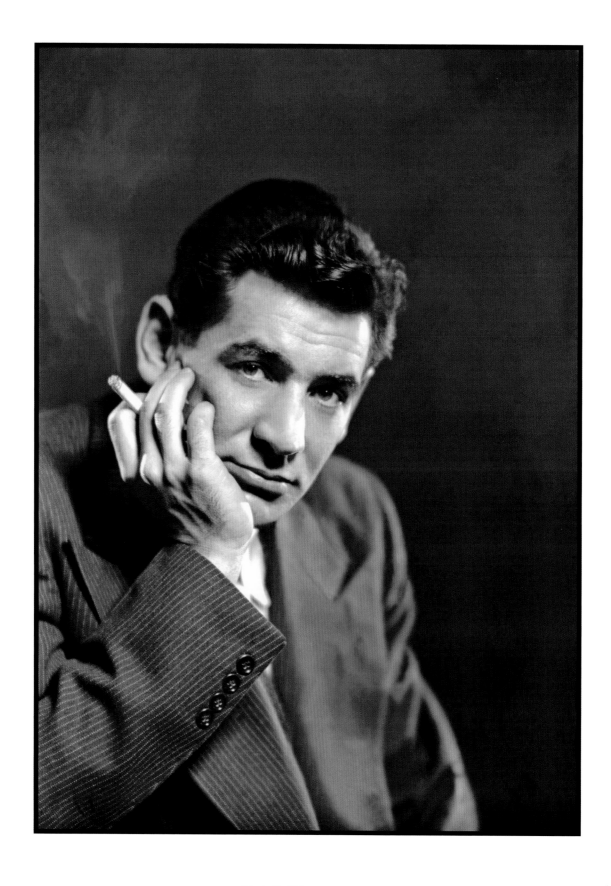

Erich Hartmann
1947.
Portrait of Leonard Bernstein.

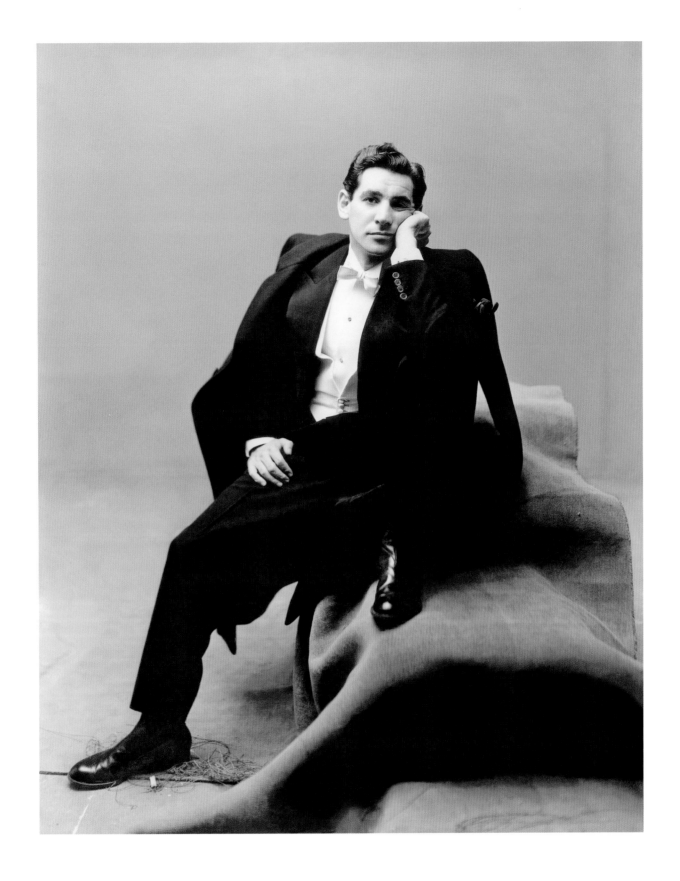

Irving Penn
1947. New York City.
Portrait of Leonard Bernstein, photographed for *Vogue* magazine.

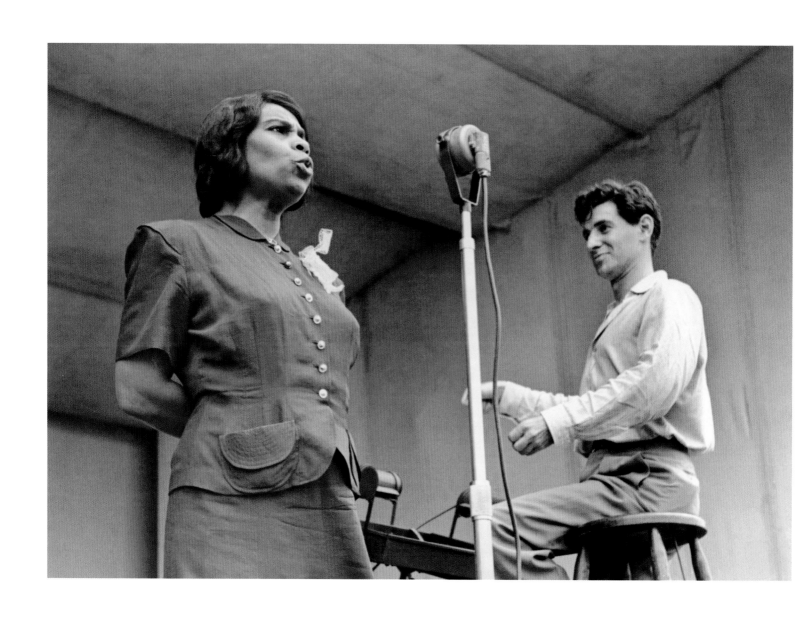

Ruth Orkin
26 June 1947. Lewisohn Stadium. New York City.
Leonard Bernstein rehearsing with Marian Anderson and the Lewisohn Stadium Symphony
Orchestra (aka the New York Philharmonic).

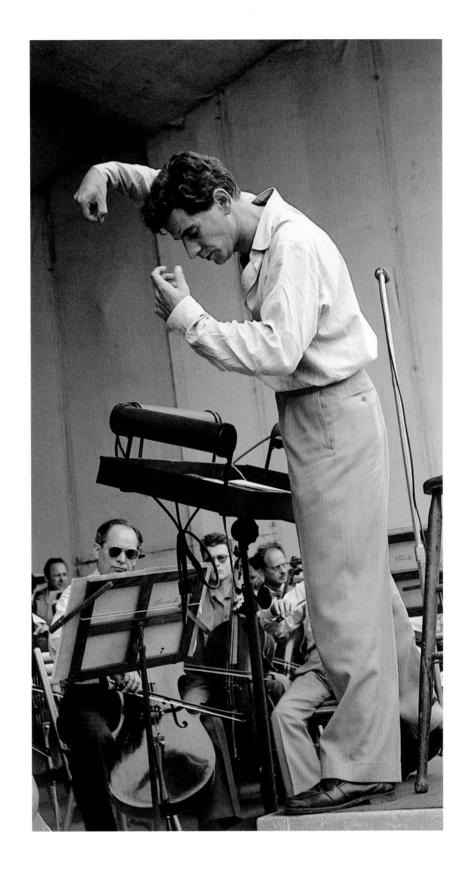

Ruth Orkin
26 June 1947. Lewisohn Stadium. New York City.
Leonard Bernstein rehearsing with the Lewisohn Stadium Symphony
Orchestra (aka the New York Philharmonic).

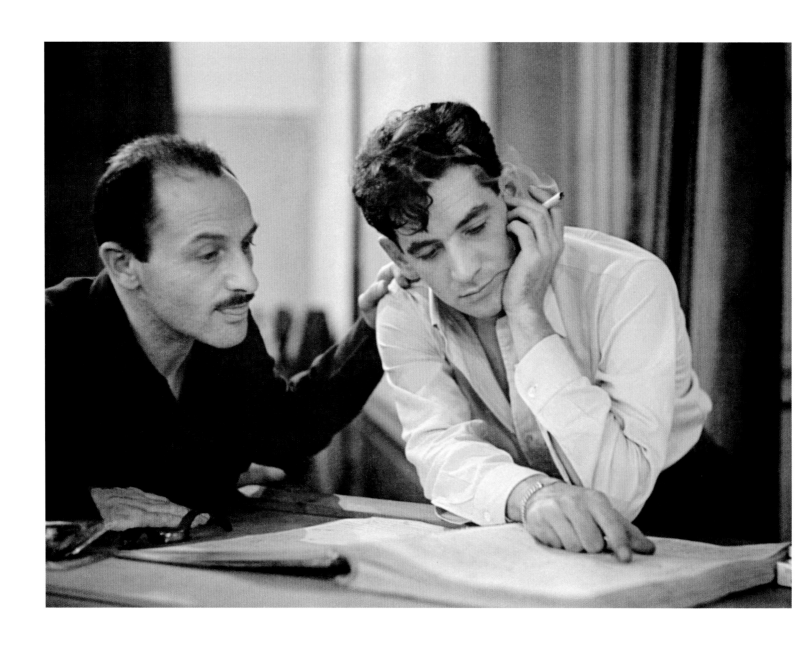

W. Eugene Smith
1947.
Leonard Bernstein with composer and lifelong friend Marc Blitzstein
during a recording session.

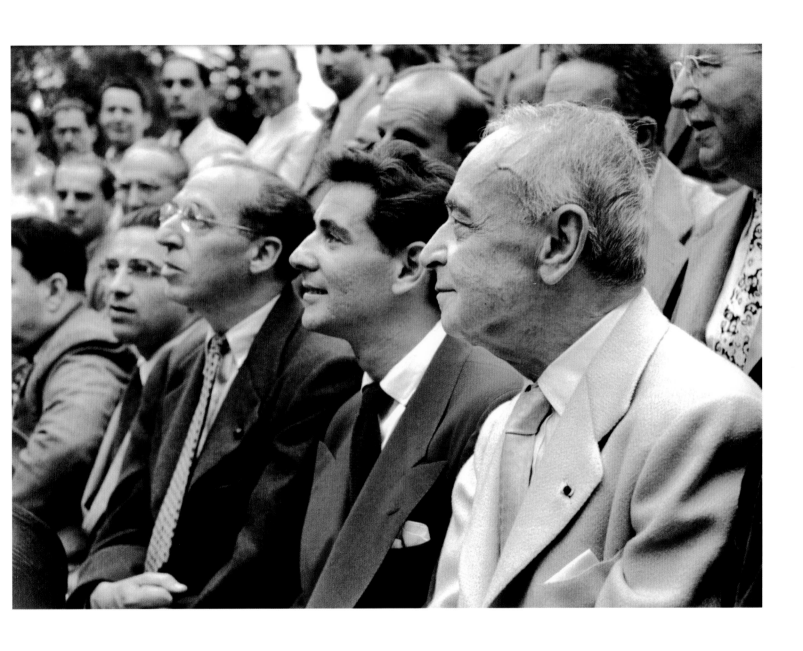

Ruth Orkin
1949. Tanglewood, MA.
L to R: Olivier Messiaen, Aaron Copland, Leonard Bernstein, and Serge Koussevitzky.
Koussevitzky was Bernstein's most important teacher and mentor.

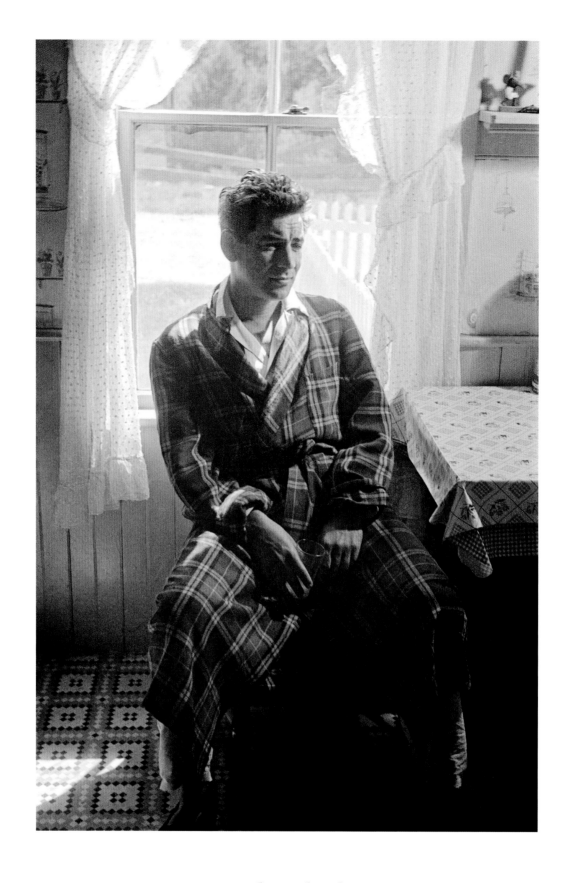

Stanley Kubrick
August 1949. A summer cottage in the Berkshires, MA.
Leonard Bernstein bathed in morning sun.

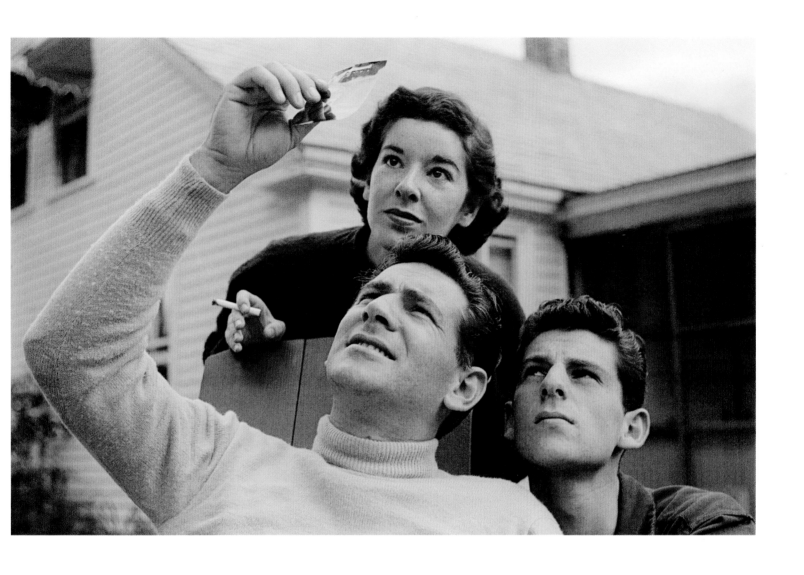

Stanley Kubrick
1949. A summer cottage in the Berkshires, MA.
Leonard Bernstein with sister Shirley and brother Burton.

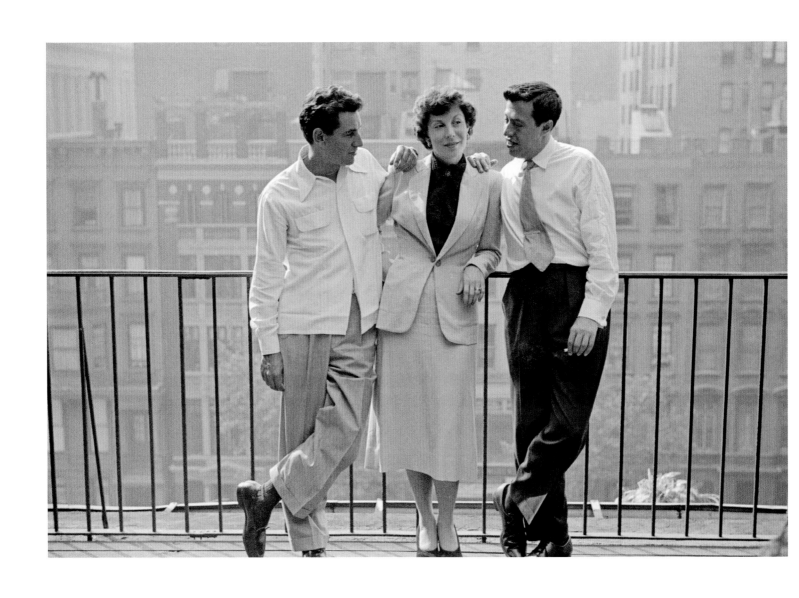

Stanley Kubrick
1949. New York City.
Leonard Bernstein with Betty Comden and Adolph Green.

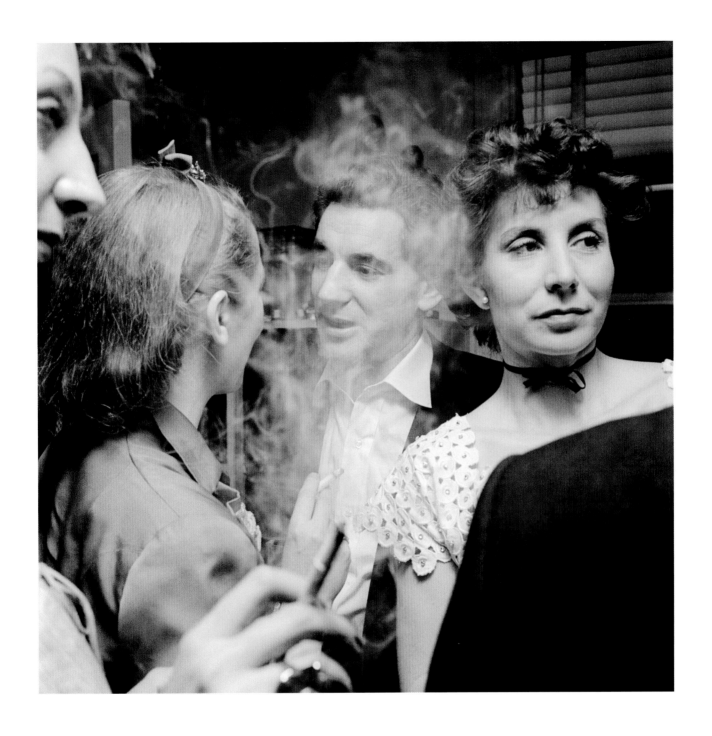

Stanley Kubrick
12 December 1949. New York City.
Leonard Bernstein at a party, with Betty Comden on the right.
The woman he is speaking to is unidentified.

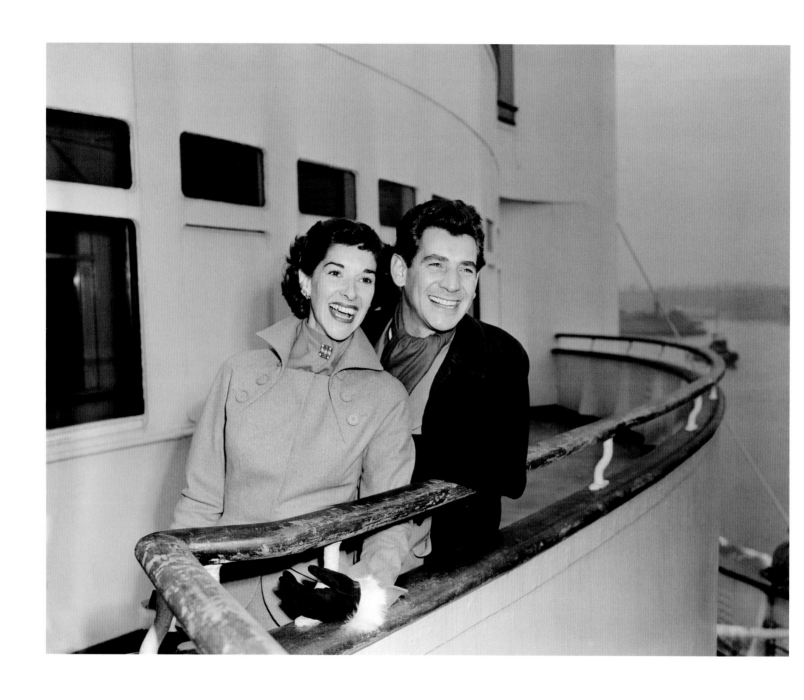

John Lindsay
January 1951. New York City harbor.
Leonard and Shirley Bernstein, returning from Europe and Israel aboard the Queen Mary.

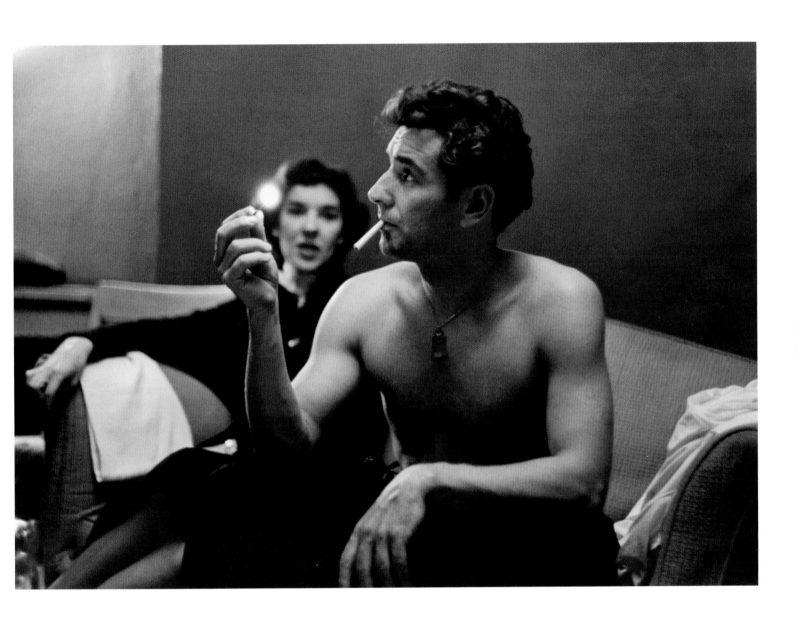

Ruth Orkin
March 1951. Carnegie Hall. New York City.
Leonard and Shirley Bernstein, backstage in his dressing room.

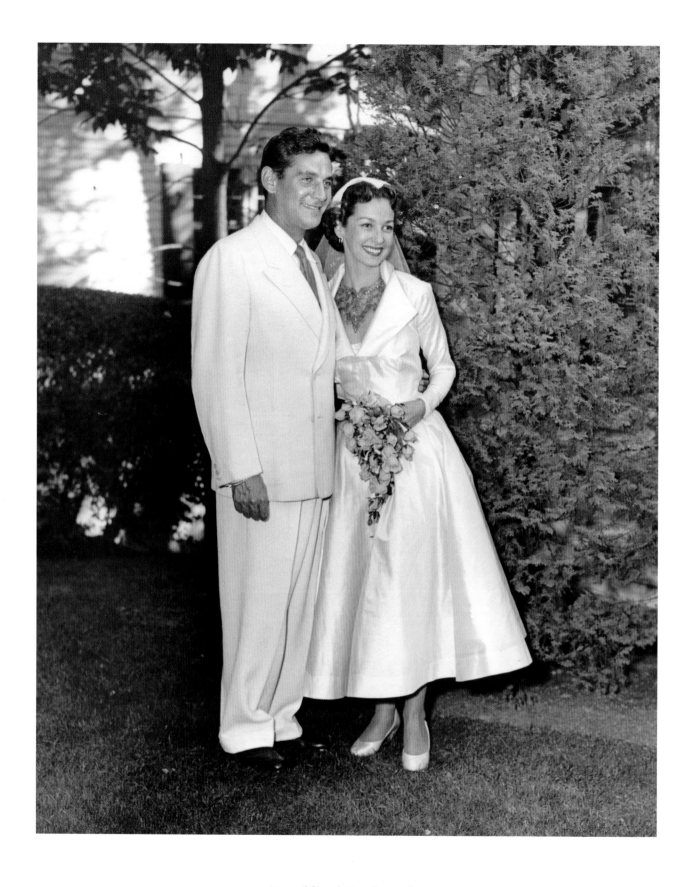

Bradford Bachrach
9 September 1951. Lawrence, MA.
The wedding of Leonard Bernstein and Felicia Cohn Montealegre;
these wedding portraits were taken in Jennie and Samuel Bernstein's backyard garden.
Bernstein wore Serge Koussevitzky's suit and shoes, which didn't quite fit him.

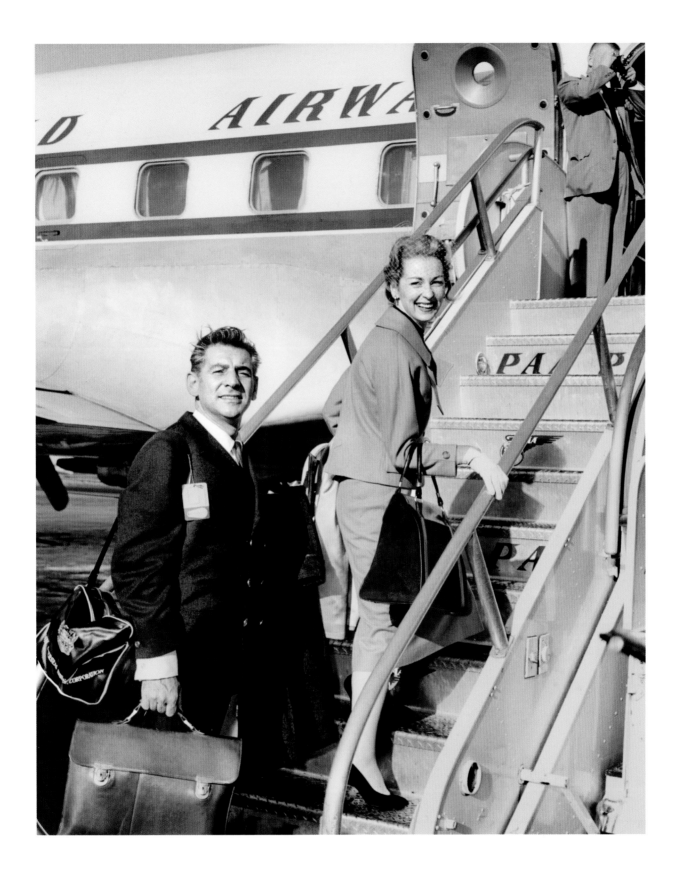

Heinz H. Weissenstein
1951. Idlewild Airport (later JFK Airport), New York City.
Leonard and Felicia Bernstein boarding an airplane.

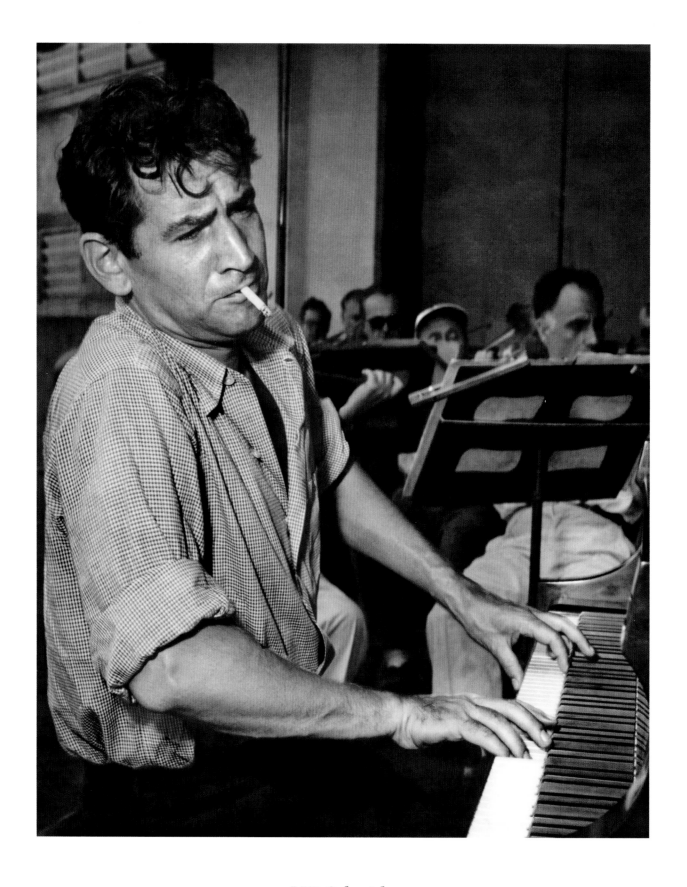

I.W. Schmidt
July 1953. Lewisohn Stadium, New York City.
Leonard Bernstein rehearsing with the Lewisohn Stadium Symphony Orchestra
(aka the New York Philharmonic).

Gordon Parks
14 November 1954. New York City.
Leonard Bernstein lecturing on and conducting Beethoven's "Symphony No. 5" during his
very first program for the TV series *Omnibus*. Behind him, standing on page 1 of the
score, are members of the Symphony of the Air (aka the NBC Symphony Orchestra).

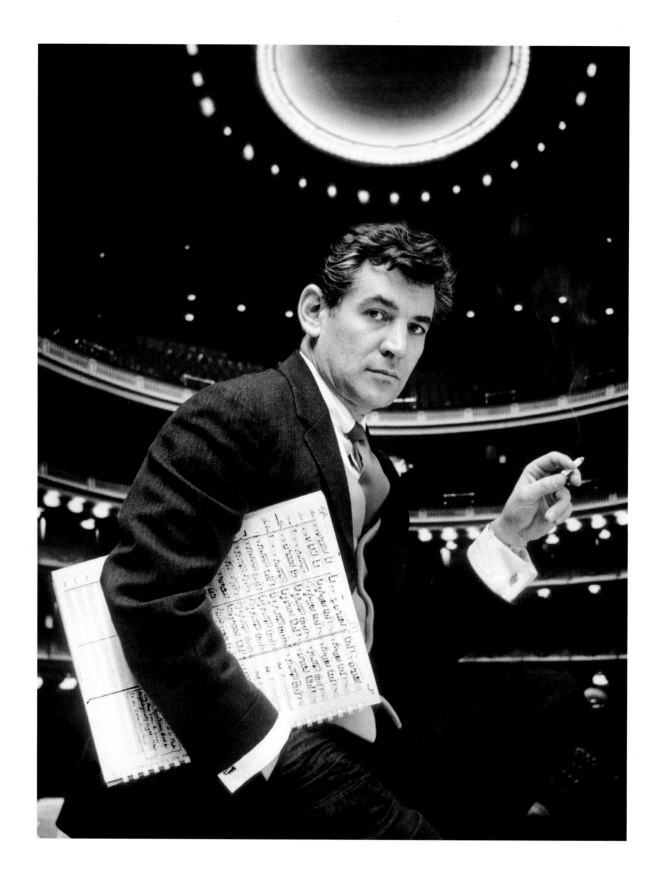

Gordon Parks
9 November 1955. Carnegie Hall. New York City.
Portrait of Leonard Bernstein on stage.

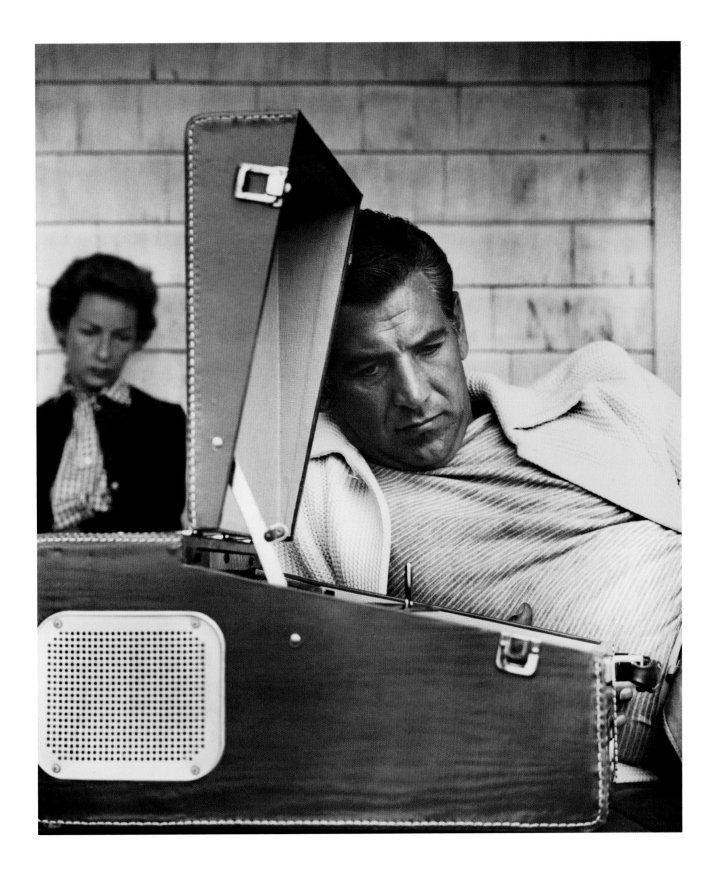

Hans Namuth
August 1956. Martha's Vineyard, MA.
Leonard and Felicia Bernstein listening to record albums on the front porch.

Alfred Eisenstaedt
20 December 1956. Carnegie Hall. New York City.
Leonard Bernstein in rehearsal with the New York Philharmonic.

Alfred Eisenstaedt
20 December 1956. On West 57th Street, New York City.
Leonard Bernstein leaving Carnegie Hall.

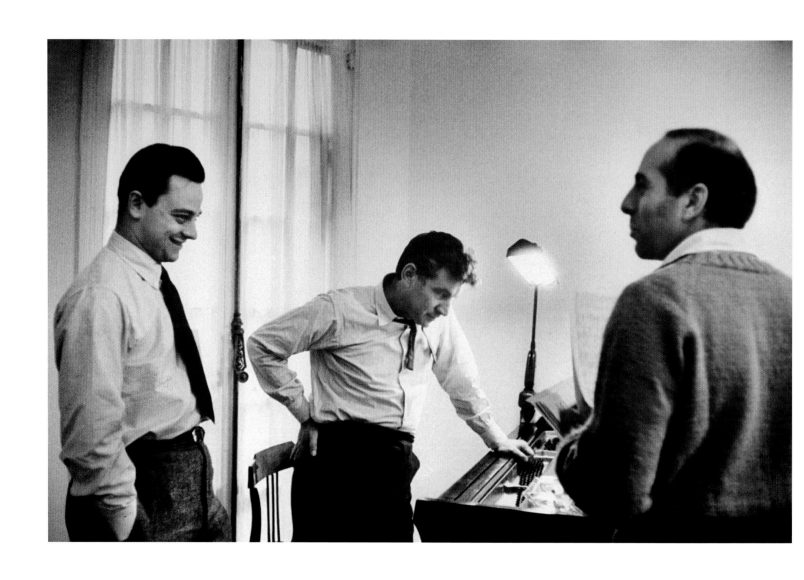

Alfred Eisenstaedt
December 1956. New York City.
L to R: Stephen Sondheim, Leonard Bernstein, and
Jerome Robbins working on *West Side Story*.

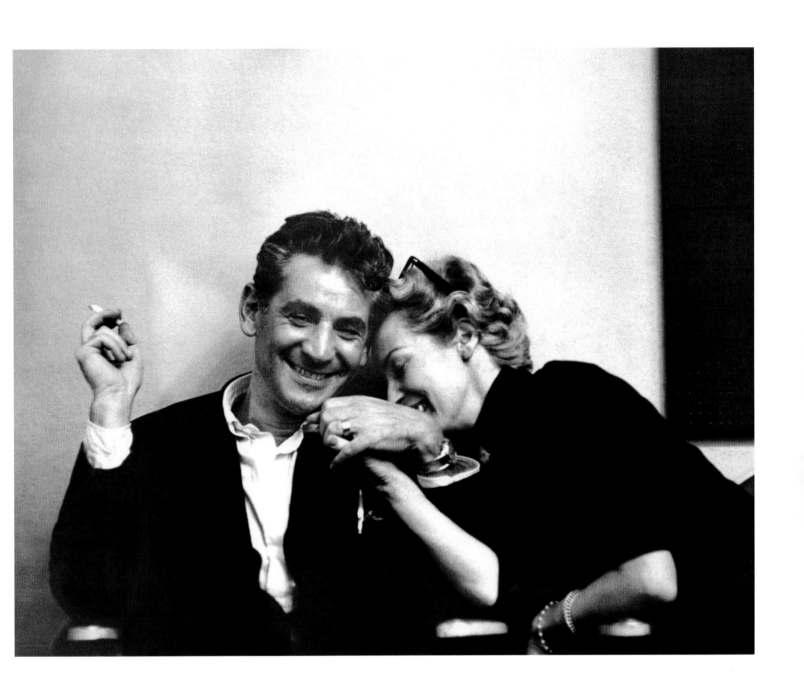

Dan Weiner
9 December 1956. New York City.
Leonard and Felicia Bernstein in the recording studio control room
as they listen to the playback of *Candide*.

1957 – 1969

THE MAESTRO

"The years I have so far spent as Music Director [of the New York Philharmonic] have brought me immense satisfaction, joy, and spiritual rewards; and our personal relationships within the orchestra are of an intimacy and brotherhood so strong as to merit the word 'Love.'"
–Leonard Bernstein, 1966

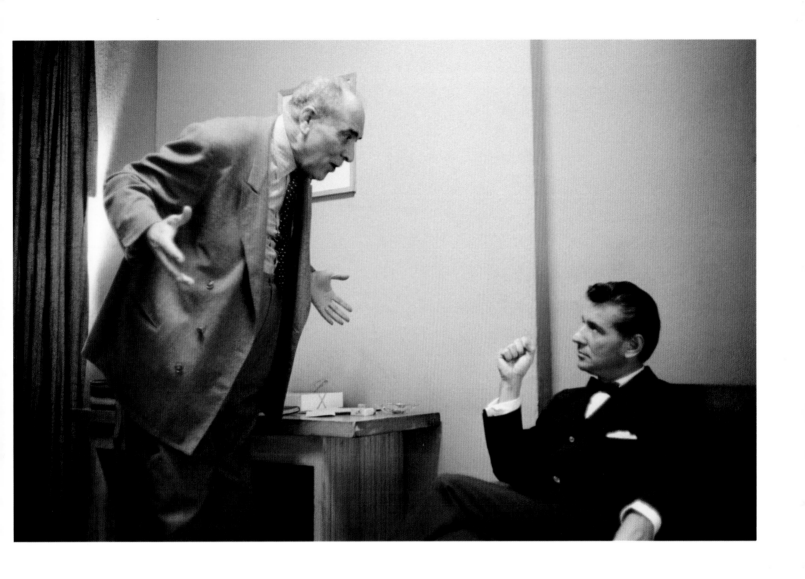

Alfred Eisenstaedt
January 1957. Carnegie Hall. New York City.
Leonard Bernstein backstage with Bruno Zirato, manager of the New York Philharmonic.

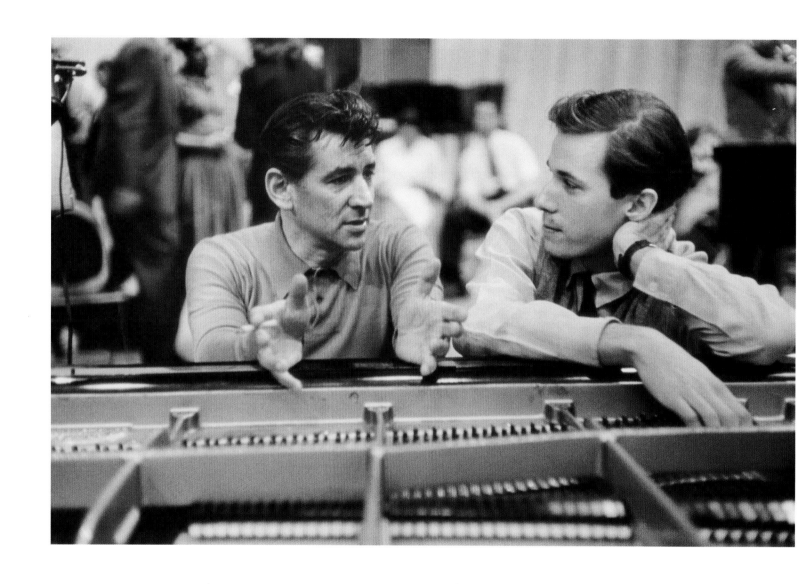

Don Hunstein
April 1957. Columbia 30th Street Studio, New York City.
Leonard Bernstein and Glenn Gould during a break in their recording session with the
Columbia Symphony Orchestra (aka the New York Philharmonic).

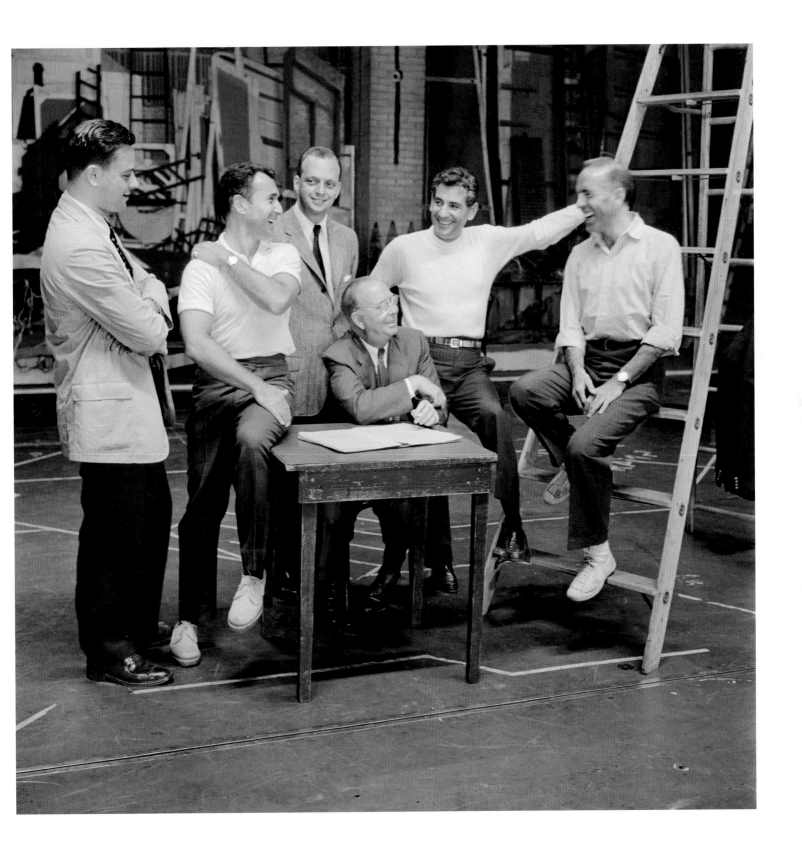

Friedman-Abeles
1957. The Winter Garden Theater, New York City.
The creative team behind *West Side Story* on the set. L to R: Stephen Sondheim, Arthur Laurents, Harold Prince, Robert E. Griffith, Leonard Bernstein, and Jerome Robbins.

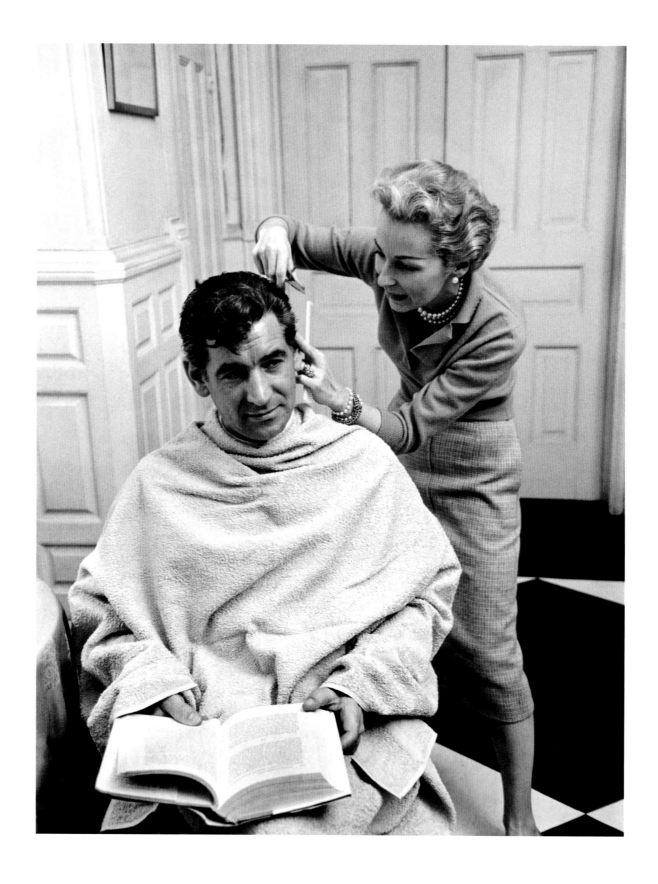

Margery Lewis
1957. The Bernstein apartment in The Osborne, New York City.
Leonard Bernstein getting a haircut from his favorite barber, Felicia.

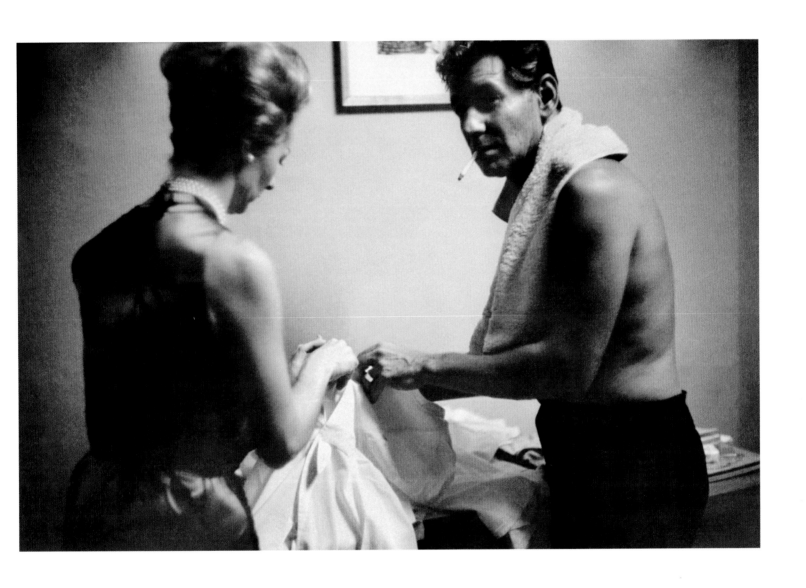

Gordon Parks
2 October 1958. Carnegie Hall, New York City.
Leonard and Felicia Bernstein backstage before the New York Philharmonic's season
opening concert, and Bernstein's first concert as Music Director of the New York Philharmonic.

Frank Mastro
2 October 1958. Carnegie Hall, New York City.
Leonard Bernstein being congratulated backstage by his parents Jennie and Samuel Bernstein
following his first concert as Music Director of the New York Philharmonic.

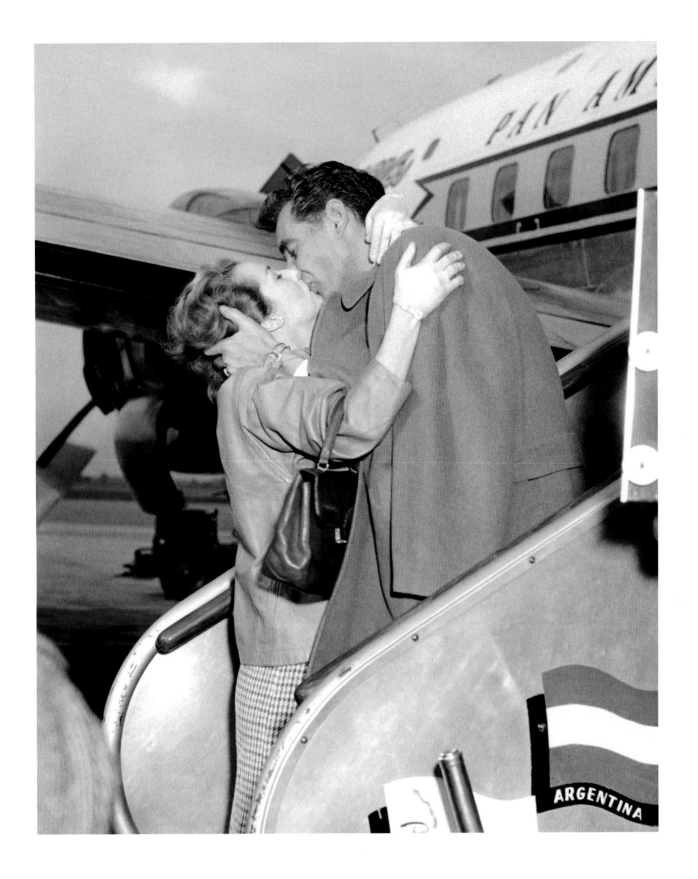

Photographer Unknown
May 1958. Buenos Aires, Argentina.
Leonard and Felicia Bernstein embrace on airplane steps
during the New York Philharmonic's South American tour.

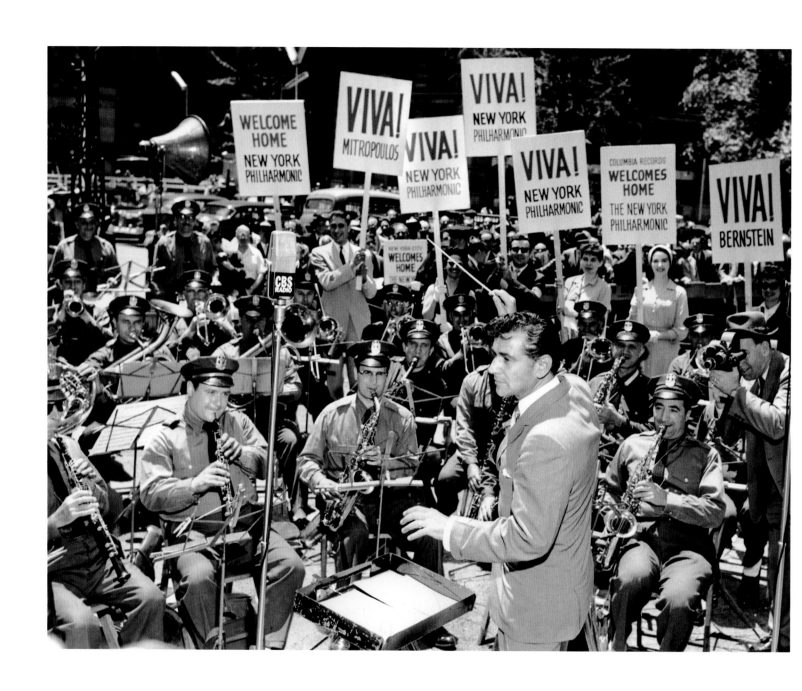

Photographer Unknown
16 June 1958. In front of City Hall, New York City.
Leonard Bernstein conducting the NYC Department of Sanitation Band at a staged event,
as part of his new duties as New York Philharmonic Music Director.

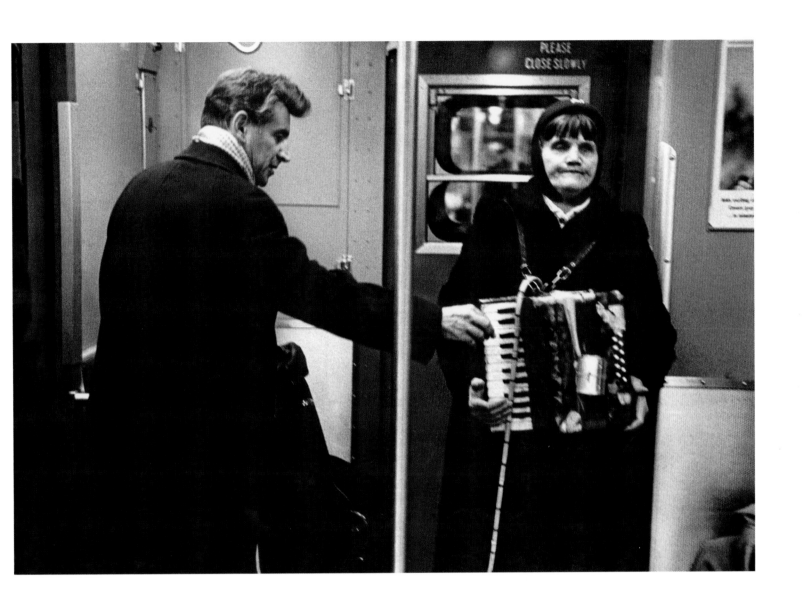

Bruce Davidson
Fall 1958. On a New York City subway train.
Leonard Bernstein giving a coin to a blind musician busking on the subway.

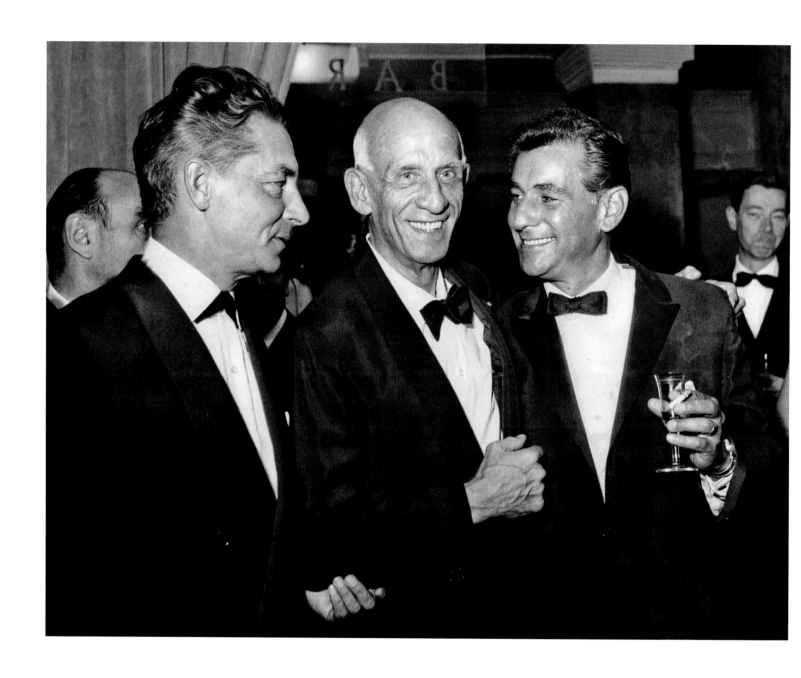

Photographer Unknown (Keystone Hamburg)
8 January 1959. Salzburg, Austria.
L to R: Herbert von Karajan, Dimitri Mitropoulos, and Leonard Bernstein at a cocktail party.

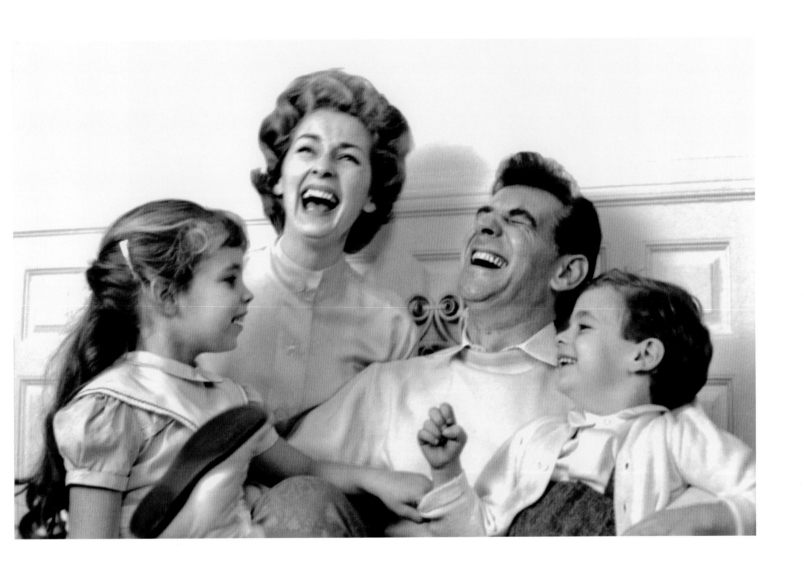

Don Hunstein
1959. The Bernstein apartment in The Osborne, New York City.
The Bernstein family—Jamie, Felicia, Leonard, and Alexander.

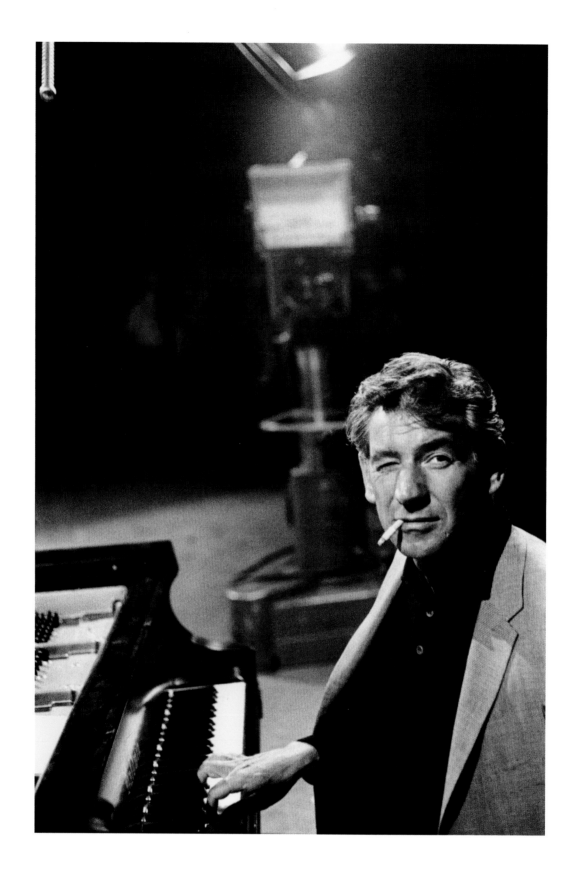

Bruce Davidson
Spring 1959. Carnegie Hall, New York City.
Leonard Bernstein during a TV rehearsal for a Young People's Concert.

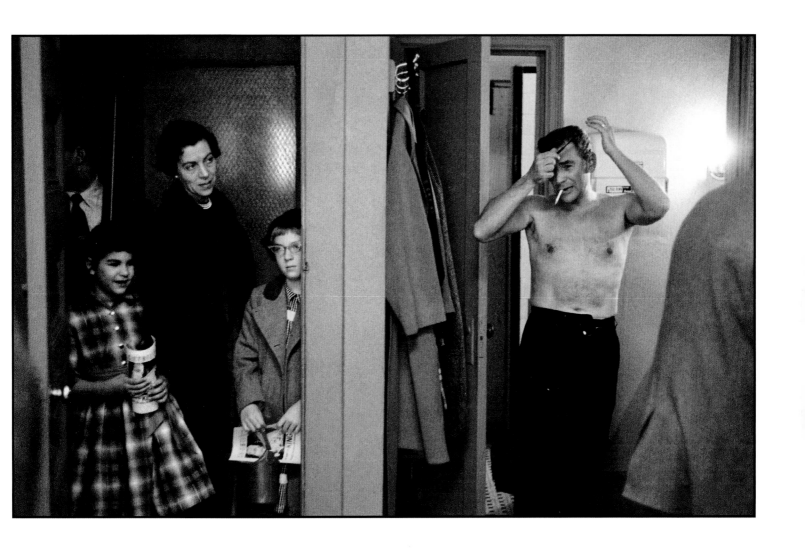

Bruce Davidson
Spring 1959. Carnegie Hall, New York City.
Leonard Bernstein emerging from his dressing room after conducting a Young People's Concert,
as fans patiently wait outside for the Maestro's autograph.

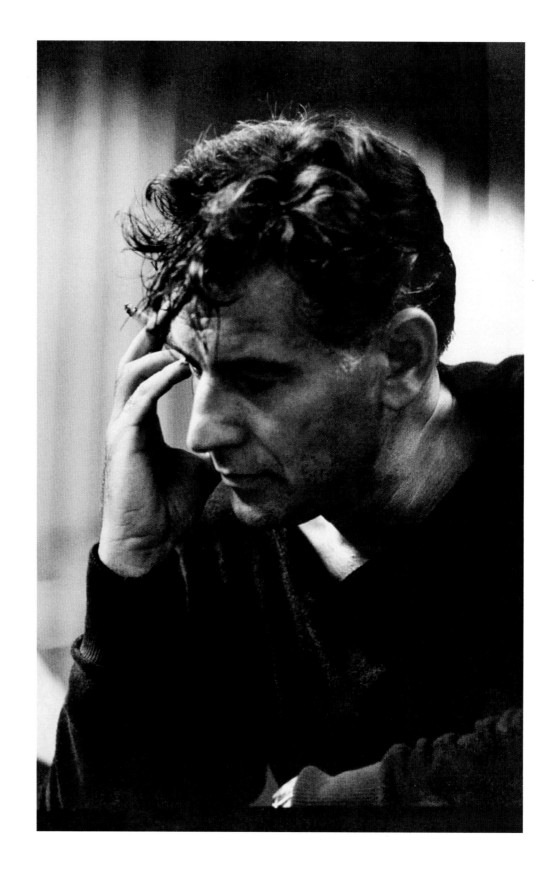

Carl Mydans
27 August 1959. Moscow, USSR.
Portrait of Leonard Bernstein.

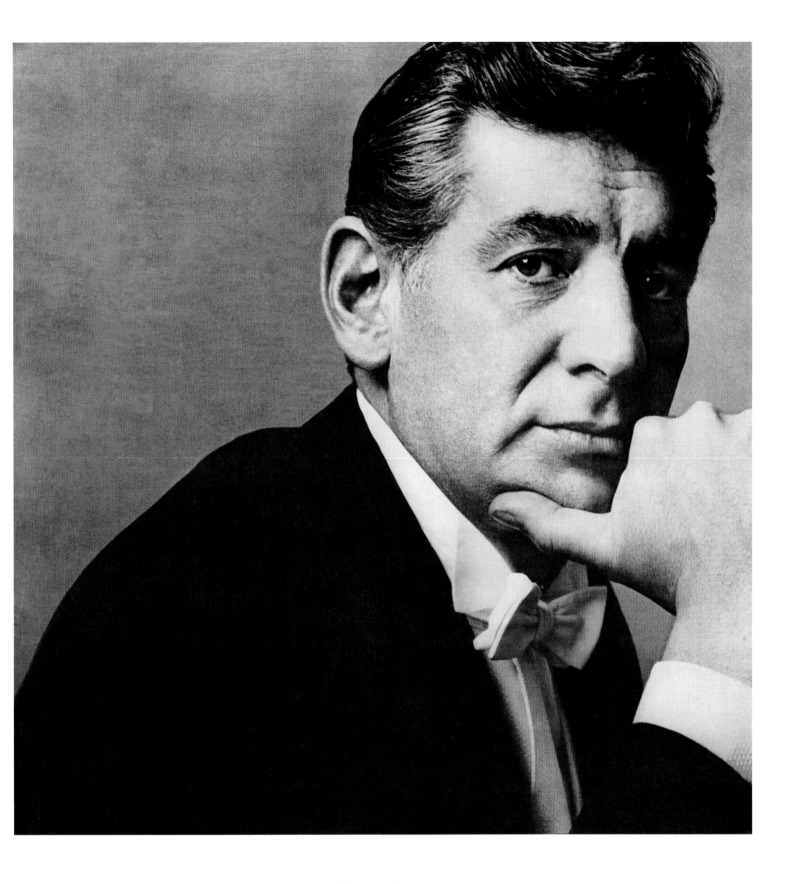

Irving Penn
c. 1959. New York City.
Portrait of Leonard Bernstein.

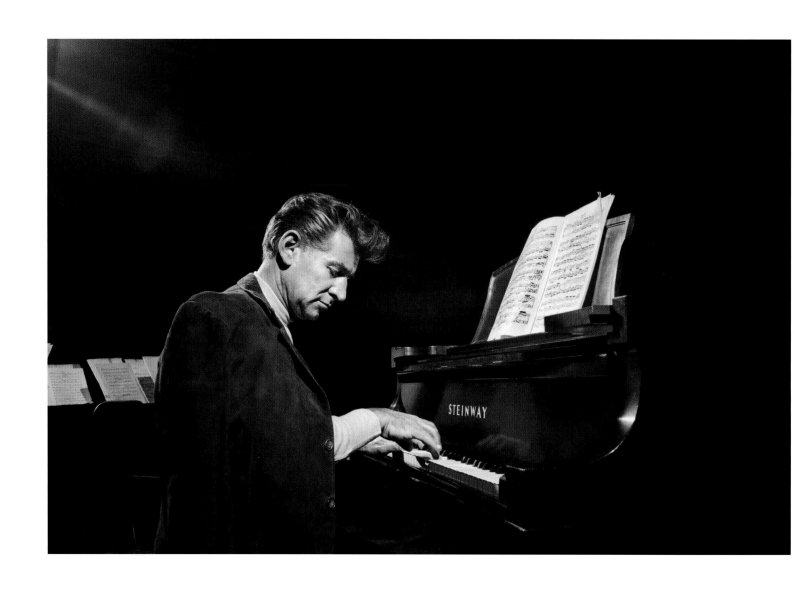

Sam Falk
1959. New York City.
Portrait of Leonard Bernstein at the piano.

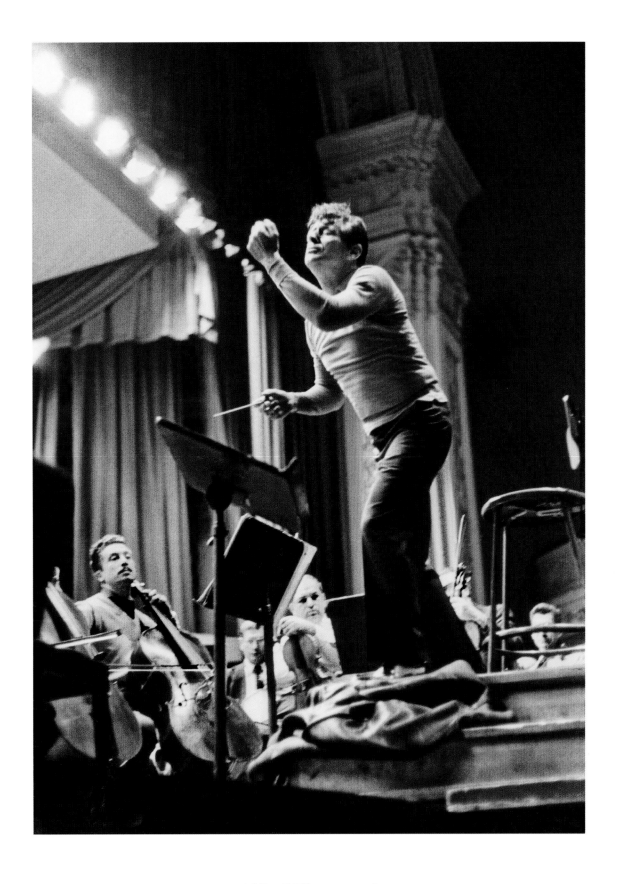

Alfred Eisenstaedt
1960. Carnegie Hall, New York City.
Leonard Bernstein in rehearsal with the New York Philharmonic.

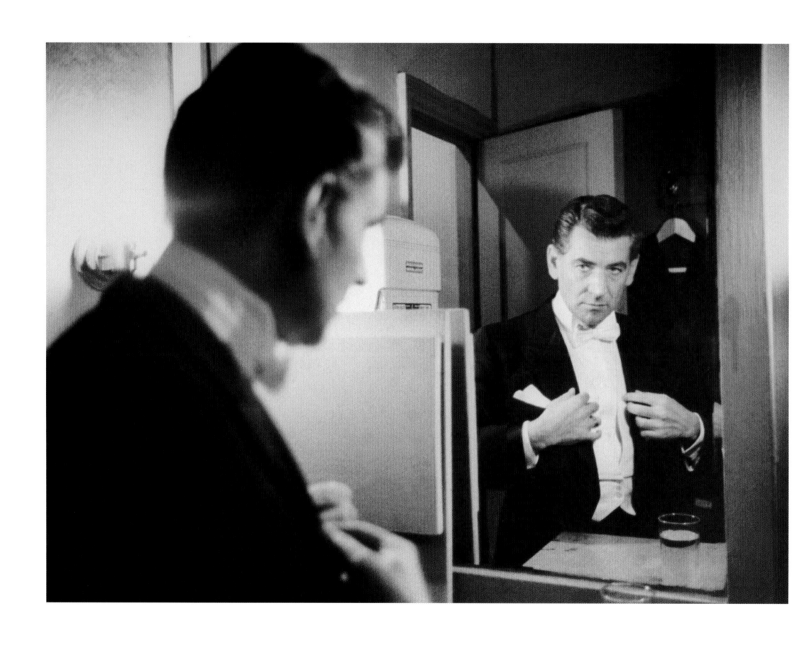

Alfred Eisenstaedt
20 February 1960. Carnegie Hall, New York City.
Leonard Bernstein in his dressing room, preparing to go on stage for a concert.

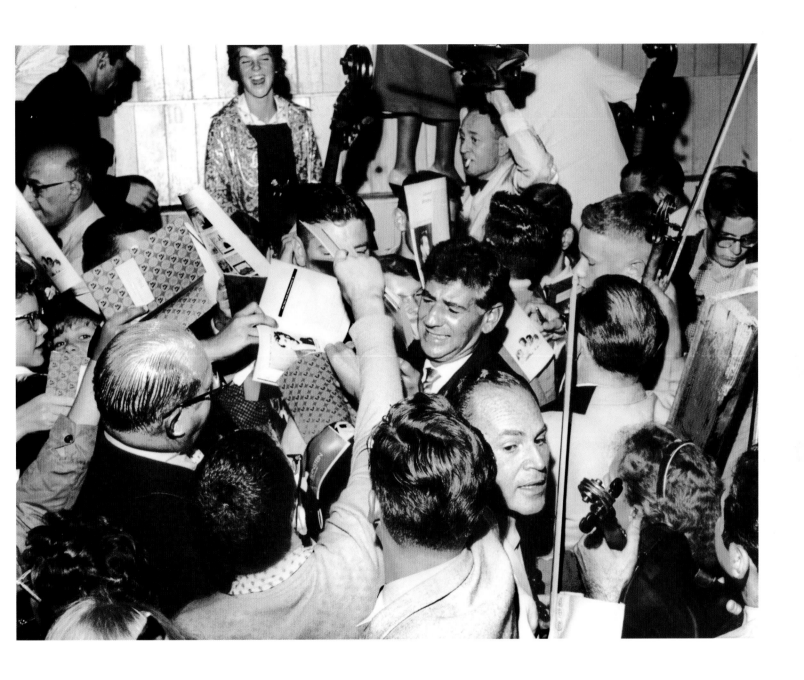

Henry Tregillas
16 August 1960. Vancouver, Canada.
Leonard Bernstein besieged by autograph seekers backstage as members
of the New York Philharmonic try to get past.

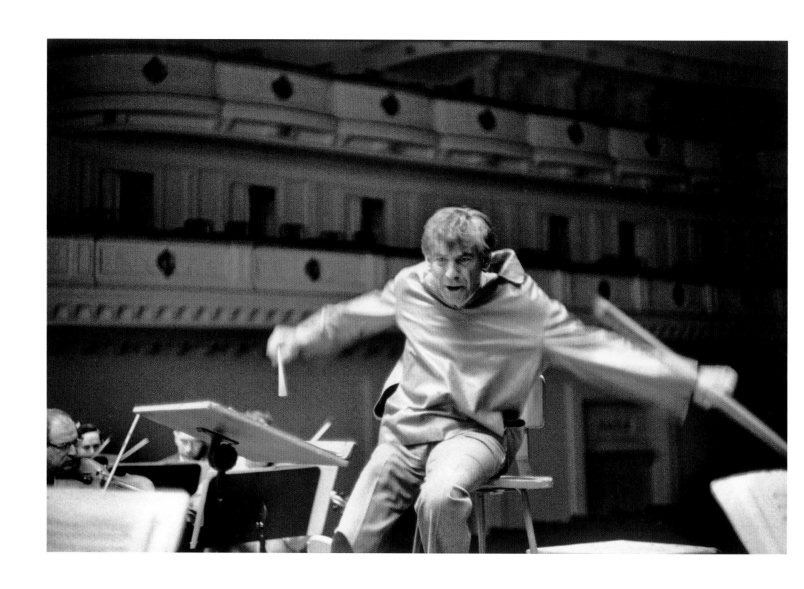

Henri Cartier-Bresson
December 1960. Carnegie Hall, New York City.
Leonard Bernstein rehearsing the New York Philharmonic for their Pension Fund concert.

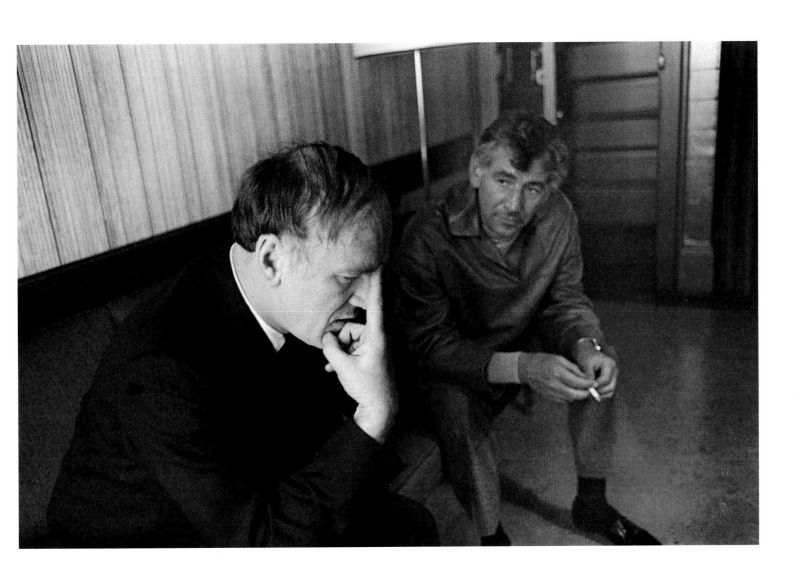

Henri Cartier-Bresson
December 1960. Carnegie Hall, New York City.
Leonard Bernstein with Sviatoslav Richter backstage, following a rehearsal of the
New York Philharmonic Pension Fund concert.

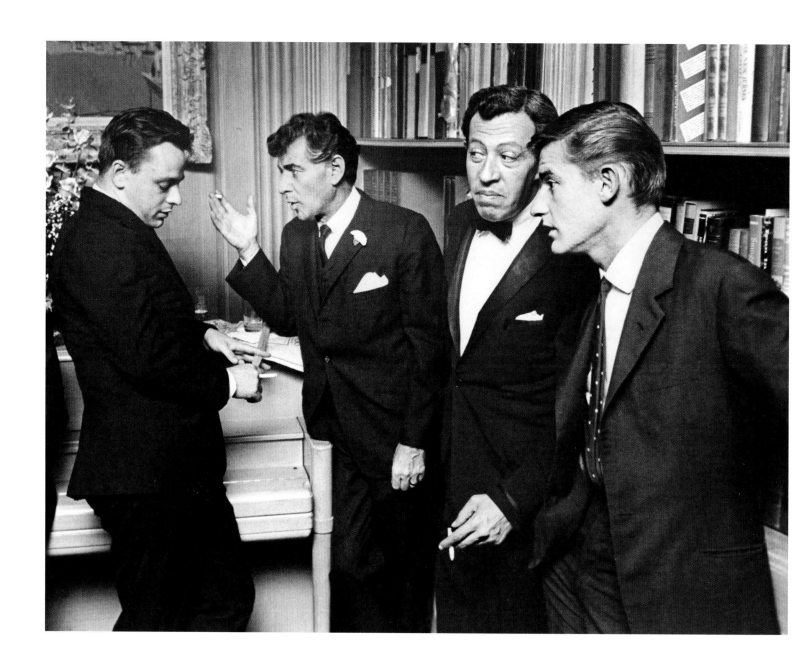

Henry Grossman
9 June 1962. New York City.
L to R: Stephen Sondheim, Leonard Bernstein, Adolph Green, and Roddy McDowall at the
wedding of Bernstein's close friend Michael "Mendy" Wager to Susan Blanchard Fonda.

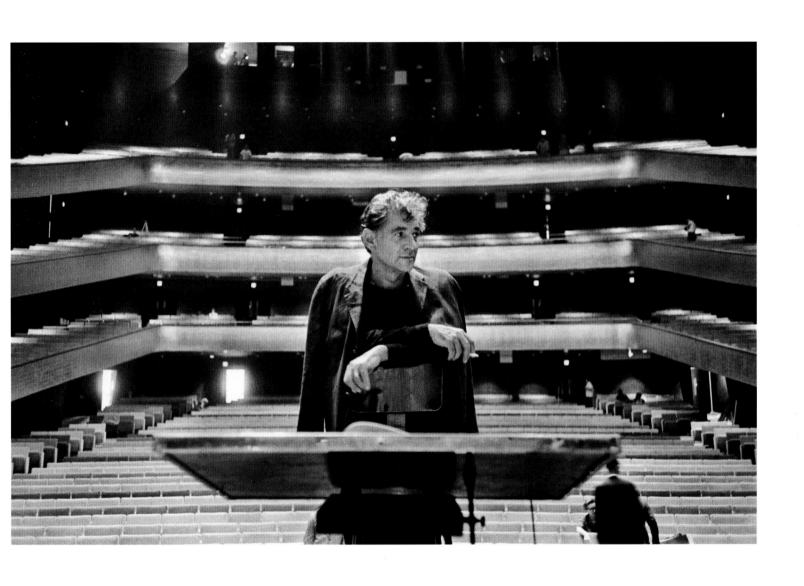

Sam Falk
September 1962. Philharmonic Hall, New York City.
Leonard Bernstein on the podium in Lincoln Center's newly built home for
the New York Philharmonic, just days before its inaugural concert.

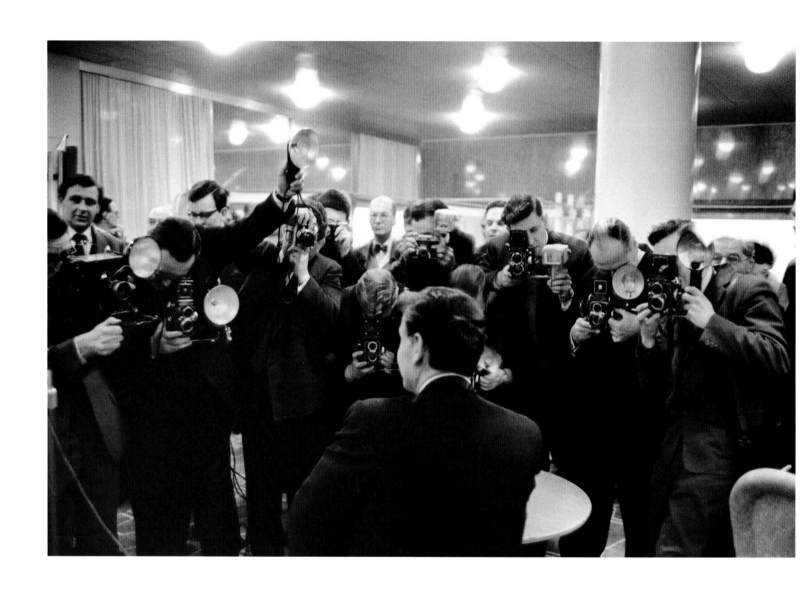

Don Hunstein
1963. Philharmonic Hall, New York City.
Leonard Bernstein facing a throng of press photographers backstage.

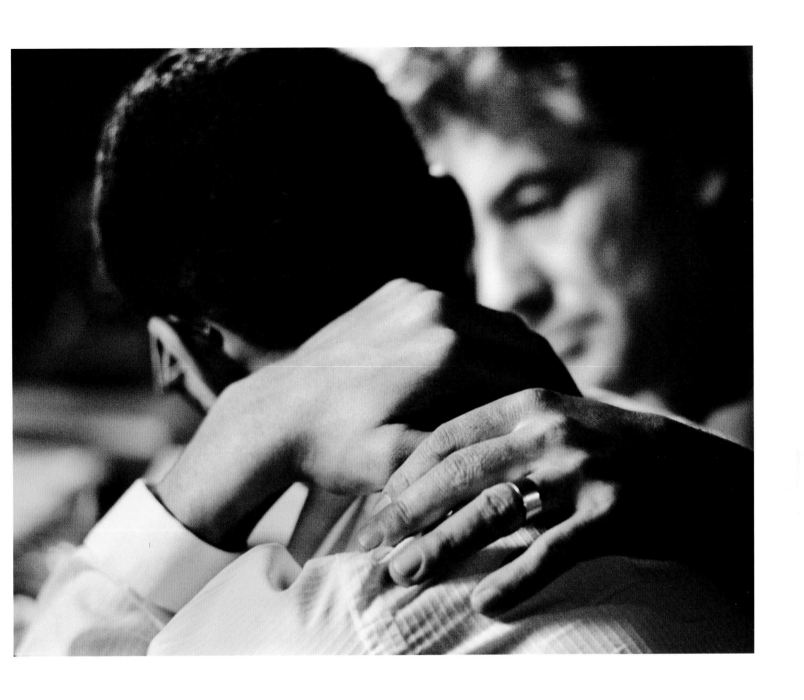

Bill Eppridge
January 1963. Philharmonic Hall, New York City.
Leonard Bernstein rehearsing with 16-year-old pianist André Watts, as this young protégé
prepares to make his New York Philharmonic debut in a Young People's Concert,
broadcast on national television.

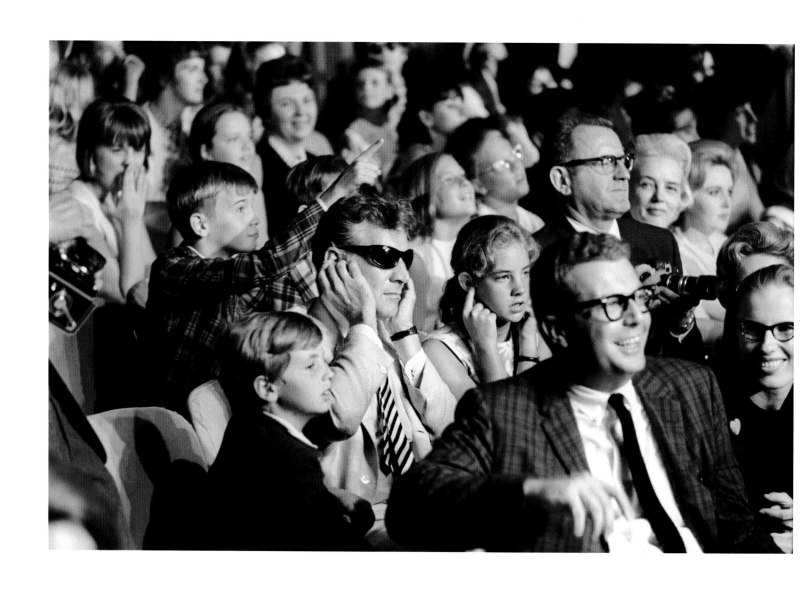

Ken Regan
14 August 1965. CBS-TV Studio 50, New York City.
Leonard Bernstein with Alexander and Jamie at the *Ed Sullivan Show* listening to The Beatles
in dress rehearsal for their fourth and final *Ed Sullivan Show* appearance.

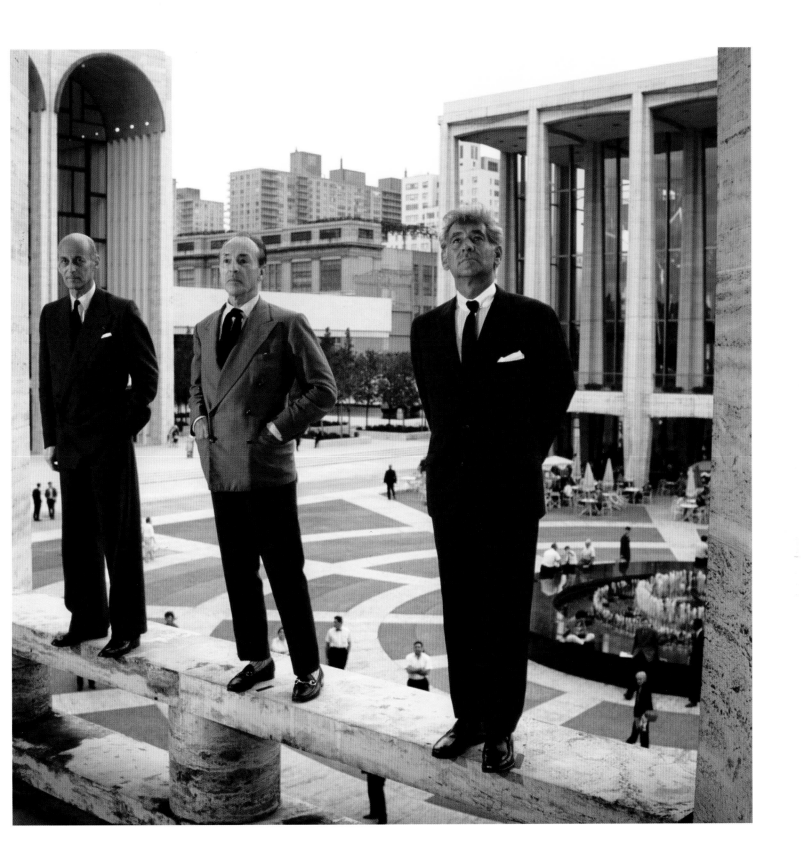

Michael Rougier

September 1966. On the balcony railing of the New York State Theater, overlooking the Lincoln Center plaza, New York City. L to R: Rudolf Bing, George Balanchine, and Leonard Bernstein (representing the three main organizations of Lincoln Center—The Metropolitan Opera, the New York City Ballet, and the New York Philharmonic), just prior to the grand opening of Lincoln Center.

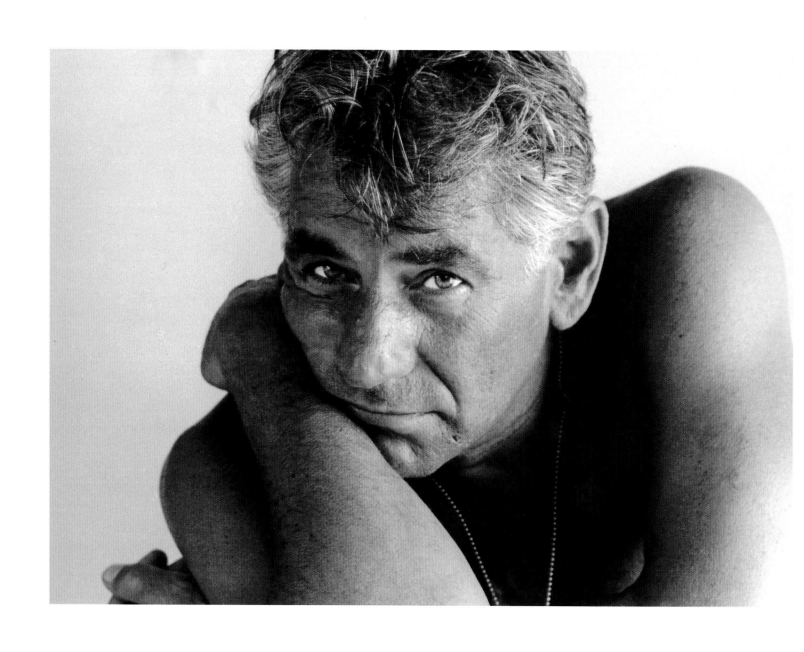

Ken Heyman
1967. Ansedonia, Italy.
Portrait of Leonard Bernstein.

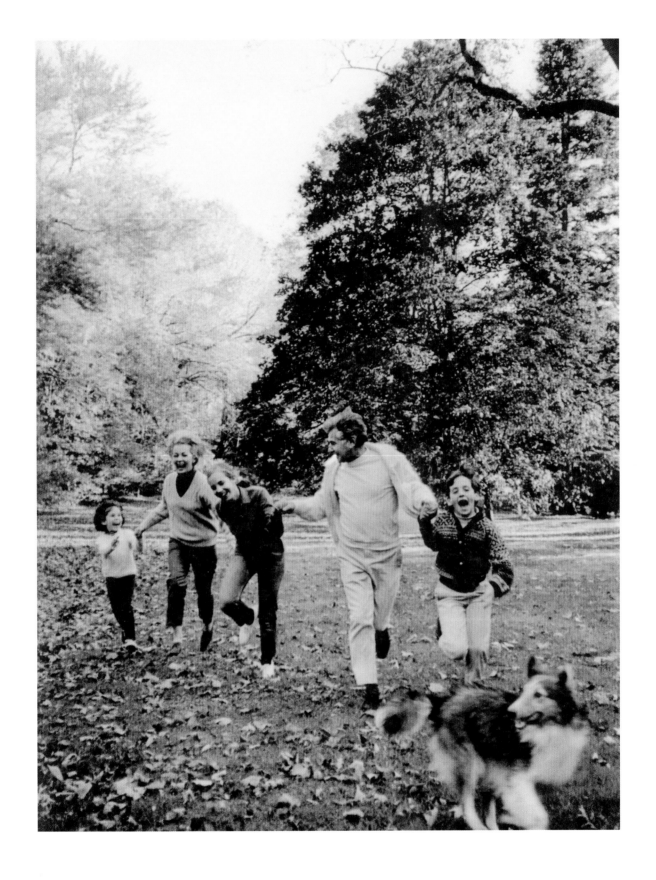

Ken Heyman
Fall 1967. Springate (the Bernstein country home), Fairfield, CT.
The Bernstein family: Nina, Felicia, Jamie, Leonard, and Alexander—and Honey the dog.

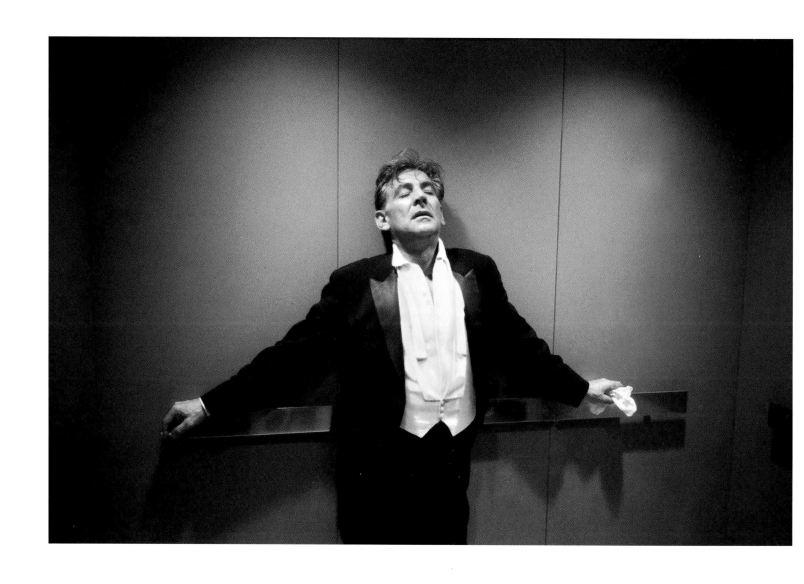

Ken Heyman
1967. Philharmonic Hall, New York City.
Leonard Bernstein riding the elevator to his dressing room after a performance.

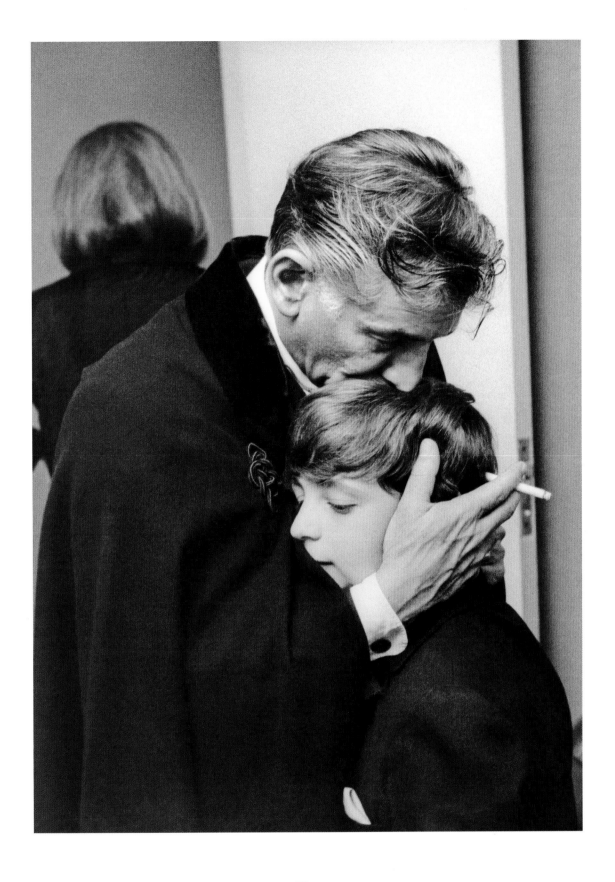

Ken Heyman
1967. Philharmonic Hall, New York City.
Leonard Bernstein being congratulated by Alexander backstage after a performance.

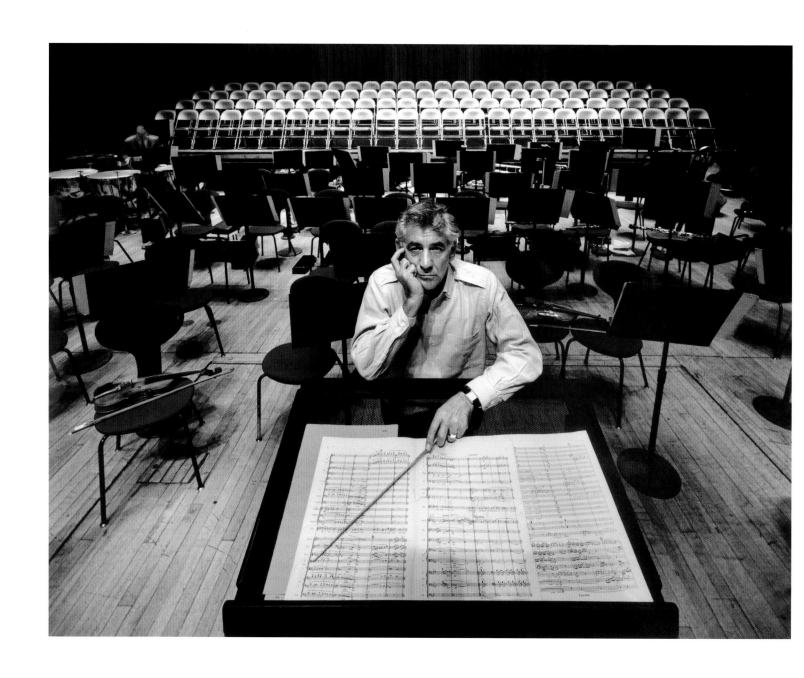

Arnold Newman
16 May 1968. Philharmonic Hall , New York City.
Portrait of Leonard Bernstein onstage.

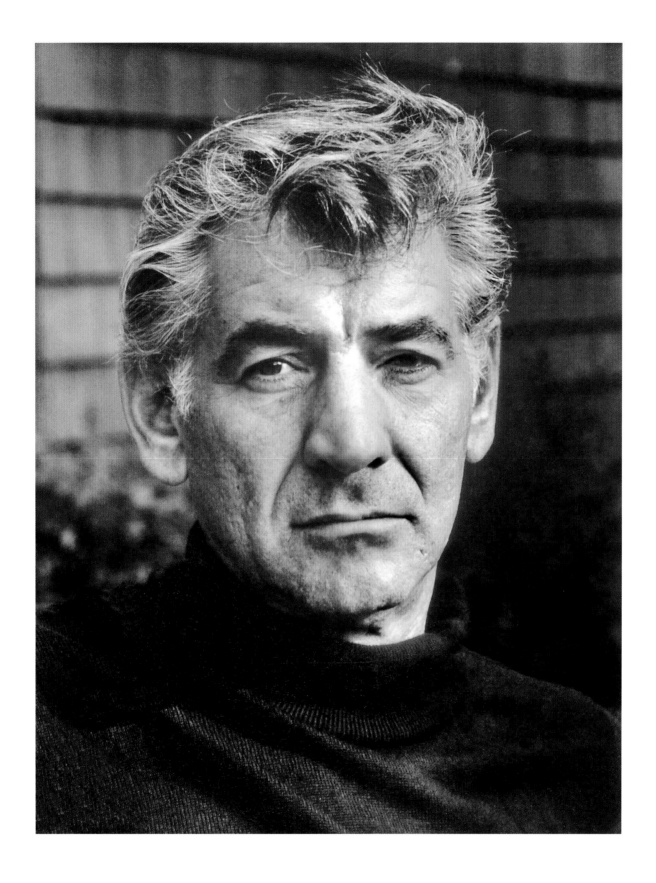

Alfred Eisenstaedt
1968.
Portrait of Leonard Bernstein

1970 – 1980

MAN OF
THE WORLD

*"I have been so lucky and blessed for
everything that's happened, and all the
privileges that I've had in my working life,
quite apart from the privileges of my personal
life. I don't think there's anything in the world
to be more grateful for than the possibility of
spending your time doing what you love, and
being with works of art that consume you."*
—Leonard Bernstein, 1968

Stephen Salmieri

14 January 1970. The Bernstein apartment at 895 Park Avenue, New York City.
Felicia and Leonard Bernstein with Donald Cox, Field Marshal for the Black Panthers.

Milton H. Greene
1970. Springate (the Bernstein country home), Fairfield, CT.
The Bernstein family—Leonard, Nina, Alexander, Jamie, and Felicia,
and Honey the dog

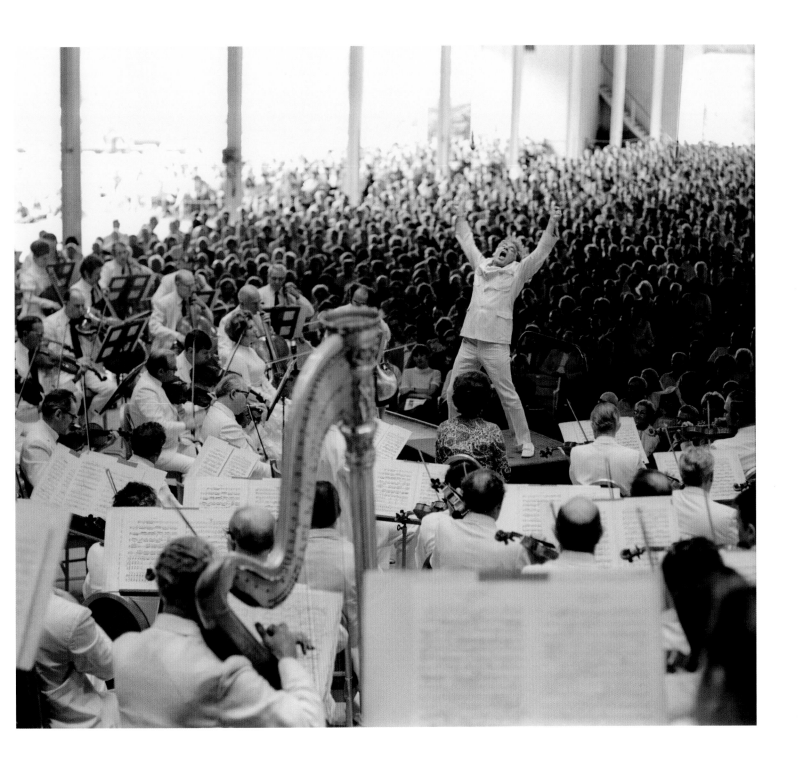

Heinz H. Weissenstein
5 July 1970. Tanglewood, MA.
Leonard Bernstein conducting the Boston Symphony Orchestra in Mahler's "Symphony No. 2."

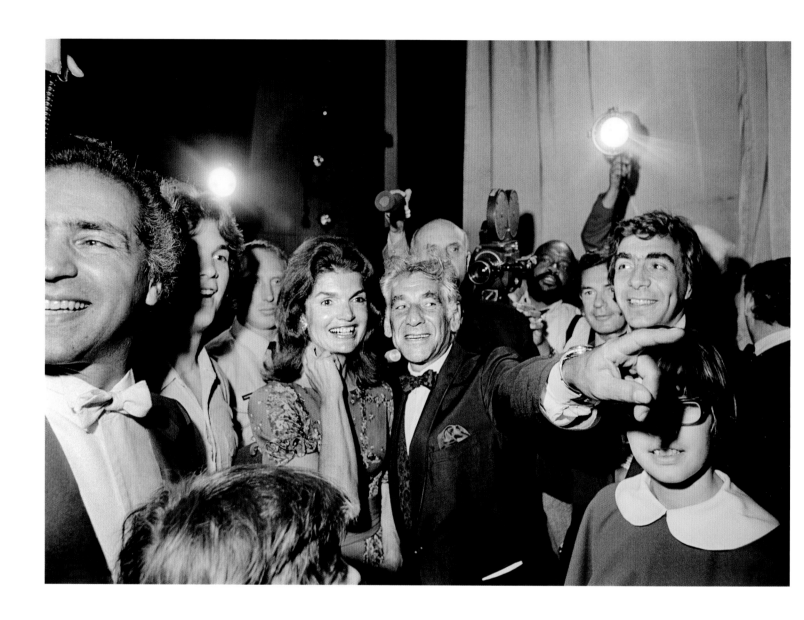

Photographer Unknown (Associated Press)
5 June 1972. The John F. Kennedy Center for the Performing Arts, Washington D.C.
Leonard Bernstein with close friend and former First Lady Jacqueline Kennedy Onassis during
her first visit to the newly opened Performing Arts Center, named in honor of her late husband,
for the "reopening" of *Mass*. At left is *Mass* conductor Maurice Peress, behind him (partially
obstructed) is Alan Titus who sang the lead role of Celebrant, directly behind Bernstein is
Roger Stevens, *Mass* producer and director of the Kennedy Center (partially obstructed), and
above Bernstein's hand is *Mass* director Gordon Davidson.

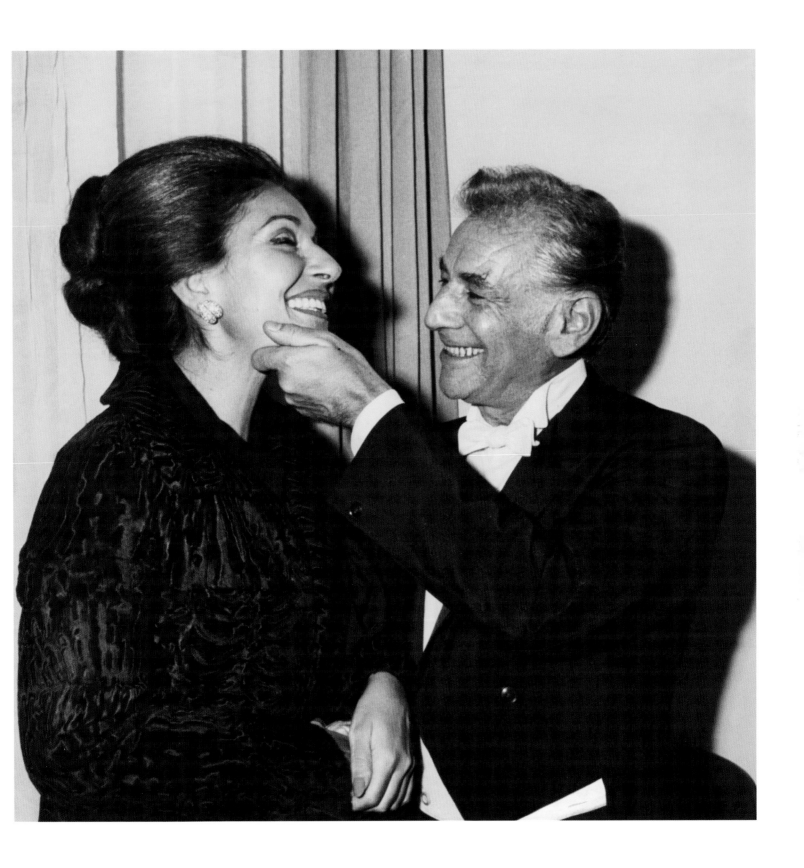

Gérard Neuvecelle
c. mid-1970s. Théâtre des Champs-Elysées, Paris, France.
Leonard Bernstein with Maria Callas.

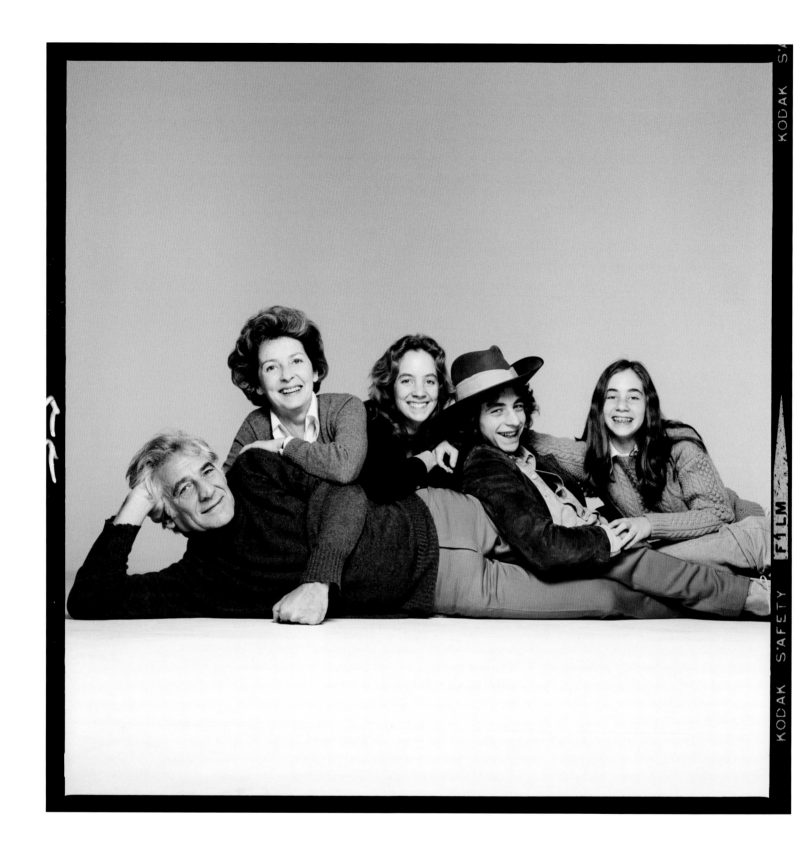

Richard Avedon
29 November 1974. New York City.
The Bernstein Family—Leonard, Felicia, Jamie, Alexander, and Nina.

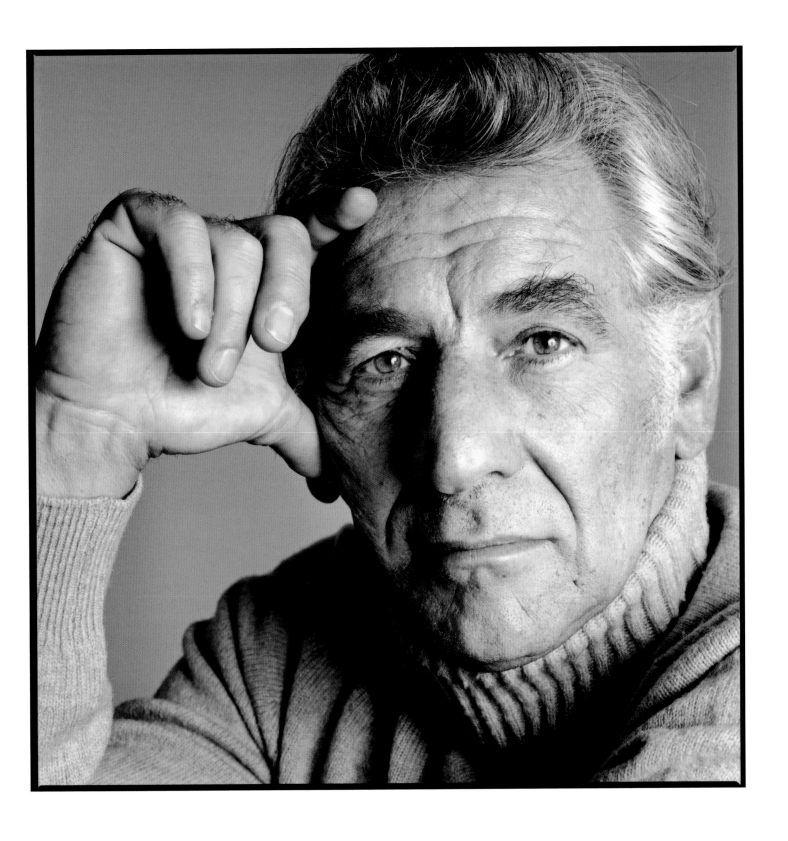

Richard Avedon
29 November 1974. New York City.
Portrait of Leonard Bernstein.

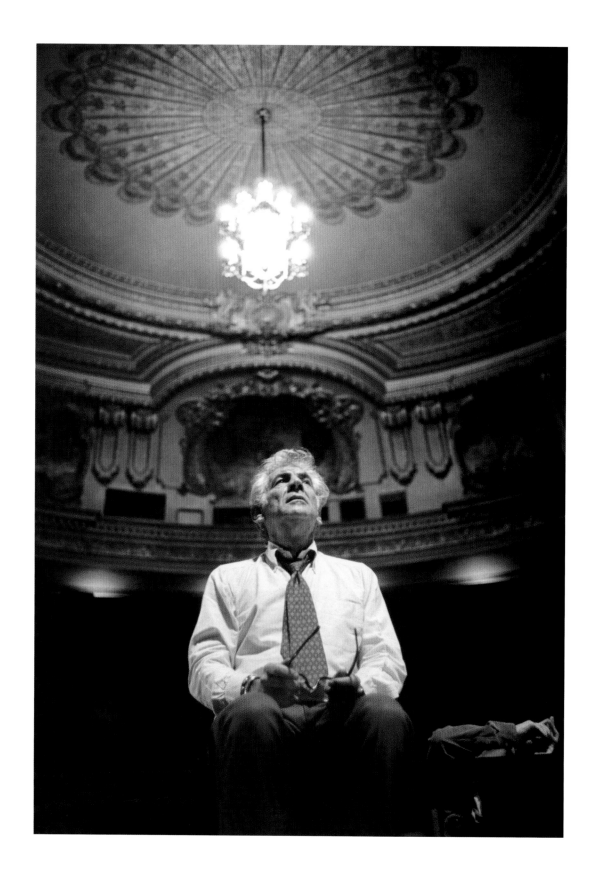

Henry Grossman
Spring 1976. Mark Hellinger Theatre, New York City.
Leonard Bernstein during a rehearsal of *1600 Pennsylvania Avenue,* his biggest Broadway flop.
Shortly thereafter, Leonard and Felicia Bernstein would separate.

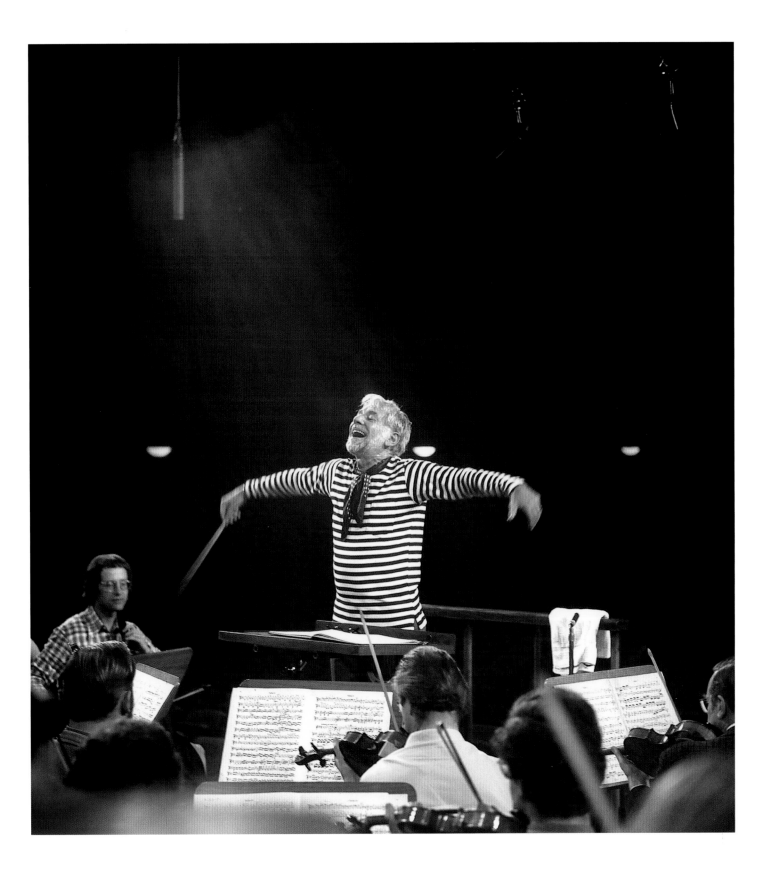

Felicitas Timpe
15 October 1976. Munich, Germany.
Leonard Bernstein rehearsing the Bavarian Radio Symphony Orchestra for an
Amnesty International benefit concert.

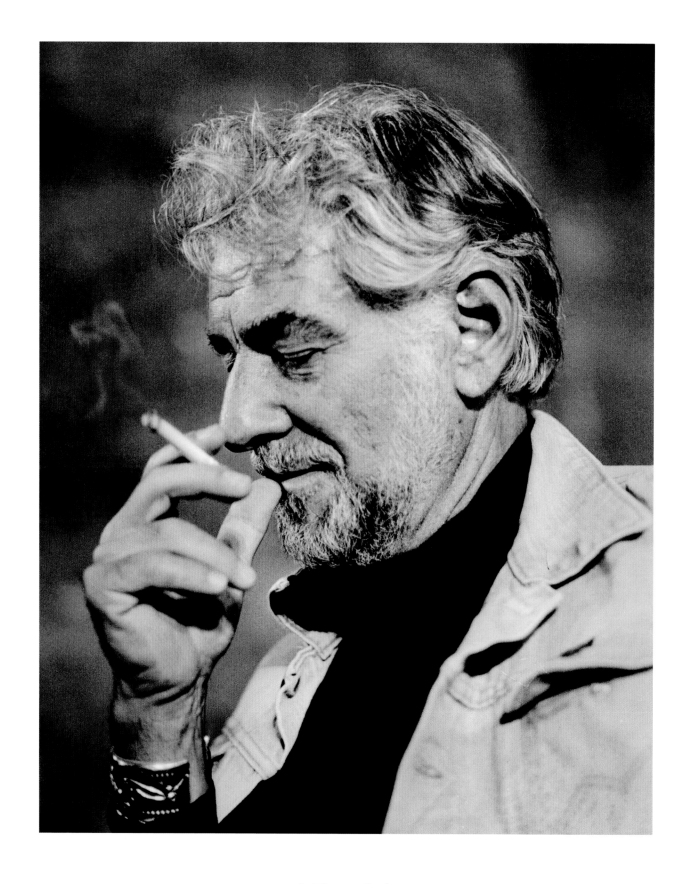

J. Ehrenthal
20 October 1976. Deutsches Museum, Munich, Germany.
Leonard Bernstein during a recording session.

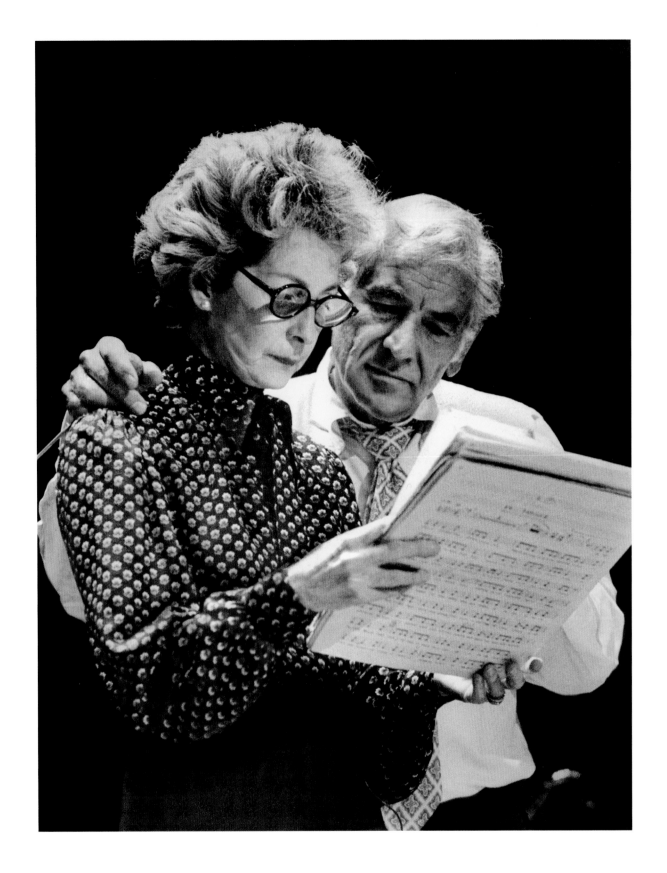

Richard Corkery
14 March 1977. Alice Tully Hall, New York City.
Felicia and Leonard Bernstein, having separated in July 1976, reconcile and reappear in public for the first time together to work on the score of Walton's *Façade,* in which Felicia narrated the Dame Edith Sitwell poems for *A Garland for Alice Tully.* Just months later, Felicia would be diagnosed with incurable lung cancer.

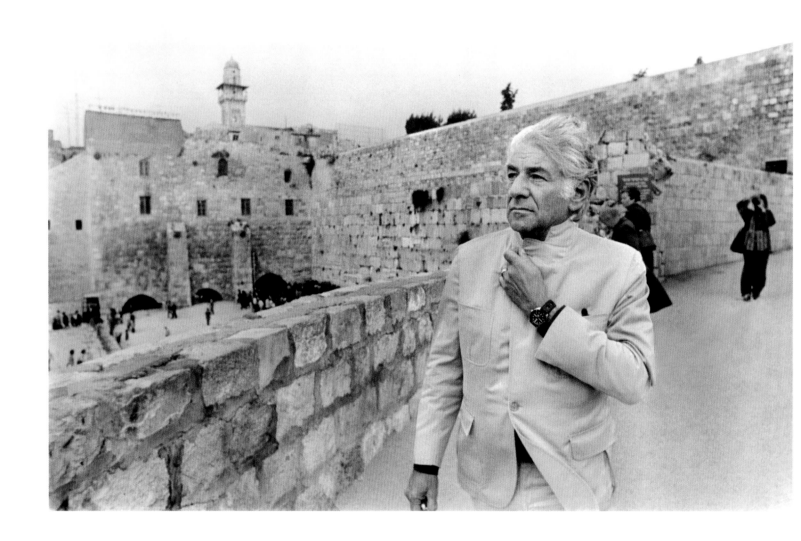

Patrick Jarnoux
1 April 1977. Jerusalem, Israel.
Leonard Bernstein coming down from the Temple Mount past the Western "Wailing" Wall.

Manuel Litran
9 September 1979. Hotel Crillon, Paris, France.
Leonard Bernstein, just over a year after the death of Felicia.

1980 – 1990

THE FINAL YEARS

"And so I have lived my long and varied life
Happily housed in music (work and play)
And in close-held, heart bound family
(Including my most precious, long-loved wife),
And teaching (which is learning) and in countless
Loving friends. I have no grave complaints.
I feel that I have lived five lives or so
Already. By the grace of God. Although
I am not quite content to die just yet:
There still remains so much to be composed.
But if I did indeed cease life today
I would not beat my fists against my Fates.
For I am the luckiest, and most blessèd, and
Most grateful person I have ever met.""
—Leonard Bernstein,
from "Beauty and Truth Revisited"
8 August 1988

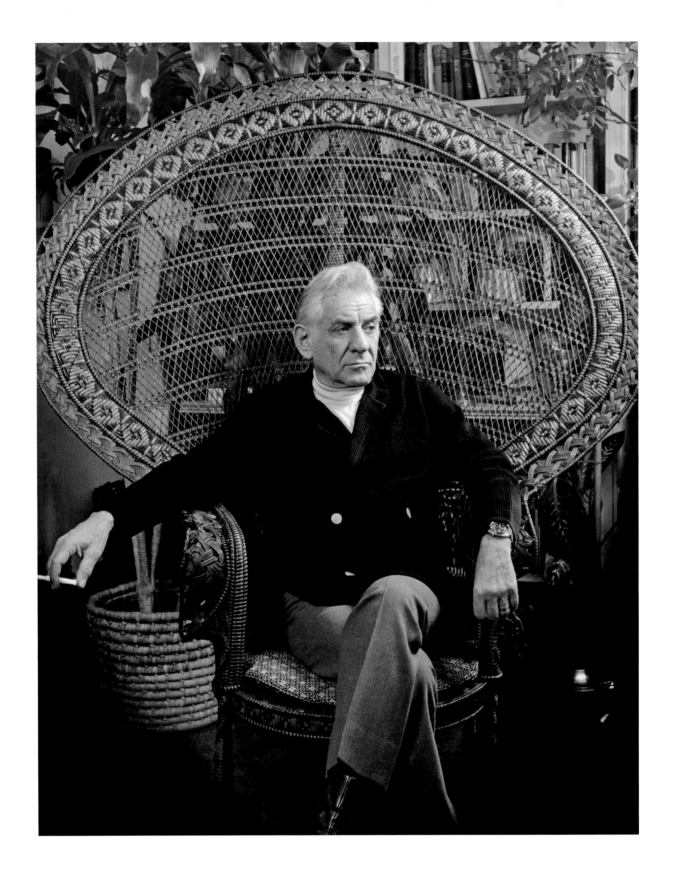

Arthur Mones
1980. The Bernstein apartment in The Dakota, New York City.
Portrait of Leonard Bernstein.

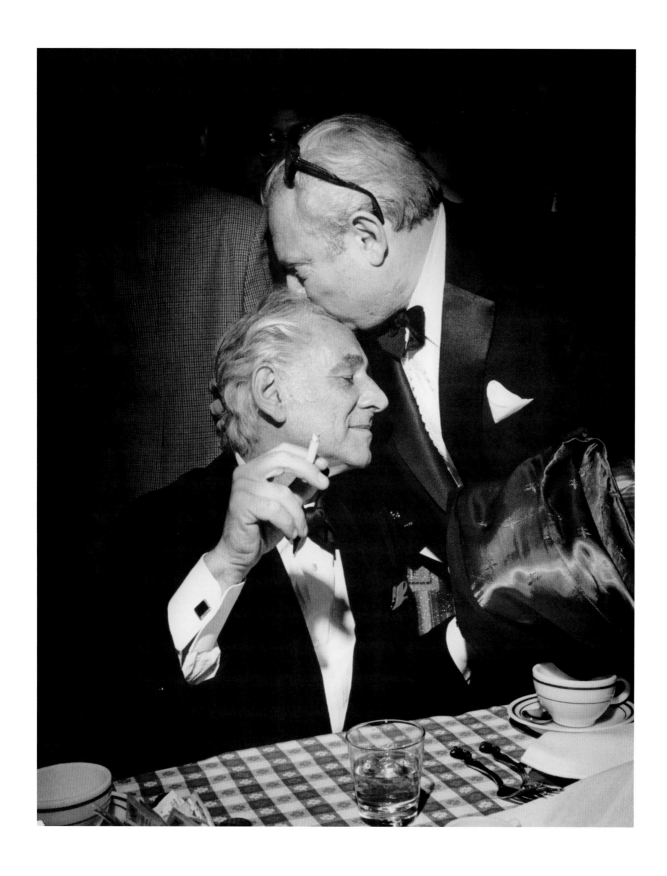

Henry Grossman
c. 1980. New York City.
Leonard Bernstein with lifelong friend Isaac Stern at a restaurant.

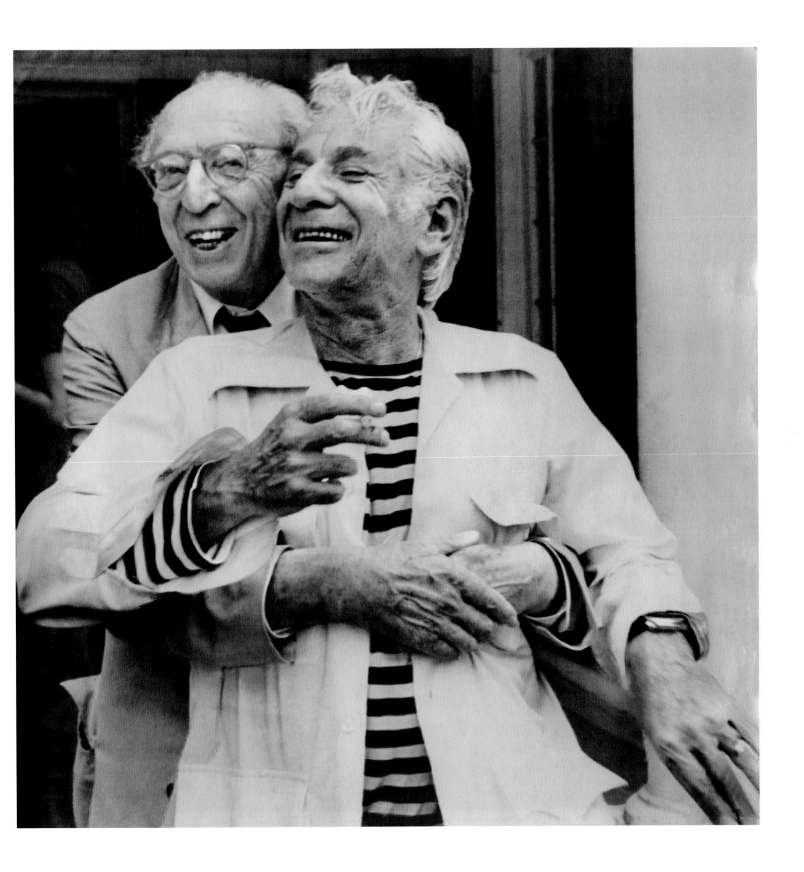

Heinz H. Weissenstein
1980. Seranak, Tanglewood, MA.
Leonard Bernstein getting a hug from Aaron Copland
as they celebrate Copland's 80th birthday.

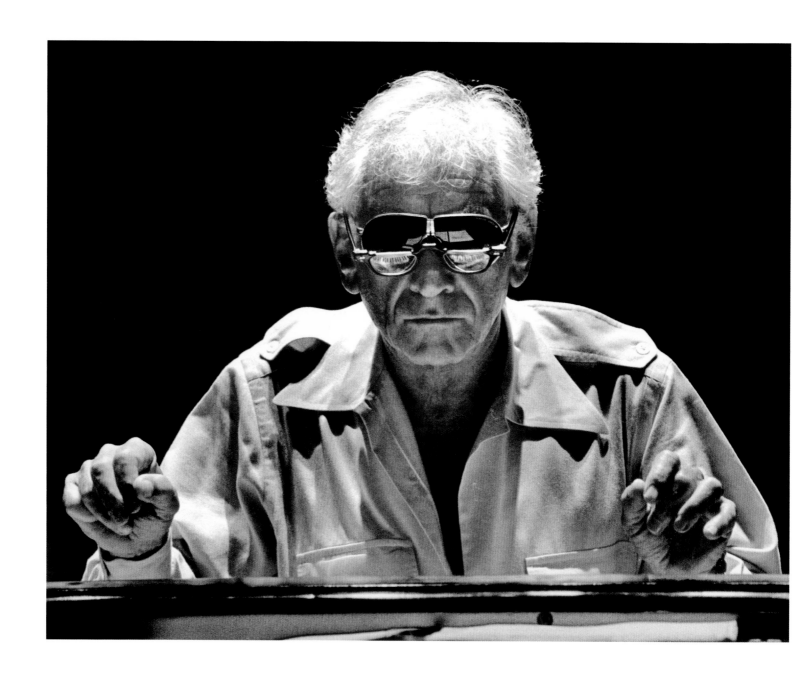

Robert Millard
1983.
Portrait of Leonard Bernstein at the piano.

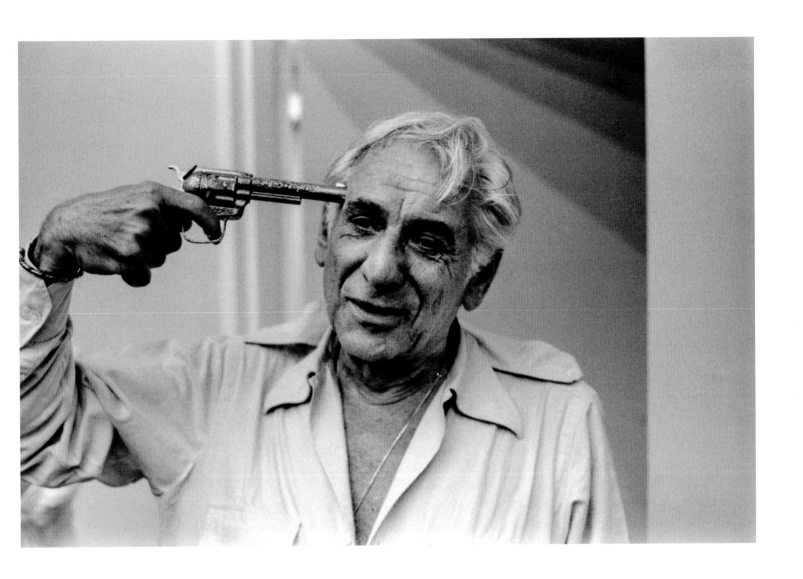

Arthur Elgort
1983.
Leonard Bernstein during the workshops for his opera *A Quiet Place* (playing with the props).

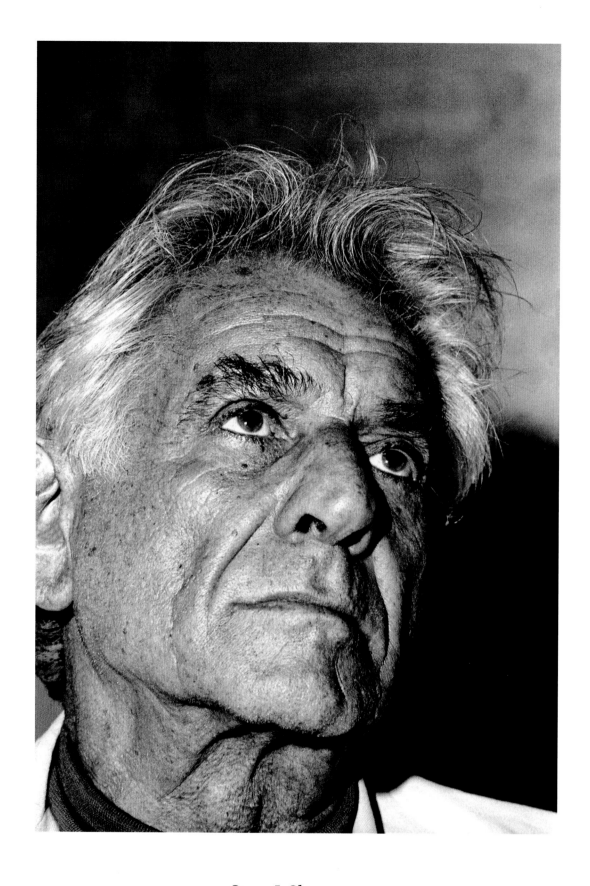

Steve J. Sherman
7 September 1984. RCA Studio A, New York City.
Leonard Bernstein during the recording sessions for *West Side Story*.

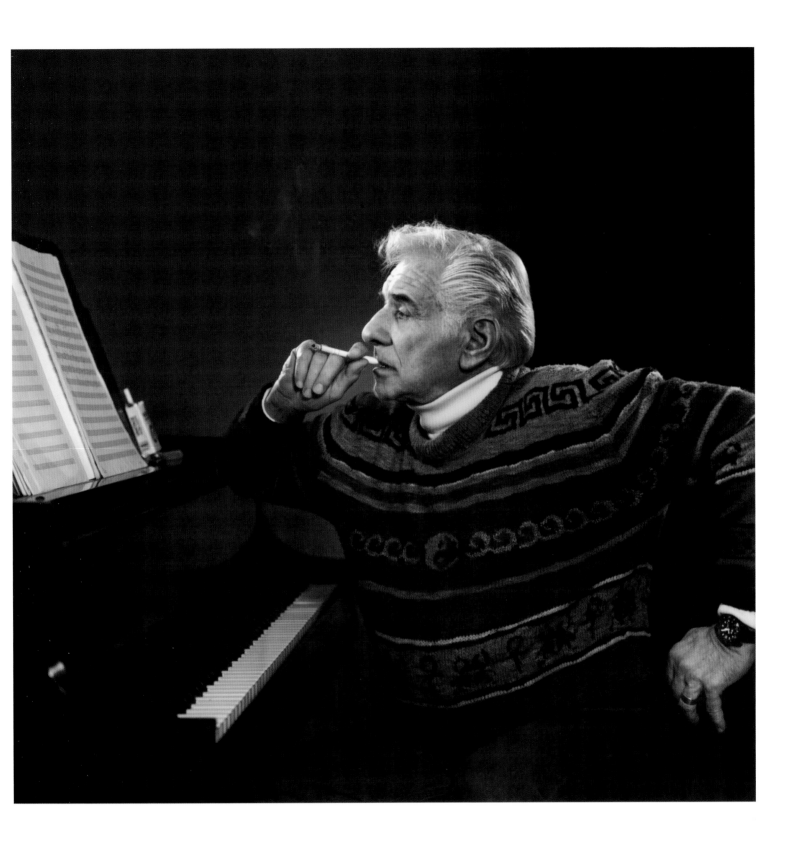

Yousuf Karsh
10 February 1985.
Portrait of Leonard Bernstein at the piano.

Andrew French
10 March 1986. The Osborne, studio 2DD, New York City.
Leonard Bernstein in his studio.

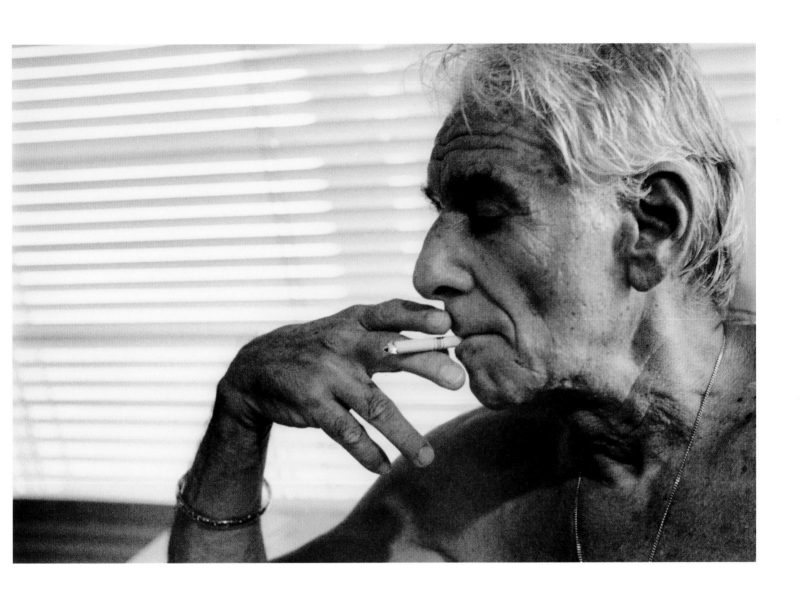

Pierre Vozlinsky
1986. Tanglewood, MA.
Portrait of Leonard Bernstein.

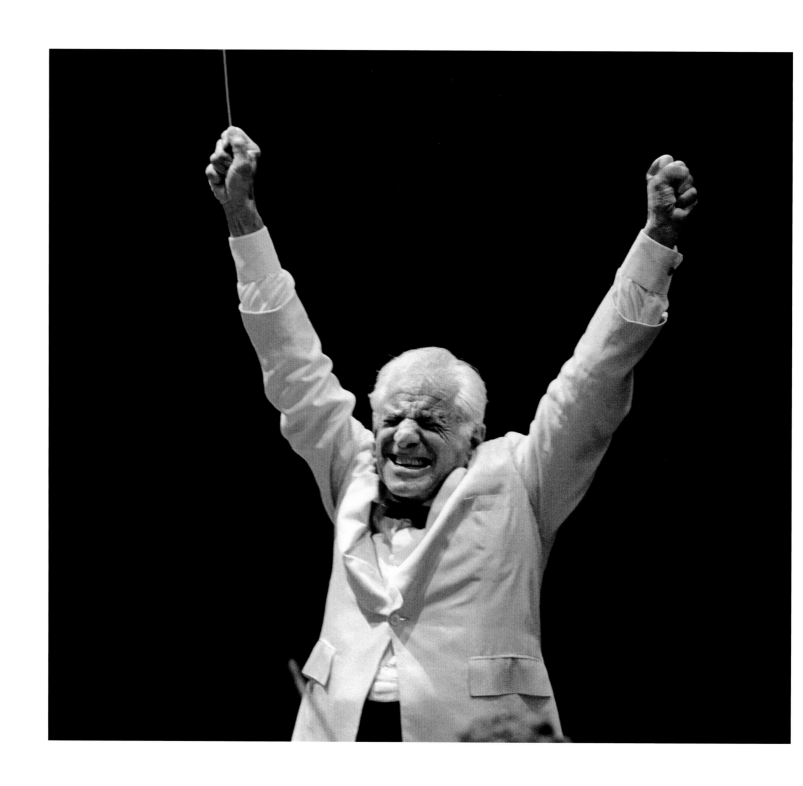

Steve J. Sherman
4 August 1986. Central Park, New York City.
Leonard Bernstein conducting the New York Philharmonic in
Tchaikovsky's "Symphony No. 6, Pathétique."

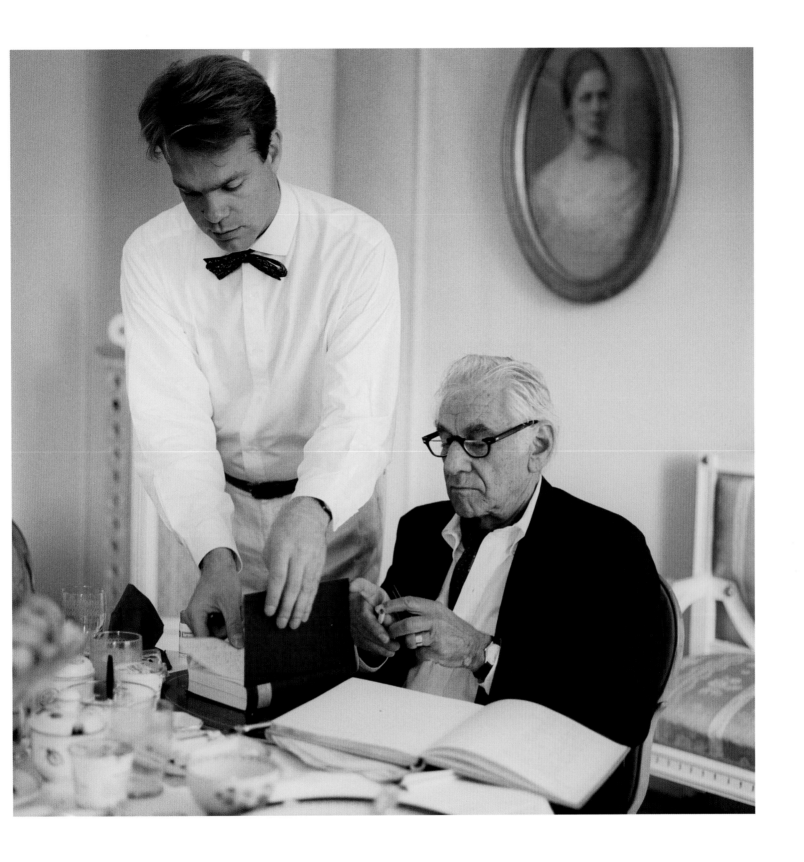

Thomas R. Seiler
1987. Wulfshagen, Schleswig-Holstein, Germany.
Leonard Bernstein with his personal assistant Craig Urquhart.

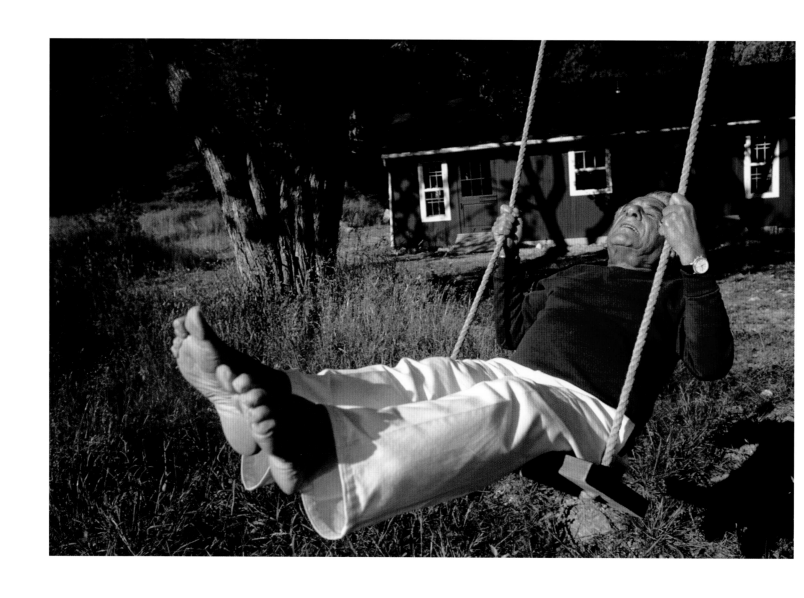

Joe McNally
1988. Springate (the Bernstein country home), Fairfield, CT.
Leonard Bernstein in a rare moment of repose.

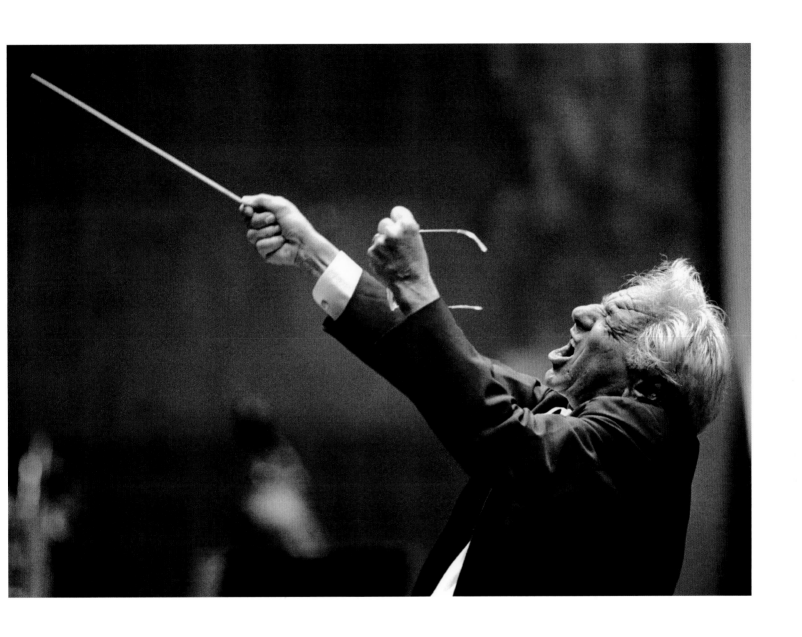

Steve J. Sherman
24 June 1988. Avery Fisher Hall, New York City.
Leonard Bernstein conducting the Chicago Symphony Orchestra in
Shostakovich's "Symphony No. 7, Leningrad."

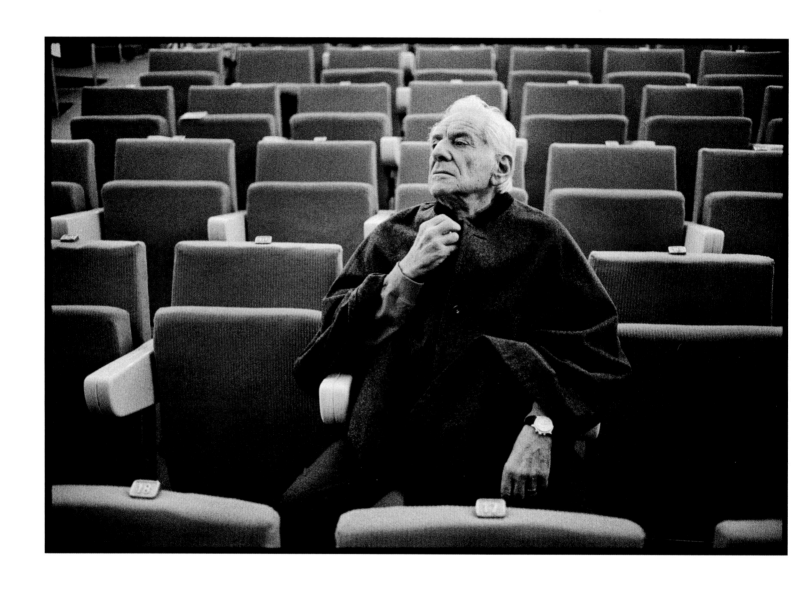

Leo Erken
1989. Warsaw, Poland.
Leonard Bernstein at a rehearsal.

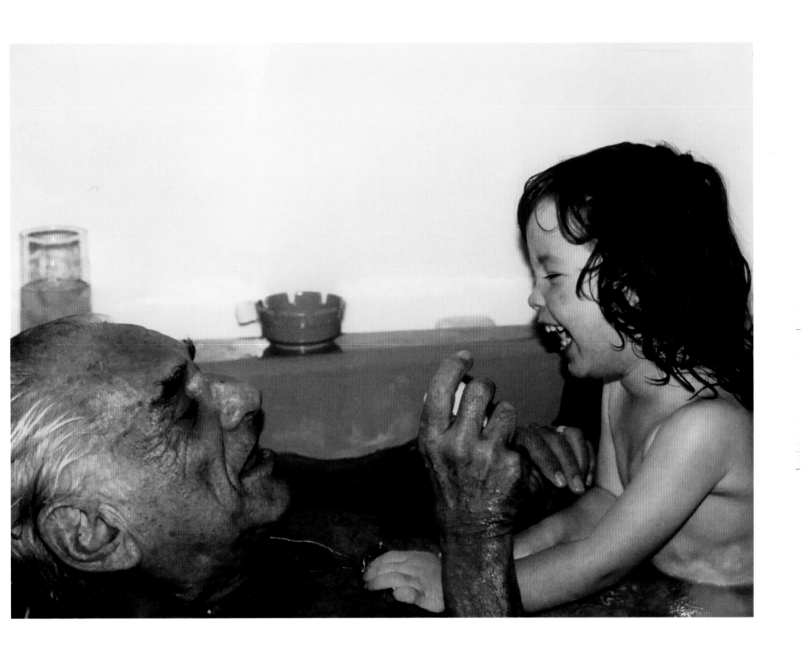

Jamie Bernstein
January 1990. Key West, FL.
Leonard Bernstein with his almost-three-year-old granddaughter Frankie,
enjoying a bath together.

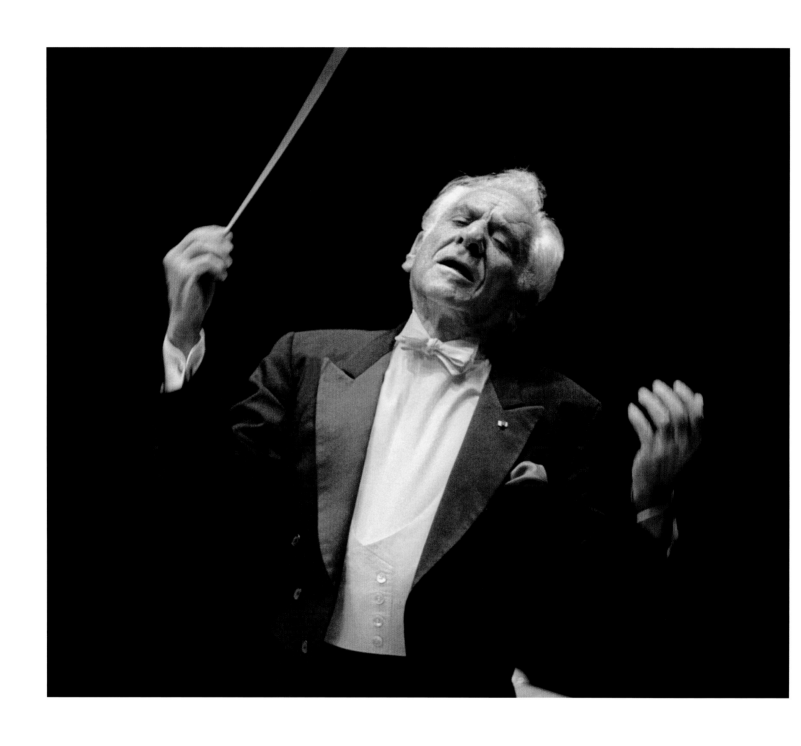

Steve J. Sherman
7 March 1990. Carnegie Hall, New York City.
Leonard Bernstein conducting the Vienna Philharmonic in Bruckner's "Symphony No. 9,"
in what would be his last performances in Carnegie Hall.

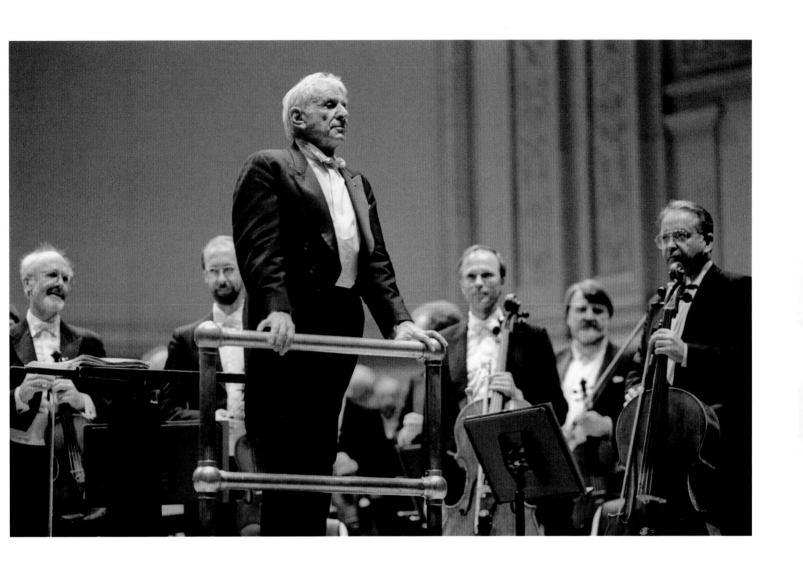

Steve J. Sherman
7 March 1990. Carnegie Hall, New York City.
Leonard Bernstein taking his final bows with the Vienna Philharmonic—
his last appearances on stage at Carnegie Hall and indeed, in New York.

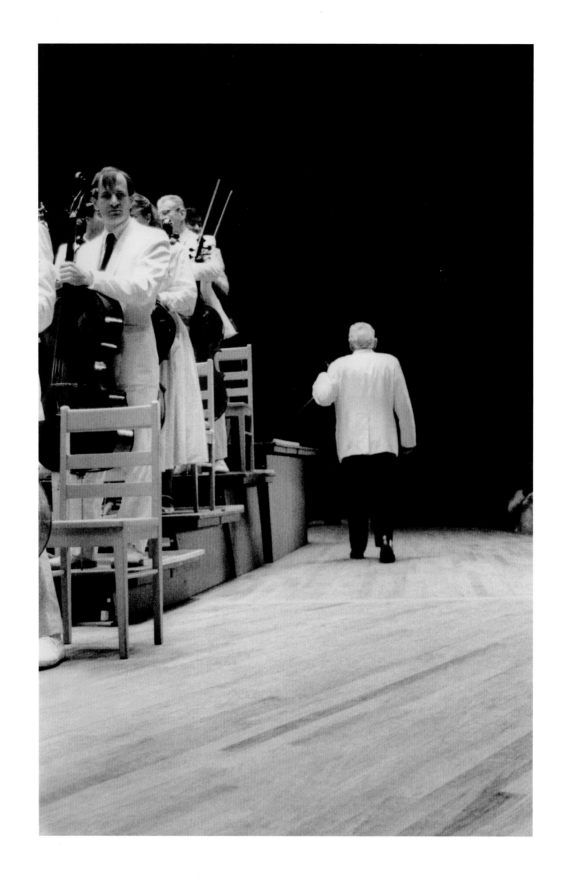

Walter H. Scott.
19 August 1990. Tanglewood, MA.
Leonard Bernstein leaving the stage for the very last time after conducting the Boston Symphony
Orchestra in Beethoven's "Symphony No. 7," his final performance.

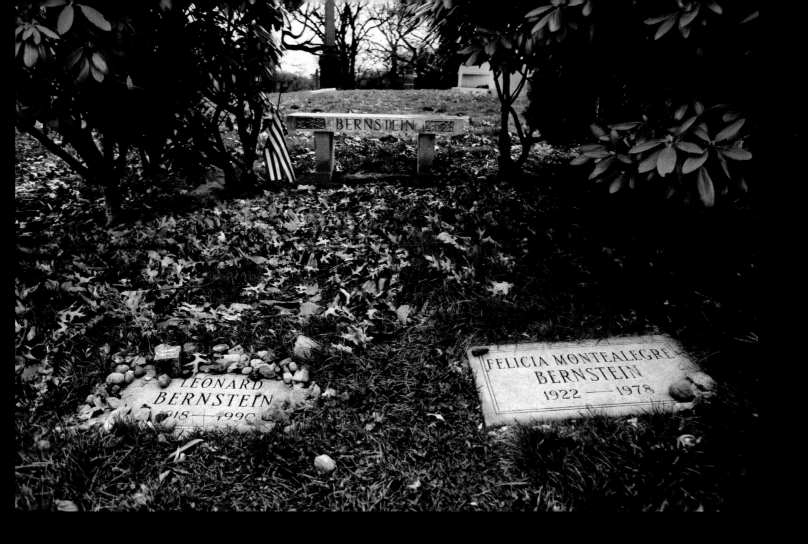

Leonard Bernstein

25 August 1918 – 14 October 1990

Felicia Montealegre Bernstein

6 February 1922 – 16 June 1978

*"Life without music is unthinkable.
Music without life is academic.
That's is why my contact with music
is a total embrace."*
–Leonard Bernstein,
1967

THE MAN,
HIS MUSIC,
AND HIS MIND

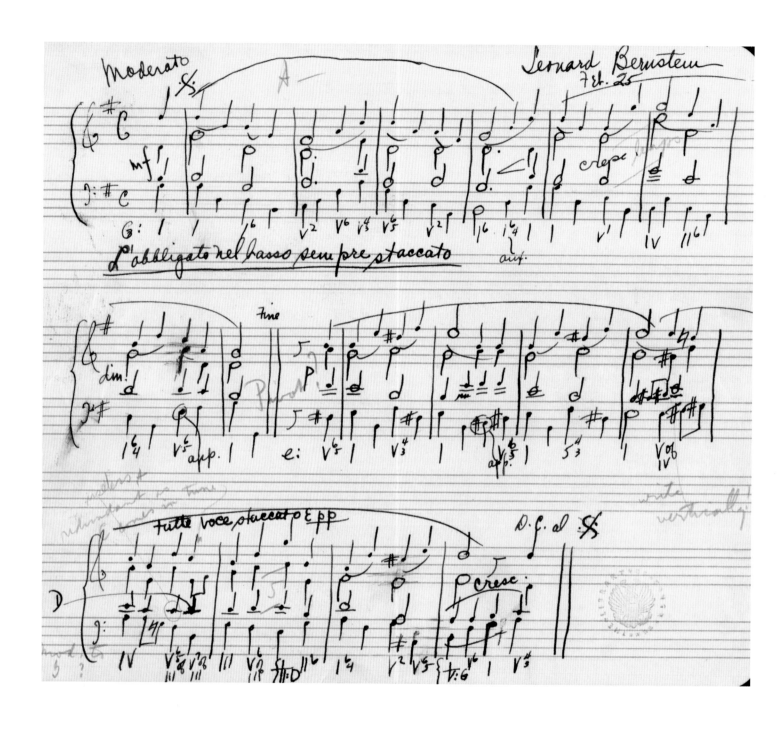

Leonard Bernstein—Harvard University coursework—exercises in harmony and counterpoint, c. 1937-1938. The professor's comments, corrections, and grades in red.

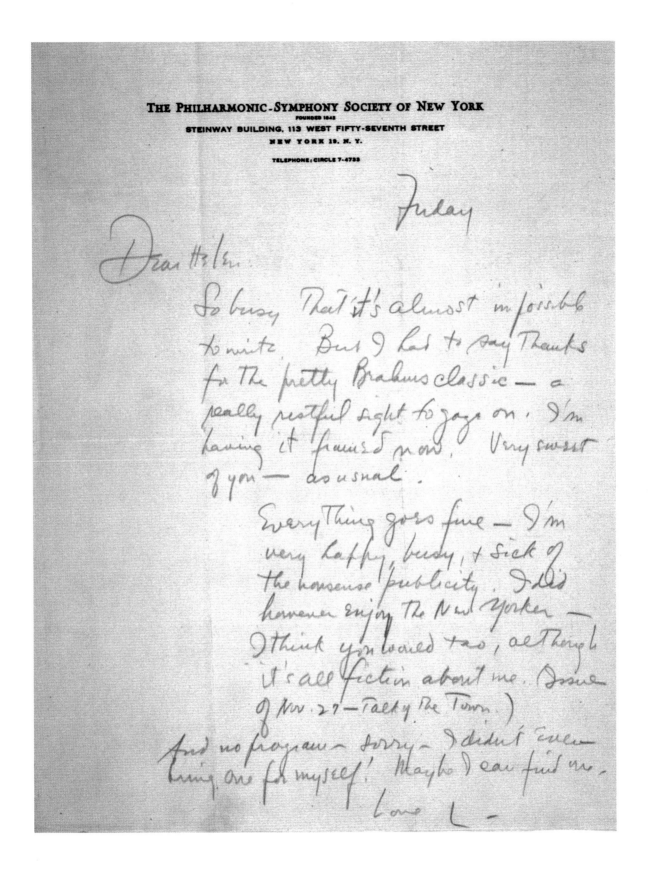

Leonard Bernstein—letter to Helen Coates,
just after his historic New York Philharmonic debut, 26 November 1943.

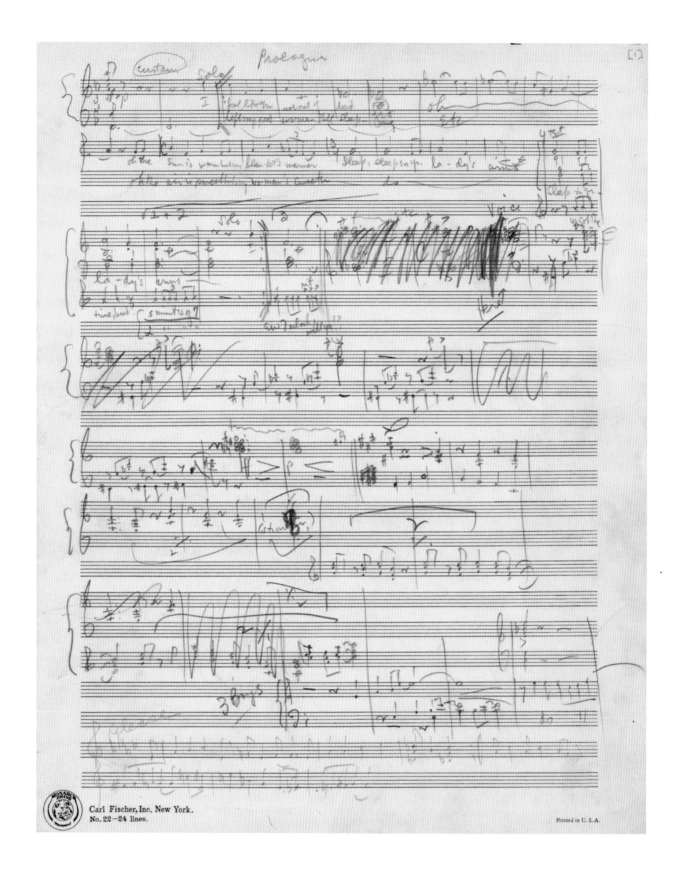

Leonard Bernstein—*On The Town*—"Prologue" sketch, 1944. Page 1.

Leonard Bernstein—*On The Town*—"Prologue" sketch, 1944. Page 2.

Leonard Bernstein—*On The Town*—"New York, New York" sketch, 1944. Page 1.

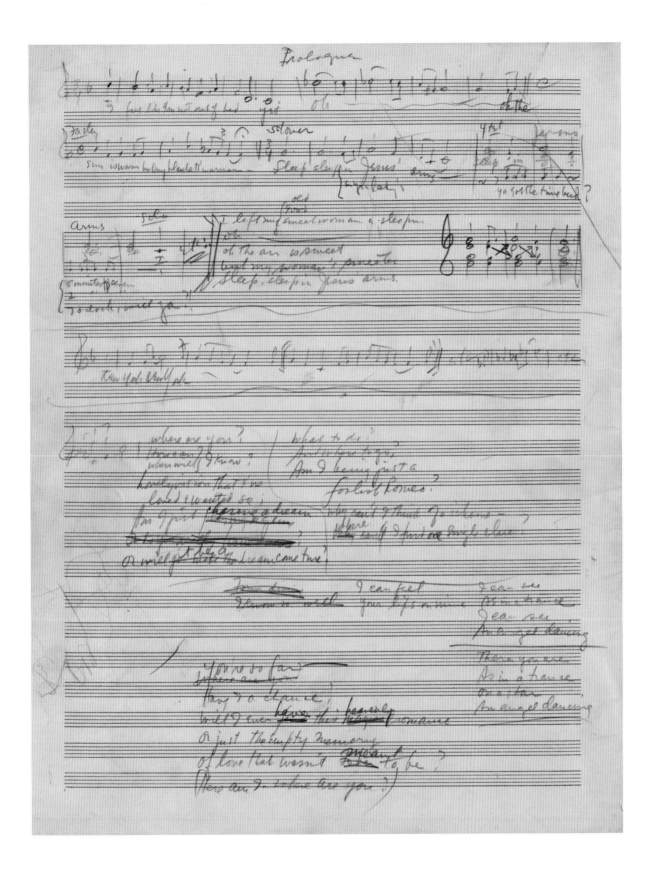

Leonard Bernstein—*On The Town*—"New York, New York" sketch, 1944. Page 2.

Hotel Castiglione
Paris
May 27, 1947

Cher
~~Bar~~ Burdumii:

We think of you so often that I finally decided to write you.

First: we hope you received the camera I bought you. It's not a gorgeous looker, but it's a first-rate, all equipped with the best. You'll have fun with it.

Second: our greatest successes are with your George Washington story. It laid them on the floor in Prague. (Didn't do so badly with the two Reds crossing the salt-mines, either.)

Third: We love you very much.

The concerts are fine, we feel fine and happy and love Europe and are always finding something that you should be here to see. For instance, the Czech word

Leonard Bernstein—letter to Burton Bernstein, 27 May 1947. Page 1.

for "no" is a sound like "nay". That would throw you. The old world is full of Mak'ism.

Saw a good deal of Shostakovich in Prague. Nice boy, but left his teeth back in Leningrad.

Shirley joins me in begging you to believe, dear sir, in the expression of my most distinguished sentiments.

Love

Lenny.

One scoop more:
The big song-hit in Paris is a little number they stole from you called, simply, "Tris."

Love to the kids in the next room.

Leonard Bernstein—letter to Burton Bernstein, 27 May 1947. Page 2.

J ury please note: and Justice be warned:
U nction is not for this Maple and Pine:
D estiny neither: they ask for no sign from
Y esterday's oracle, sibyl or seer.

A nswers of ominous birds are amiss:
N o nuptial impermeability this:
D arkness may never envelop their kiss.

D ark all you seers, you sibyls of sin,
A uspicious, oracular, prolix and vain:
V alid remain for the children of Cain: but
Exorcised — out — from this Maple and Pine.

O nly the front-lines of faith they desire:
P ossible truth, and truth under fire.
P resent them with these, and you bless them entire.

Love,
Blessings.

This happened
after seeing you.
It is my private invocation
of whatever gods There are (if
They will listen to a sonnet) to bring
you your hearts' desires.

Leonard Bernstein—acrostic sonnet for the wedding
of David Oppenheim and Judy Holliday, 1948.

Humboldt 53
Cuernavacacacaca

Dear Burt:

OK, a nice rational letter, on a sheet torn wildly out of my
beloved clip-bo-o-ardt.

Rational. Two things, in that order:

One: having received Hilee's wire, we moaned and groaned for
a day or so, and then Feloo conceived the great plan of wiring
Swoowpe without Hilee's knowledge and sheerly begging him to release
her. We are waiting for the answer now. F. is confident it will
work. Until we hear something we are delaying buying the tickies
pending our knowing how many tickies to buy. Rational enough?

Two: whatever the outcome re: Hilee, YOU MUST COME ANYWAY. Our
first thought of comfort after getting the Wire was: well
Baudumu will came anyway. This is important; and stop all this
not-wanted nonsense. You can't imagine how wantingly you are wanted!

Rational enough? The remaining steps are 1)word from Sw., and 2)
getting tickets accordingly and 3) mailing it/them -- where, to
Hanover or Boston (if Hilee is not coming)? If she does come
I'll mail them to her in NYC.

Rational enough? In all cases, WE ARE EXPECTING YOU. Selah.

Maybe you can tell me how to finish my fucking little opera. I've
also written a little story you will like. F. is blooming, and we
are both happy and aching from horses and tennis. The pool is
being painted and refilled with nice fresh water for you. There are
also many nymphomaniacs around town for your pabulum.

Good luck on your exams.

Lau,

Leonard Bernstein—letter to Burton Bernstein, 11 December 1951.

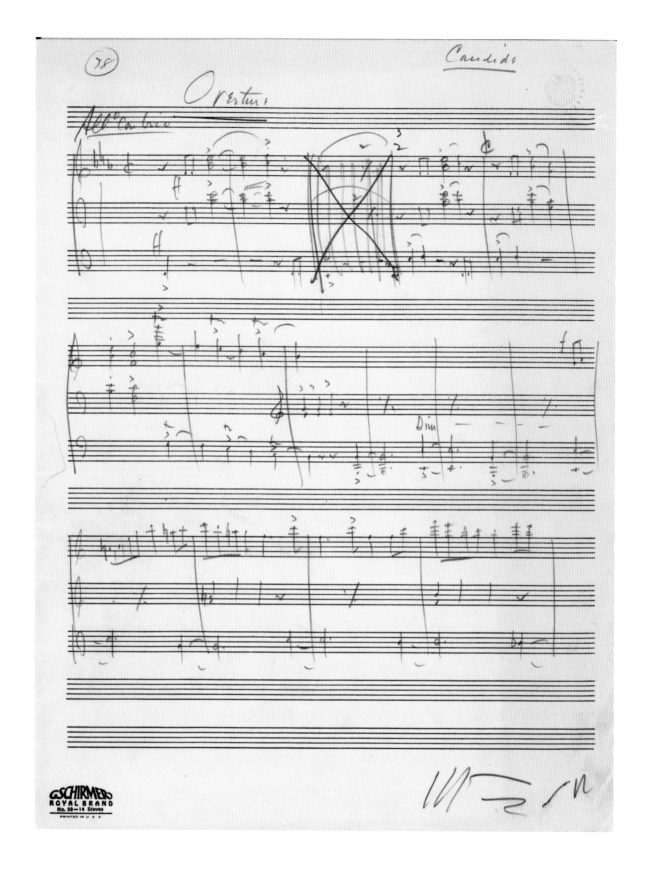

Leonard Bernstein—*Candide*—"Overture" sketch, 1955-1956. Page 1.

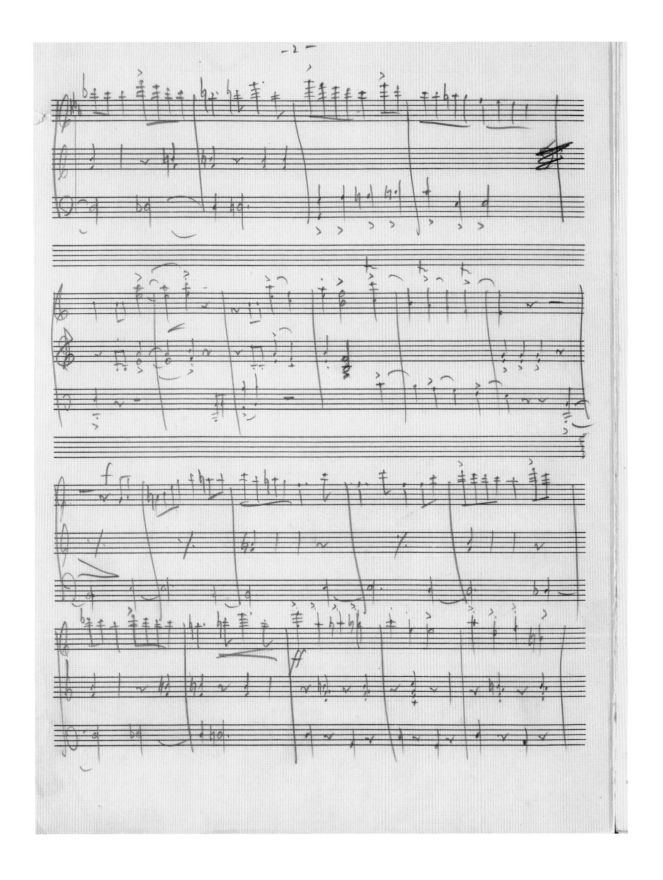

Leonard Bernstein—*Candide*—"Overture" sketch, 1955-1956. Page 2.

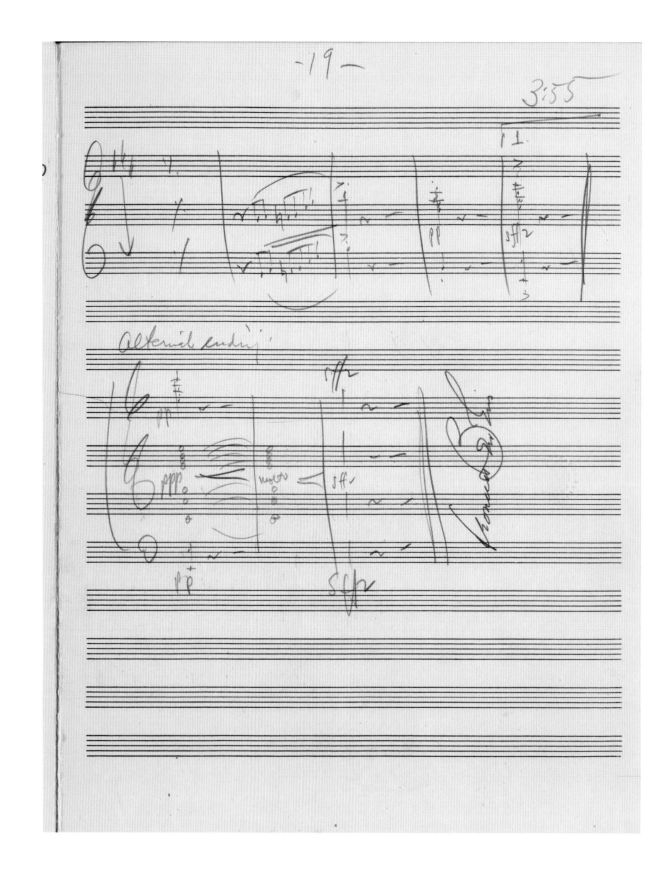

Leonard Bernstein—*Candide*—"Overture" sketch, 1955-1956. Page 19 (end).

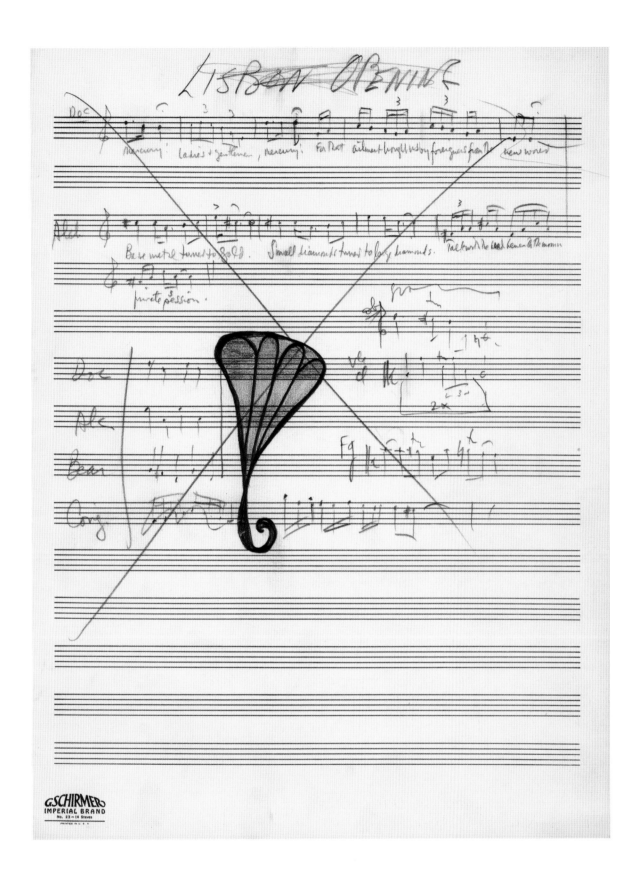

Leonard Bernstein—*Candide*—"Lisbon opening" sketch, 1955-1956. Page 1.

Leonard Bernstein—*Candide*—"Make Our Garden Grow" lyrics sketch, 1955-1956.

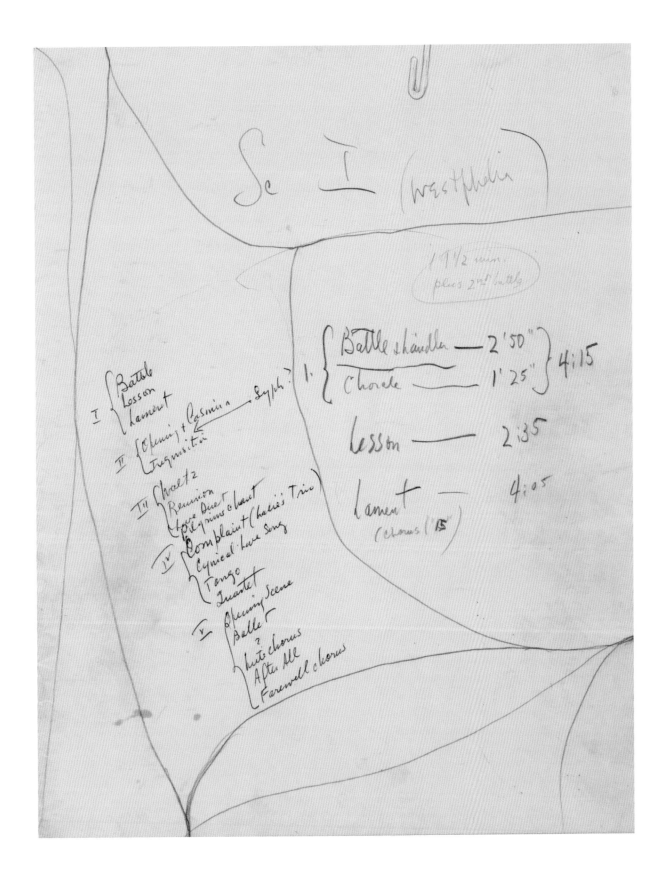

Leonard Bernstein—*Candide*—"Westphalia" architecture notes, 1955-1956.

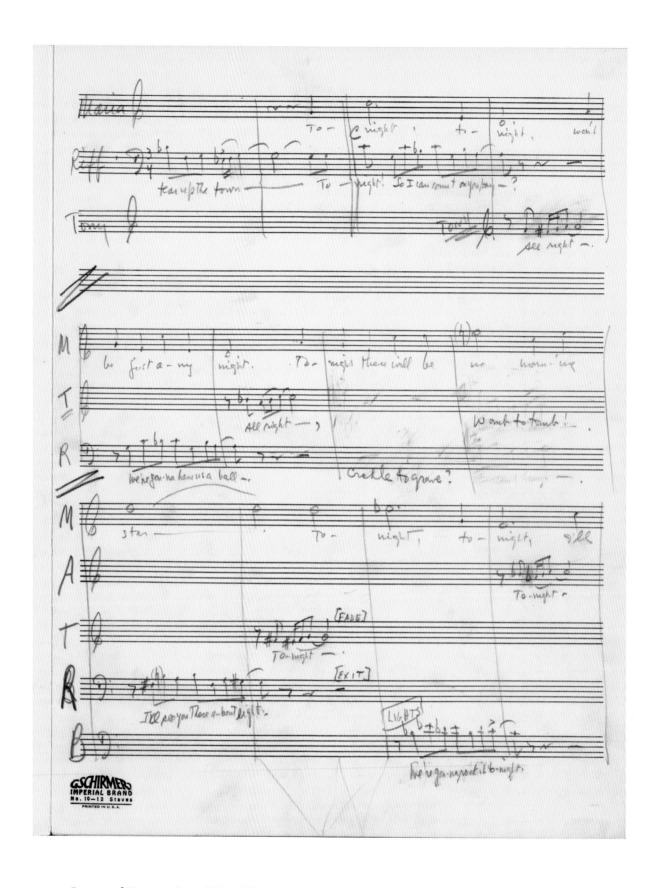

Leonard Bernstein—*West Side Story*—"Quintet" (Tonight) sketch, 1956-1957. Page 5.

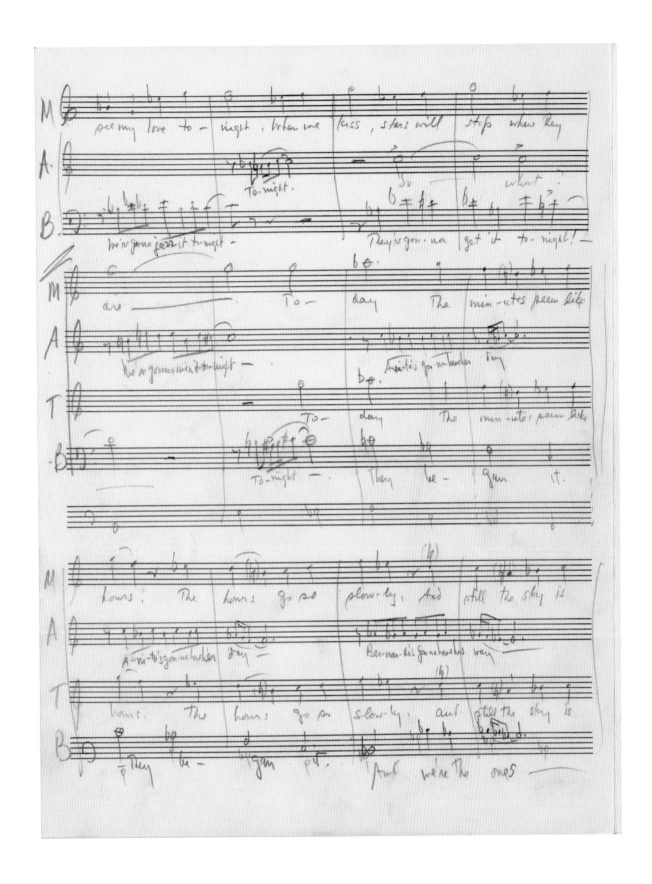

Leonard Bernstein—*West Side Story*—"Quintet" (Tonight) sketch, 1956-1957. Page 6.

Leonard Bernstein—*West Side Story*—"Dance at the Gym" sequence sketch, 1956-1957. Page 3.

Leonard Bernstein—*West Side Story*—"Dance at the Gym" sequence sketch, 1956-1957. Page 36.

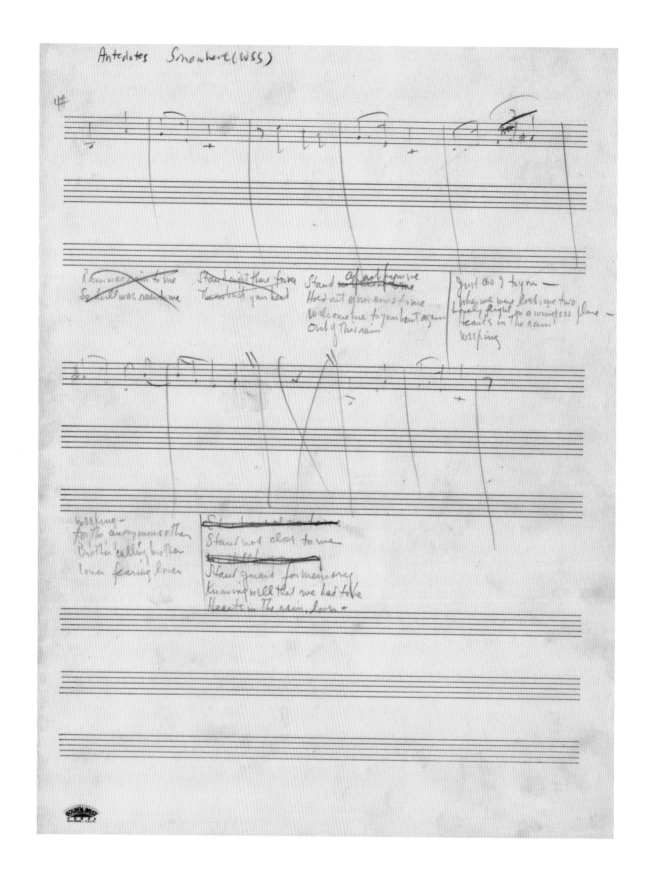

Leonard Bernstein—*West Side Story*—"Somewhere" sketch, 1956-1957.

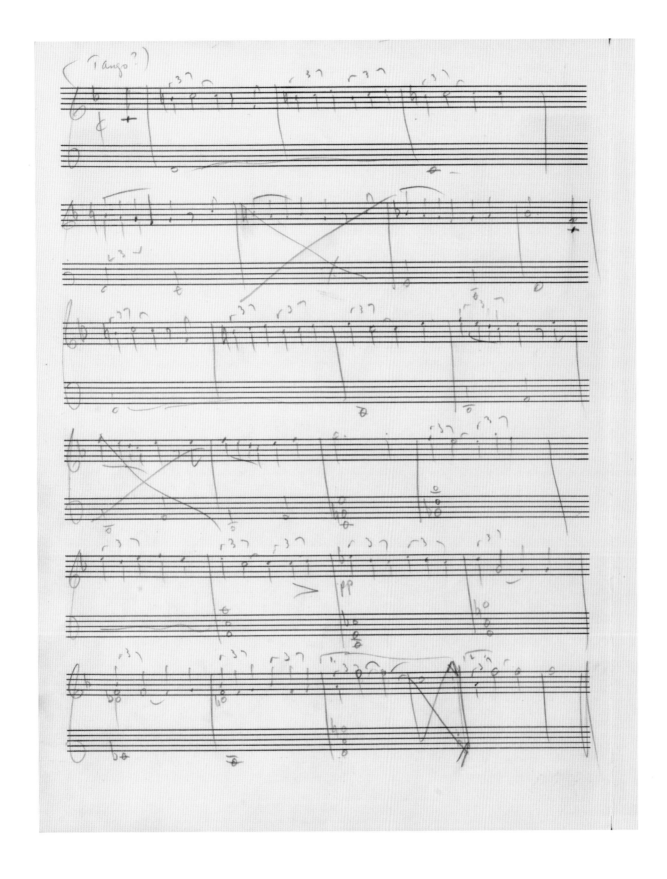

Leonard Bernstein—*West Side Story*—"Maria" sketch, 1956-1957.

8 Aug already!

Darling: I had a real scare with the news of Asian flu — + when your letter came about how you were all down with it I got scareder. But your cable made me feel better — please be careful! I can't bear the thought of you all sick.

I missed you terribly yesterday — We wrote a new song for Tony that's a killer, + it just wasn't the same not playing it first for you. It's really going to save his character — a driving $\frac{2}{4}$ in the great tradition (but of course fucked up by me with $\frac{3}{4}$'s and what not) — but it gives Tony balls — so that he doesn't emerge as just a euphonic dreamer —

Leonard Bernstein—Letter to Felicia Bernstein (visiting family in Chile) while finishing *West Side Story*. 8 August 1957. Page 1.

These days have flown so — I don't
sleep much; I work every — literally
every — second (since I'm doing four
jobs on this show — composing, lyric-
writing, orchestrating, + rehearsing the
cast). It's murder, but I'm excited.
It may be something extraordinary.
We're having our first runthru for PEOPLE
on Friday — please may they dig it!
And Friday + , I leave for Washington
on Tues. the 13th — so soon, so soon.
It's all rushed by like a cyclone.
Of course, we're way behind on orchestration,
etc. — but that's the usual hassle.

How are you? You don't say.
Are you fatter from eating? (Me, I'm
a bit skinnier.) Do you smoke? (I do,
lots.) Have you skied? (I haven't.)
Do you love me?
Bless you + be well !!
Love

I adored Jamie's letter. Especially the lentils.

Leonard Bernstein—Letter to Felicia Bernstein (visiting family in Chile)
while finishing *West Side Story*, 8 August 1957. Page 2.

Jefferson Hotel, Washington

Darling:

It's all too Exciting. I never dreamed it could be like this — reviews such as one would write for oneself — The whole town up and doing about The show — those delicious long lines at The box office — morale high — dignitaries every night — The Senate practically in toto — parties — hot newspapers — all the atmosphere of a mid-season opening — gala — emeralds, furs — The works. Only thing missing — you. How I longed to have you there & share the excitement! Of course, as they say, it's only Washington, not New York — don't count chickens. But it sure looks like a smash, & all our Experiments seem to have worked. The book works, the tragedy works, the ballets shine, the music pulses & soars, & There is at least one history-making set. It's all too good to be true.

I've just lunched at the White House. no más. Invited by Sherman Adams & the whole gang. Again — you should have been There! What a beautiful place — such credenzas, such breakfronts. I really felt "in". Adams & Rabb & Ben. Snyder — all were

Leonard Bernstein—Letter to Felicia Bernstein (visiting family in Chile) after the triumphant opening of *West Side Story*, 23 August 1957. Page 1.

talking of nothing but West Side Story. I think the whole government is based on it. Jim Hagerty (Ike's press secretary) turns out to be a fan of mine! It's all so crazy and unexpected. Even Adams turns out to be an amateur musician!

Now listen! When are you coming home? I have a constant feeling you're about to turn up any minute — but look, the time is drawing near. Only 10 days to Labor Day. And the summer's over. What I hope is that you'll all be back for the Philly opening (Monday the 9th) which is our anniversary, for Chrissake —— or even for Jamie's birthday on Sunday. Please try to manage it, huh? Why stick around that plaguey place, bored as you are, after Labor Day? Let me know right away when you plan to return, and darling, hurry home. I can't stand not seeing the children, and I need my girl!

I love you
L

23 Aug '57
I'm 39 in 2 days!!

Leonard Bernstein—Letter to Felicia Bernstein (visiting family in Chile)
after the triumphant opening of *West Side Story*, 23 August 1957. Page 2.

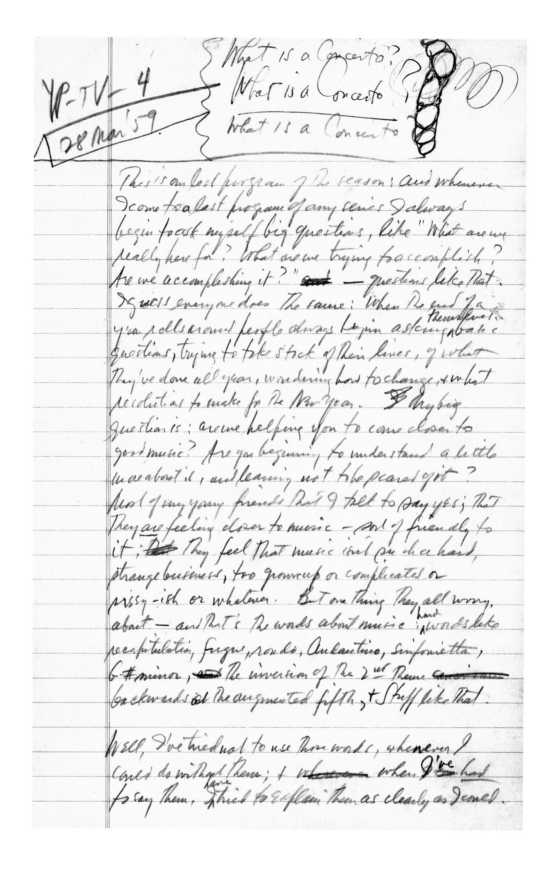

What is a Concerto?
What is a Concerto?
What is a Concerto

This is our last program of the season; and whenever I come to a last program of any series I always begin to ask myself big questions, like "What are we really here for? What are we trying to accomplish? Are we accomplishing it?" — questions like that. I guess everyone does the same: When the end of a year rolls around people always begin asking themselves basic questions, trying to take stock of their lives, of what they've done all year, wondering how to change, & what resolutions to make for the New Year. My big question is: are we helping you to come closer to good music? Are you beginning to understand a little more about it, and learning not to be scared of it? Most of my young friends that I talk to say yes; that they are feeling closer to music — sort of friendly to it. They feel that music isn't such a hard, strange business, too grownup or complicated or sissy-ish or whatever. But one thing they all worry about — and that's the words about music; hard words like recapitulation, fugue, rondo, Andantino, Sinfonietta, 6# minor, the inversion of the 2nd theme backwards at the augmented fifth, & stuff like that.

Well, I've tried not to use those words, whenever I could do without them; & when I've had to say them, I tried to explain them as clearly as I could.

Leonard Bernstein—*Young People's Concert*—"What is a Concerto?" script draft, March 1959. Page 1 of 10.

162

But there are some *musical* words which can't be explained in a second; *it* takes time to learn about *them*, and what's more, it takes listening to the actual music *they describe before* you really know what they mean. Now one of those words that bothers people is *the* Italian word Concerto, which is really a very simple word *that ought to mean* nothing else but a concert. That's what it does mean in Italian — a concert. Concerto — concerto (Eng. pron.) — concert. That's all *the same* idea. But in music the word has come to mean a lot of other things; & that's what we're going to find out about today.

The original meaning of concerto — or of concert, for that matter — is the idea of things happening together; a football team performs in concert; *the players* make a concerted effort to win. As McCall's magazine would say, it means "togetherness." In music it came to mean the "togetherness" of musicians, who had come together to play or sing in a group. So ever since music began to be written for the entertainment of audiences like you, composers have used the word Concerto to name their pieces. All kinds of different musical forms used to be called concertos, even though they weren't pieces we would call concertos today. All sorts of different pieces used to be called symphonies, too, or sonatas. These were also just general words to describe the same thing the

Leonard Bernstein—*Young People's Concert*—"What is a Concerto?" script draft, March 1959. Page 2 of 10.

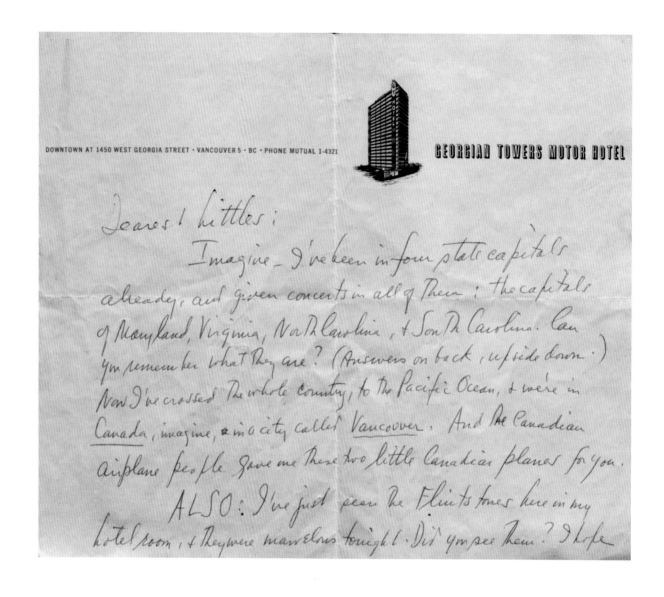

Dearest Littles:

Imagine — I've been in four state capitals already, and given concerts in all of them: the capitals of Maryland, Virginia, North Carolina, & South Carolina. Can you remember what they are? (Answers on back, upside down.) Now I've crossed the whole country, to the Pacific Ocean, & we're in Canada, imagine, & in a city called Vancouver. And the Canadian airplane people gave me these two little Canadian planes for you.

ALSO: I've just seen the Flintstones here in my hotel room, & they were marvelous tonight. Did you see them? I hope

Leonard Bernstein—Letter to Jamie and Alexander, 21 April 1961. Page 1.

164

it was the same one — about the crazy jazz, and Hot Lips, &
Fred singing "When the Saints Go Marching In". I thought it was
wonderful. And I can't get that tune out of my head:

Be good, both of you. I love you and miss you and
think of you all the time. And remember to sing:

Daddy's Coming Home in May!
Yay Yay Yay Yay Yay Yay Yay!
(or maybe, Hooray!)

Hugs & kisses,

Daddy Rennukt

21 April 1961

ANSWERS:
Beethoven
Richmond
Robert &
Columbia

← ANSWERS

Leonard Bernstein—Letter to Jamie and Alexander, 21 April 1961. Page 2.

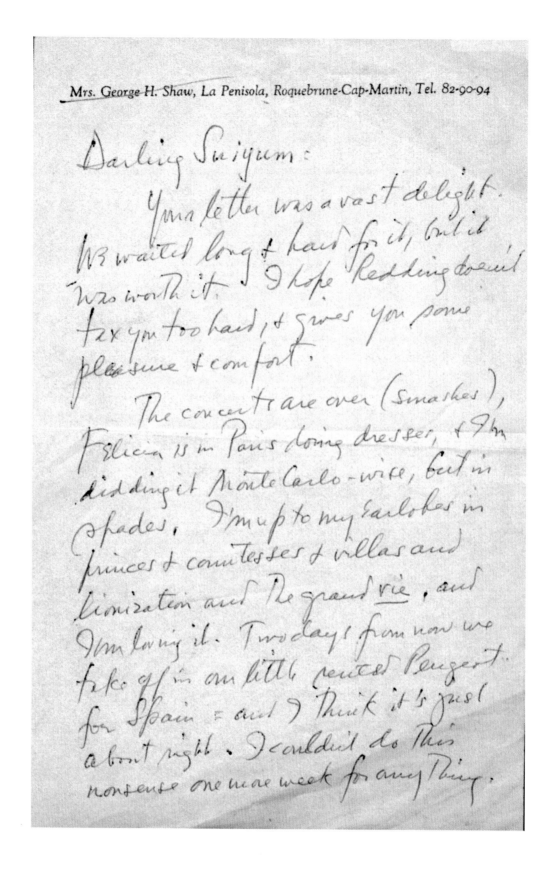

Mrs. George H. Shaw, La Penisola, Roquebrune-Cap-Martin, Tel. 82-90-94

Darling Snigum:

Your letter was a vast delight. We waited long & hard for it, but it was worth it. I hope Redding doesn't tax you too hard, & gives you some pleasure & comfort.

The concerts are over (smashes), Felicia is in Paris doing dresses, & I'm kidding it Monte Carlo-wise, but in spades. I'm up to my earlobes in princes & countesses & villas and lionization and the grand *vie*, and I'm loving it. Two days from now we take off in our little rented Peugeot for Spain — and I think it's just about right. I couldn't do this nonsense one more week for anything.

Leonard Bernstein—letter to Shirley Bernstein, 30 July 1962. Page 1.

It's an incredible phase of insane social climbing — everyone's climbing to a big fat rich nowhere. But as I'm the kid of the moment, I'm loving it. But basta.

I drove through 22d yesterday & almost cried with nostalgia and mixed emotions. I'm finally beginning to read Akhnaton — it's glorious. I think of you a lot, & hope rays of light are appearing on your several horizons. I'll be home in two weeks, and we'll embrace.

Give the enclosed to my darling babies. Much love to you —

Prince Lehmuki † , A.P.F.

30 July '62

you luck in assembling it, with directions in French!)

I've sent a boat for the littles — magnificent! Rainier's kids have one like it, & it's great for the pool. I've arranged for Pan-Am. to ship it to you, so you don't have to go to Idlewild or anything. But I wish

Leonard Bernstein—letter to Shirley Bernstein, 30 July 1962. Page 2.

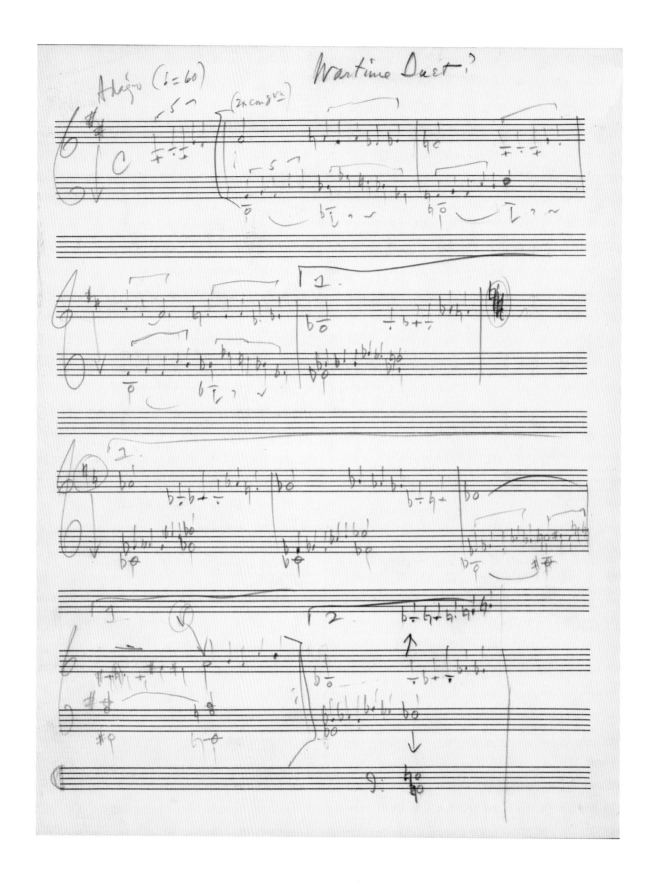

Leonard Bernstein—*Chichester Psalms,* 3rd Movement—"Wartime Duet?" sketch, 1965. Page 3.

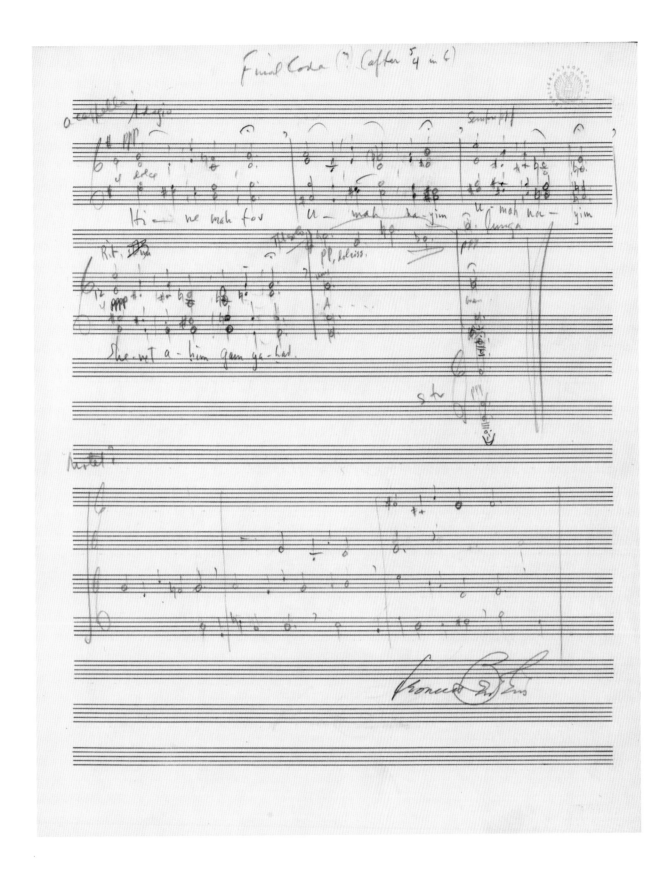

Leonard Bernstein—*Chichester Psalms*—"Final Coda" sketch, 1965.

Leonard Bernstein—*Young People's Concert*—"Charles Ives: American Pioneer" show sketch, January 1967. Page 1.

Ives

<table>
<tr><td>?</td><td>9</td><td>Washington</td><td>Sporting Element</td></tr>
<tr><td></td><td>4</td><td>Hoot & ladder</td><td>Playing with music</td></tr>
<tr><td></td><td>5</td><td>Question</td><td>Special attitude, using</td></tr>
<tr><td></td><td></td><td>Songs — ?</td><td>other music, both</td></tr>
<tr><td></td><td>6³⁰</td><td>America</td><td>serious + non-serious</td></tr>
</table>

22½

Pretended not to care
about not being performed—
but danced a jig + cut
beard at broadcast of
2ⁿᵈ symph.

Brings up question:
what is American?
European music had its folk-roots
(chorales, minuets, folk-songs, marches)
Am music had only Indian + Negro —
So Ives seized on traditional tunes—
patriotic, hymns, pop-songs —
(Clementine, America, etc.)

2 Songs, neither
of which is really a
song: Rainbow
Lincoln
But: Ives' big sense
of Optionals : (cf Halloween,
almost everything else) — chorus
or solo voice; Eb or Basset,
a Voice why not voice?

Fun Licence

26 in 1900
Stopped writing
in 1916
(except small things in 20's)
So all this at least 50 yrs old

Oh my darlin'
Clementine

Leonard Bernstein—*Young People's Concert*—"Charles Ives: American Pioneer" show sketch,
January 1967. Page 2.

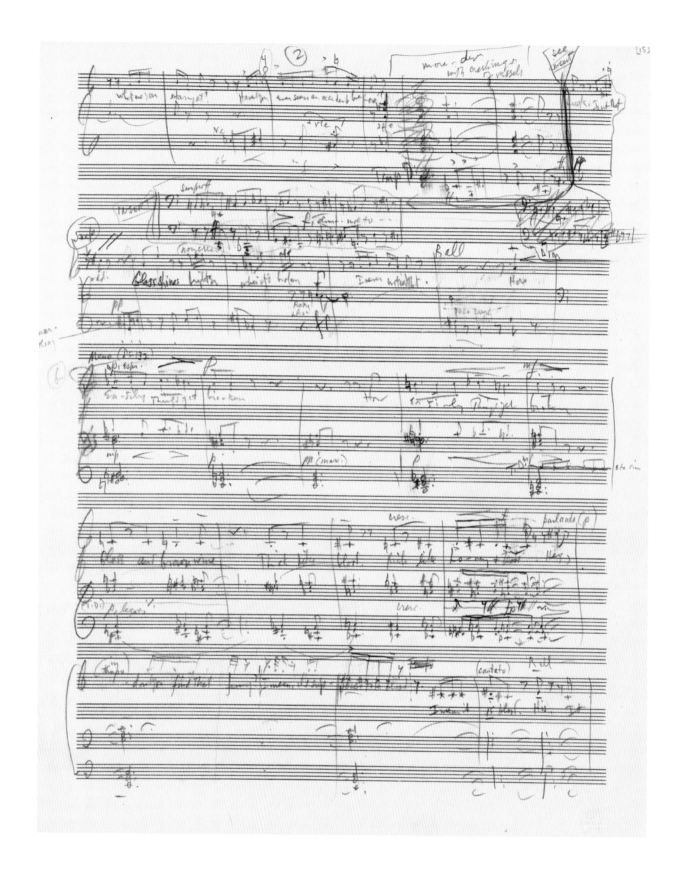

Leonard Bernstein—*Mass*—"Things Get Broken" sketch, 1970-1971. Page 15.

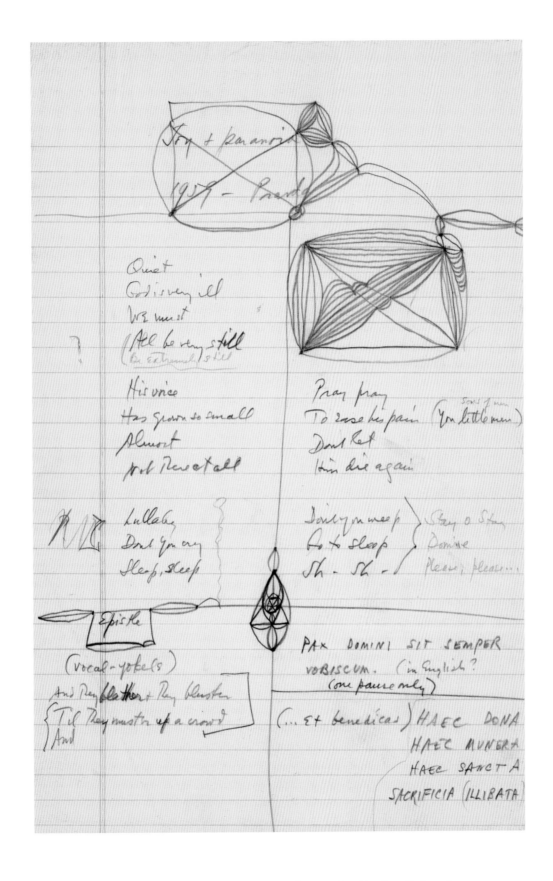

Leonard Bernstein—*Mass*—"Fraction: Things Get Broken" sketch, 1970-1971.

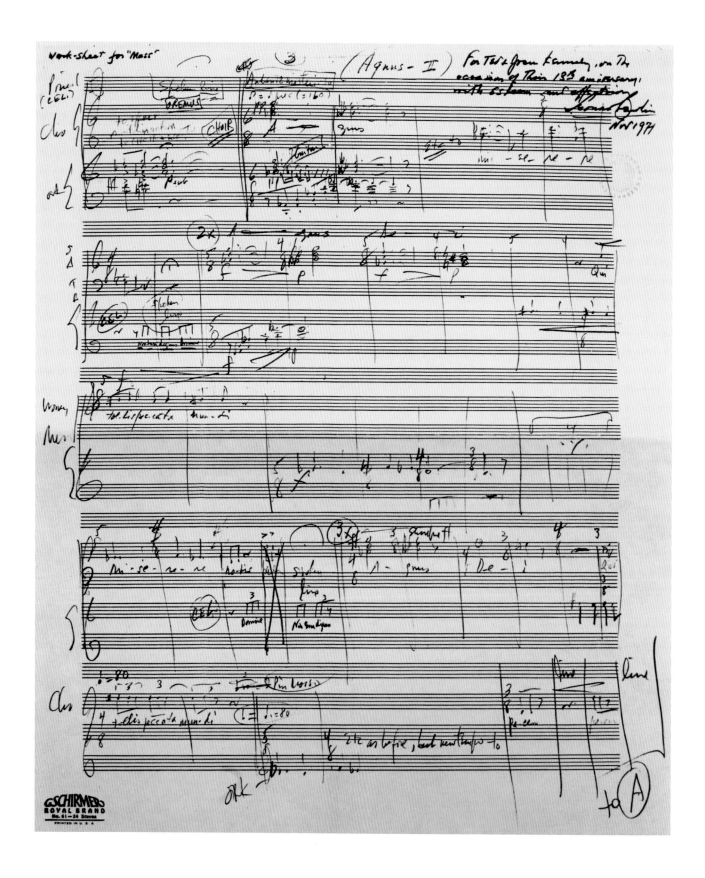

Leonard Bernstein—*Mass*—"Agnus II" sketch, 1970-1971. Page 1.
Page inscribed: "For Ted and Joan Kennedy, on the occasion of their 13th
Anniversary, with esteem and affection, Leonard Bernstein Nov 1971"

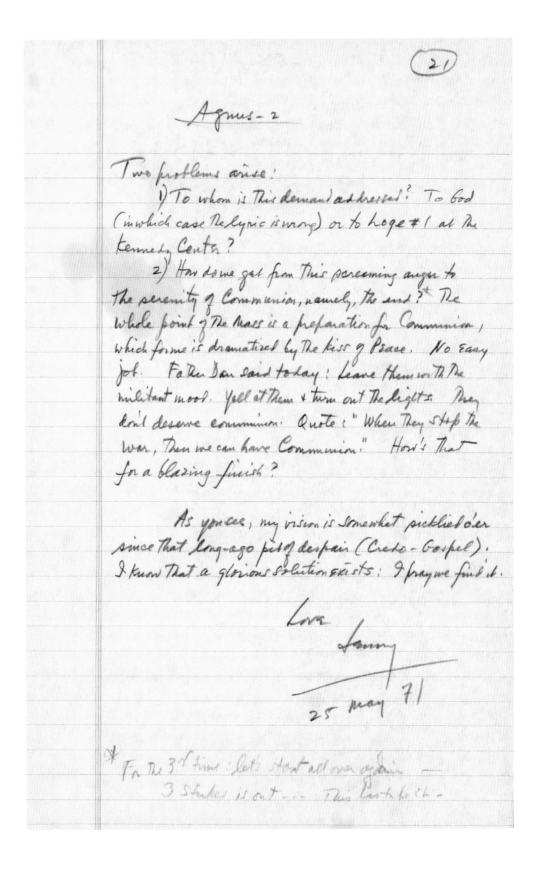

Leonard Bernstein—*Mass*—"Agnus II" notes, 25 May 1971.

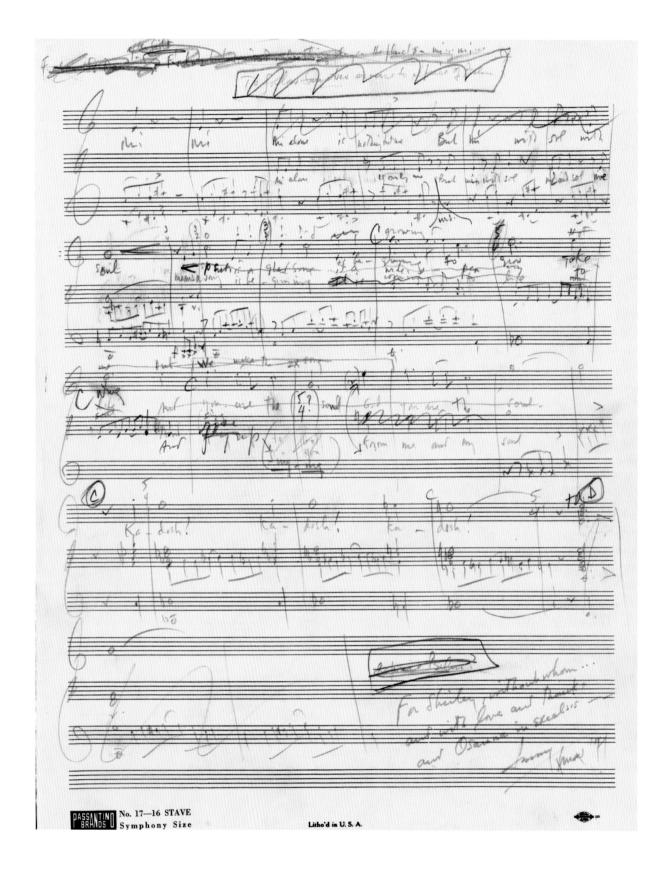

Leonard Bernstein—*Mass*—"Sanctus" sketch, 1970-1971.
Page inscribed: "For Shirley, without whom...and with love and thanks
and Osanna in Excelsis—Lenny Xmas '71."

For Mine Schwesteahs

or

"Nothing Could Be Finer Than to Be a Forty-Niner"

I thought of finding you a gift
Of cashmere, silk or leather;
But nothing seems so precious as
October's Bright Blue Weather.

When H. H. Jackson thought it up
She had her head together,
And Hilee in mind, as high she penned
"October's Bright Blue Weather".

So may it be for all your life;
And when your birthdays trouble you
Remember you are shone upon
By high O-B-B-W.

Love mööahs,
3 Oct '72

Leonard Bernstein—Letter to Shirley Bernstein on her 49th birthday,
3 October 1972.

177

MY DEAR FRIENDS, WELCOME.

THE HEBREW LITURGY SAYS "WELCOME" AS:

THE ROMANS TRANSLATE THAT AS: "BENEDICTUS QUI VENIT IN NOMINE DOMINI," WHICH IN THIS PLACE OF WORSHIP SAYS: "BLESSED ARE THEY WHO COME IN THE NAME OF THE LORD."

AND SO YOU ARE ALL BLESSED, WHATEVER THE NAME IS OF THE LORD IN WHOSE NAME YOU'VE COME: - BLESSED NOT ONLY BY HIM, NOR CERTAINLY BY ME, BUT BY THE SIMPLE HOLY ACT OF YOUR COMING. IN YOUR COMING YOU ARE DOING THE LORD'S WORK, AND THE LORD'S WORK IS PEACE; AS WE HAVE SURELY LEARNED BY NOW, THE GLORY OF GOD IS PEACE ON EARTH, AND GOOD WILL; AND THE END OF EVERY CHRISTIAN MASS IS DONA NOBIS PACEM; (GRANT US PEACE), JUST AS EVERY JEWISH SERVICE CONCLUDES WITH THE BENEDICTORY PHRASE: (AND MAY HE GRANT YOU PEACE). SHALOM IS OUR KEY WORD HERE TONIGHT, OUR PASSWORD TO THIS ANNUAL VIGIL OF THE NEW YEAR.

LAST YEAR'S VIGIL WAS PERHAPS A BIT MORE HOPEFUL THAN THIS ONE: WE THEN, AT LEAST, HAD AN ELECTION YEAR TO WHICH WE COULD LOOK FORWARD, PLAN, MOVE MOUNTAINS. THIS TIME WE LACK THAT SPECIFIC HOPE; THE MOUNTAINS REMAIN UNMOVED; INDEED THEY SEEM TO BE MORE GRIMLY IMMOBILE THAN EVER, MOVING ONLY IN THEIR UPWARD GROWTH, AS THEY ARE PILED HIGHER AND HIGHER WITH MORE AND MORE USELESS, NEEDLESS, MINDLESS, COUNTLESS, HEARTLESS MACHINERIES OF DESTRUCTION. THESE METICULOUSLY SOPHISTICATED ENGINES OF DEATH ARE NO LONGER INTENDED FOR MERE FRATRICIDE, NOR EVEN MASS HOMICIDE, NOR EVEN GENOCIDE, BUT RATHER GEOCIDE,

Leonard Bernstein—speech at the Cathedral of St. John the Divine (New York City) Peace Concert, 31 December 1984. Page 1.

THE MURDER OF THE WORLD ITSELF. AND HERE WE ARE ON THE EVE OF
ANOTHER YEAR, WITH NO ELECTIVE POSSIBILITY AT HAND, AND WITH
THE JINGLE BELLS LOUDLY PROCLAIMING PROSPERITY, RISING MARKETS,
DECREASING UNEMPLOYMENT, FAT HARVESTS, NEW NEGOTIATIONS - ALL
HYPOCRISIES, ~~FALSEHOODS~~ PSEUDO-TRUTHS. THE REAL TRUTHS, ALAS, ARE FAMINES,
DROP-OUTS, LIP-SERVICE IN HIGH PLACES, GLOBAL POVERTY, AND THE
AFFLUENCE OF A CREDIT-CARD ECONOMY. ALL OF THESE HAVE ONE
COMMON ENEMY: PEACE. BECAUSE PEACE WOULD SHOOT HOLES INTO THE
VERY FABRIC OF OUR HYPOCRITICAL SUPERSTRUCTURE; A REAL WORLD-WIDE
PEACE MIGHT JUST RUIN THE POWER OF OUR MULTI-NATIONAL GIANTS,
AND OF OUR SUPER-NATION-STATES; IT MIGHT JUST CAUSE THE ILLITERATE
TO JOIN HUMAN CULTURE; IT MIGHT JUST ALLOW FOR THE STARVING MILLIONS
OF OUR WORLD-SOCIETY TO GET FED. BUT THAT WOULD SPOIL ALL THE
FUN, WOULDN'T IT? WHAT WOULD WE DO WITH ALL OUR EVER-INCREASING
NUCLEAR KNOW-HOW? USE IT FOR PEACEFUL PURPOSES, LIKE IRRIGATING
DESERTS, OR EXPLORING INTELLIGENCE IN SPACE? DON'T BE SILLY. AND
WHAT WOULD WE DO WITH ALL OUR EVER-INCREASING COMPUTER SOPHISTICATION?
MAKE UNIVERSAL COMMUNICATION AND LEARNING A REALITY? ONCE AND FOR
ALL WIPE OUT CANCER, AIDS, THE COMMON COLD? NONSENSE: THINK WHAT
WOULD HAPPEN TO OUR PORN AND VIOLENCE VIDEOS, OUR ENDLESS
VARIATIONS ON STAR WARS. TO SAY NOTHING OF OUR MORE AND MORE
EXTRAVAGANT COMMERCIALS. CAN'T DO WITHOUT THEM. THEN WHAT WOULD
HAPPEN TO ALL OUR GREEDY GREEN MONEY? FEED, HOUSE, CLOTHE,
BUILD? OF COURSE NOT. WE NEED IT TO MAKE MORE GREEDY GREEN
MONEY. THAT'S THE BUSINESS WE'RE IN - THE MONEY BUSINESS.

GEORGE BERNARD SHAW SAID A WONDERFUL THING IN HIS PREFACE
TO MAJOR BARBARA: THE WORST OF CRIMES IS POVERTY. TODAY WE MIGHT

Leonard Bernstein—speech at the Cathedral of St. John the Divine (New York City) Peace Concert,
31 December 1984. Page 2.

ADD TO THAT: THE BEST OF SOLUTIONS TO THAT CRIME IS PEACE. AND SO WE HAVE COME HERE TO PRAY, AS WE HAVE BEFORE, AGAIN AND AGAIN: NOT JUST PASSIVELY TO PRAY FOR AN ABSTRACTION CALLED PEACE, BUT TO JOIN HANDS AND MINDS IN OUR PRAYER, TO REAFFIRM OUR STUBBORN CONTENTION THAT PEACE IS POSSIBLE; THAT WE KNOW MILLIONS OF OTHERS ALL OVER THE WORLD ARE JOINING US TODAY IN THIS SAME LONGING, YEARNING, STRIVING OF THE SOUL, AND THAT OUR HUMAN SPECIES IS NOT ONE OF MONSTERS, OR OF STUPEFIED BIGOTS, BUT BASICALLY A RACE OF INTELLIGENT BEINGS, MEN OF GOOD WILL, WHO CAN ULTIMATELY UNDERSTAND THE DESPERATE NEED, THE UNIVERSAL JOY, AND THE SIMPLE COMMON SENSE OF A WORLD AT PEACE.

AND, WHILE WE COUNT OUR BLESSINGS, LET'S NOT FORGET TO BE THANKFUL THAT WE HAVE THIS FORUM, THIS SACRED SOAP-BOX, WHERE WE CAN SAY ALL THESE THINGS IN FREEDOM AND IN LOVE.

AND, LET'S NOT FORGET THAT IN THE ACT OF COMING HERE, BLESSED AS YOU ARE, YOU, WE, ARE TAKING ONLY THE FIRST OF AN INFINITE SERIES OF STEPS, ACTIVE STEPS, TOWARD DOING WHAT WE CAN, ALL OF US IN OUR VARIOUS WAYS, TO HELP OURSELVES DISARM, DISARM, AND FINALLY, DISARM.

MY OWN CONTRIBUTION TO THIS SERVICE WILL BE VERY BRIEF: A PRAYERFUL SONG BY GUSTAV MAHLER, CALLED URLICHT - PRIMEVAL LIGHT - WHICH IS A SETTING OF AN OLD GERMAN FOLK POEM, IN WHICH A CHILD SINGS OF HIS LONGING FOR THE ETERNAL BLISS OF HEAVEN.

Leonard Bernstein—speech at the Cathedral of St. John the Divine (New York City) Peace Concert, 31 December 1984. Page 3.

IN A METAPHORICAL SENSE, AND ALSO IN THE SENSE IN WHICH MAHLER
USED THIS SONG AS THE 4TH MOVEMENT OF HIS RESURRECTION SYMPHONY,
THIS MUSIC REFLECTS THE PURE INNOCENT CHILD IN EACH OF US, THE
CHILD THAT LONGS FOR, AND BELIEVES IN, THE SUPREME MIRACLE OF
PEACE.

Leonard Bernstein—speech at the Cathedral of St. John the Divine (New York City) Peace Concert,
31 December 1984. Page 4.

Leonard Bernstein—speech at the Cathedral of St. John the Divine (New York City) Peace Concert, 31 December 1984. Handwritten draft dated 30 December 1984. Pages 1 to 4.

greedy green money. That's the business we're in — the money business.

George Bernard Shaw said a wonderful thing in his preface to Major Barbara: ~~The worst of crimes~~ is poverty. Today we might add to that: ~~The best of solutions to~~ ~~that~~ ~~way to combat~~ that crime is peace. And we have come here to pray, as we have before, again & again: not just passionately to pray for an abstraction called peace, but to join hands and minds in our prayer, to reaffirm our stubborn conviction that peace is possible, that we know millions of others all over the world are joining us today in this same ~~effort of the soul~~ longing, yearning, striving of the soul;

and that our human species is not one of monsters, or of stupefied bigots, but basically a race of intelligent beings, men of good will, who ~~with~~ ~~if~~ ~~if~~ ~~the help~~ ~~of~~ ~~prayers~~ can ultimately understand the ~~desperate~~ terminal the simple need, ~~in~~ joy, and common sense of a world at peace. [OVER]

My own contribution to this service ~~is to perform~~ will be very brief: a prayerful song by Gustav Mahler, called Urlicht — Primeval light — which is a setting of an old German folk poem, in which a child sings of his longing for the eternal bliss of Heaven, ~~and of his determination~~ ~~not to be deflected from the path~~ ~~thereto.~~ In a metaphorical sense,

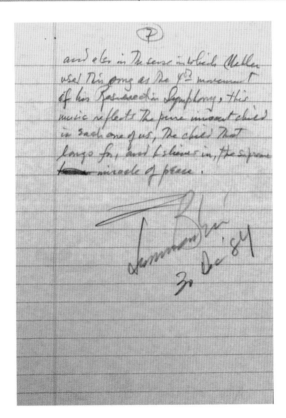

and also in the sense in which Mahler used this song as the 4th movement of his Resurrection Symphony, this music reflects the pure innocent child in each one of us, the child that longs for, and believes in, the supreme ~~to~~ miracle of peace.

Leonard Bernstein
30 Dec 84

Leonard Bernstein—speech at the Cathedral of St. John the Divine (New York City) Peace Concert, 31 December 1984. Handwritten draft dated 30 December 1984. Page 5 to 7.

LEONARD BERNSTEIN

21 March 1988

By the time you have become a junior high-
school student you should have learned, with any
luck, to love learning. Loving (yourselves, one
another, your teachers, Keats, Euclid, Bach,
Beatles) is the only way to genuine learning -
that is, learning that will always be part of you,
always animating your mere existence. There is
no other way.

Good luck and love,

Leonard Bernstein's response to a Michigan junior high school teacher who wrote to a
cross section of famous people, including Bernstein, requesting brief comments for
his students on how "they might try to succeed and to become solid citizens of their
community," 21 March 1988.

For 10 May '89

For H.G.C.

Almost Goodbye
~~(Almost a Sonnet)~~

Helen, your middle name was Grace.
Oh yes, Grace was your middle name.
"Goodness," you would say, "goodness gracious!"
And you departed with grace, as you meant to.
You remain, all the same, just as you meant to,
In a million mysterious, graceful ways.

"It's all meant to be," you would say; "I'm ready.
Guardian angels are guarding us both.
I believe it and know it. You are not to worry.
Please." A command. And if I doubted,
Good gracious, how can I doubt it now?
For inasmuch as I am reduced in grace,
I have gained one guardian angel more.

Leonard Bernstein
6 May '89
(3 March ")

Leonard Bernstein—memorial poem—"Almost Goodbye" for Helen Grace Coates,
his longtime secretary, 6 May 1989.

SS 60th

Verse: Dear Steve:
When I was forty,
 (Remember?)
You teased me
With "How's your back, Shorty?"
 Pretty rotten.

Dear Steve:
When I was fifty,
 (Remember?)
You pleased me
With something quite nifty
 I've forgotten.

But Steve,
You passed up sixty
 (Remember?)
Not easy
To rhyme with sixty
Except with something weak,
 slant, or oblique
Like "bitch(t)y"
 or "Vramitzky"

Vranitzky [handwritten annotation]

 or "I can't decide on <u>which</u> key. . . ."

Burthen: So, revenge!
 (waltz) It's all fixed,
'Cause you're <u>sixty</u> now!

We're quits and even,
Even-steven,
'Cause you're <u>sixty</u> now!

Coda: And poor Stephen
 (tune: Soon you'll be leavin'
 "Poor Your sixties well behind, *me & only* [handwritten annotation]
 Jenny") I wish you <u>Schöne</u> <u>Ferrien</u>,
'Cause as a septuagenarian
You won't have to make up your mind!

Leonard Bernstein—poem for Stephen Sondheim's 60th birthday,
December 1989.

For HJK: Finalizing The Deal, I Believe You Call It.

I make a deal with God.
 God, she was tough to deal with.
 Deal f me a tempting clause—
 Then a sharp zap to the kidneys.

It wasn't a real deal,
Really, just a sort of
Gentlepersons' Agreement.
We almost shook on it;
The swag was Time, time
Not just to live it out
To the maximum, only to write
That one important piece.

"How do you know it will be
That important?" she asked.
"I'll know, all right, but there'll be
No way to prove it. Not in a court
Of law, especially our kind
Of court. No witnesses."
"Bullshit," she murmured. "It's the same
Old thing again: Afraid
To Die, afraid to try
The consequences of Not to Be."
"Wrong," I said. "Afraid
Died in my vocabulary
Long ago — except for hurting
Someone I love, and then
Of not writing my Piece
Before my Not to Be!"
Long discussion; not to bore you
With it: We swapped arguments)
We weighed the truths and lies.

Then she became suddenly kinder,
At the same time changing gender.
"I offer the Answer to the Unanswered Question
In trade for cancer, or lethal indigestion."

I thought to myself: unfair bargaining.

Much more painful to know the Answer
Than any form of mortal cancer.

(Hasn't that ever occurred to you?
(You being my friend, not Her/Him.))

"But the Cosmos," she argued,
"The ultimate macro-atom."

"No deal. Thank you, madam."
Changing gender, she played her ace
In the hole. The biggest. "Beginningless."
That did it. I signed on.
We shook on it.
I'm still shaking.

 LB Rev. Prague
 29 may '90

Leonard Bernstein—"Finalizing the Deal, I Believe You Call It," handwritten,
for HJK (Harry J. Kraut, his manager), revised in Prague, Czechoslovakia, 24 May 1990.

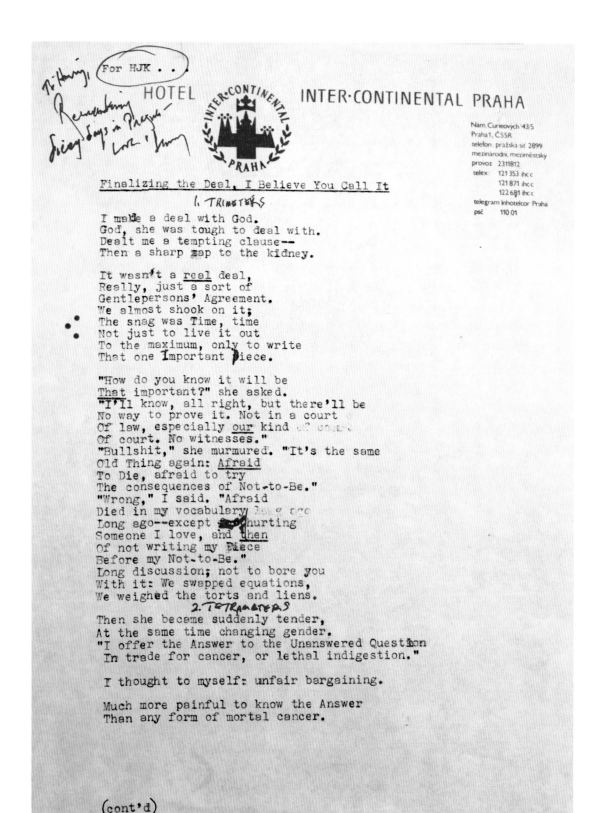

Leonard Bernstein—"Finalizing the Deal, I Believe You Call It," For HJK (Harry J. Kraut), 29 May 1990. Page 1.
Inscribed: "To Harry, Remembering dicey days in Prague—Love, Lenny"

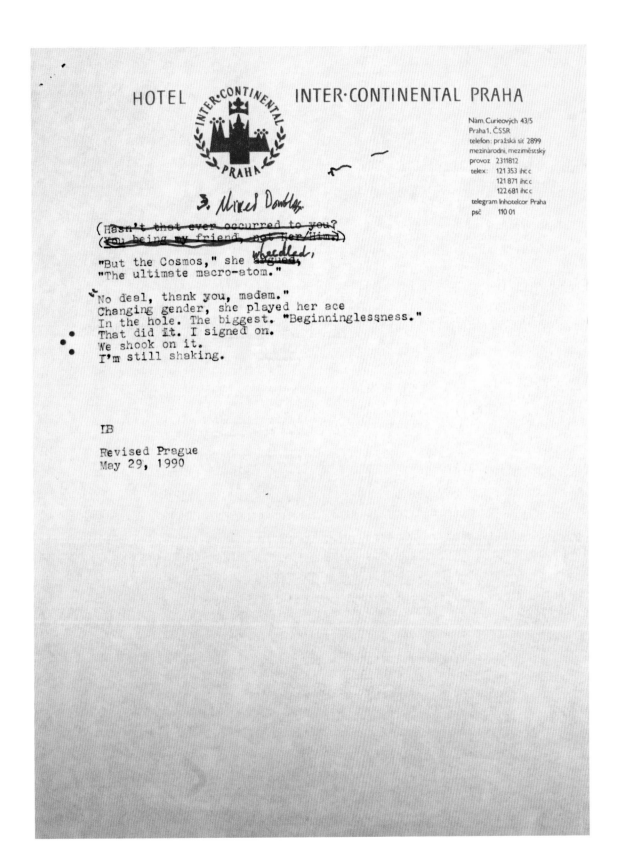

HOTEL INTER·CONTINENTAL PRAHA

Nám. Curieových 43/5
Praha 1, ČSSR
telefon: pražská síť 2899
mezinárodní, meziměstský
provoz 2311812
telex: 121 353 ihcc
 121 871 ihcc
 122 681 ihcc
telegram Inhotelcor Praha
psč 110 01

3. *Mixed Doubles.*

~~(Hasn't that ever occurred to you?~~
~~(You being my friend, not Her/Him.)~~
"But the Cosmos," she ~~argued,~~ *wheedled,*
"The ultimate macro-atom."

"No deal, thank you, madam."
Changing gender, she played her ace
In the hole. The biggest. "Beginninglessness."
That did it. I signed on.
We shook on it.
I'm still shaking.

IB

Revised Prague
May 29, 1990

Leonard Bernstein—"Finalizing the Deal, I Believe You Call It," 29 May 1990. Page 2.

Leonard Bernstein—"Three Days at Lenox Hill" (hospital, New York City), draft,
Part I: ONCOLOGY, 13 June 1990.

```
              Three Days at Lenox Hill

                        I

      [The last couplet of a 1939 sonnet:
        . . . with all the research in cancer,
        No one has yet come up with a suitable answer.]

  O ne-half century later, ye gods, this is true,
              still, and
  N ever so true as now, with AIDS added, and the
  C ommon cold still unsolved, and coyly elusive
              new viral strains
  O f what used to be tsked off as flu, or grippe,
  L aryngitis, run-down condition (that kid always
              did have a weak chest).
  O ver and over now it's ovariectomies, metastases,
              the ubiquitous ballerina that answers
              to the name of
  G alina Lymphoma, and KS and PCP, . . . more and
              more names, numbers, initials, acronyms
              than have been known on earth until
  Y esterday.

                        13 June 1990
```

```
      [parts II and III to come]
```

Leonard Bernstein—"Three Days at Lenox Hill,"
Part I: ONCOLOGY, 13 June 1990.

"Perhaps the best I can have done today is to remind you of what you surely knew already, of the life-or-death importance of living out the Will to Love; to remind you by my personal confession of success or failure in my own struggle to make love a practiced reality; to remind you by nudging your awareness—and my own—of the profound moral imperative we share to make our lives a moment-by-moment, uninterrupted action of bearing witness. "

–Leonard Bernstein
27 January 1985

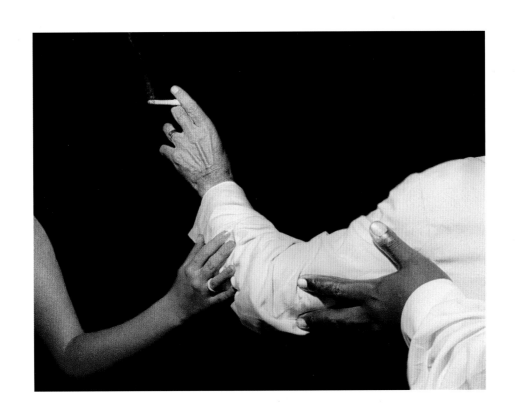

APPENDICES

PHOTO CREDITS, NOTES, INDEX

NOTES

THE PHOTOGRAPHS

All quotes: © Amberson Holdings, LLC, used by permission of The Leonard Bernstein Office, Inc.

• Page 28 "How could I know..." Samuel Bernstein

• Page 38 "Some day, preferably..." Leonard Bernstein 1955

• Page 66 "The years I have so far spent..." Leonard Bernstein 1966

• Page 100 "I have been so...": Leonard Bernstein, interview with Arnold Michaelis for WQXR Radio, 1968.

• Page 114 "And so I have lived...": Leonard Bernstein, "Beauty and Truth Revisited", part II, 8 August 1988, Library of Congress, Music Division, Leonard Bernstein Archive, box 101.

THE MAN, HIS MUSIC AND HIS MIND.

All quotes: © Amberson Holdings, LLC, used by permission of The Leonard Bernstein Office, Inc.

• Page 134 "Life without music..." Leonard Bernstein, "A Total Embrace", 10 November 1967.

• Page 192 "Perhaps the best I can...": Leonard Bernstein, "Hope in the Nuclear Age" speech delivered at All Souls Unitarian Church, 27 January 1985. Library of Congress, Music Division, Leonard Bernstein Archive.

All music sketches, manuscripts, letters/correspondences, poems, and writings are from the Leonard Bernstein Collection, Music Division, The Library of Congress, and all used by permission as follows:

Leonard Bernstein's letters and writings: © Amberson Holdings, LLC, used by permission of The Leonard Bernstein Office, Inc.

INDEX